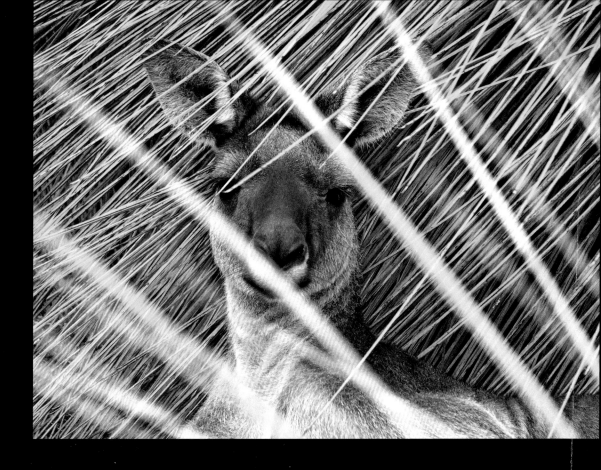

FOCUS **on Australia**

WINNING PHOTOS FROM THE NATION'S BEST

Professionals and Amateurs using Lumix cameras

LUMIX™

life

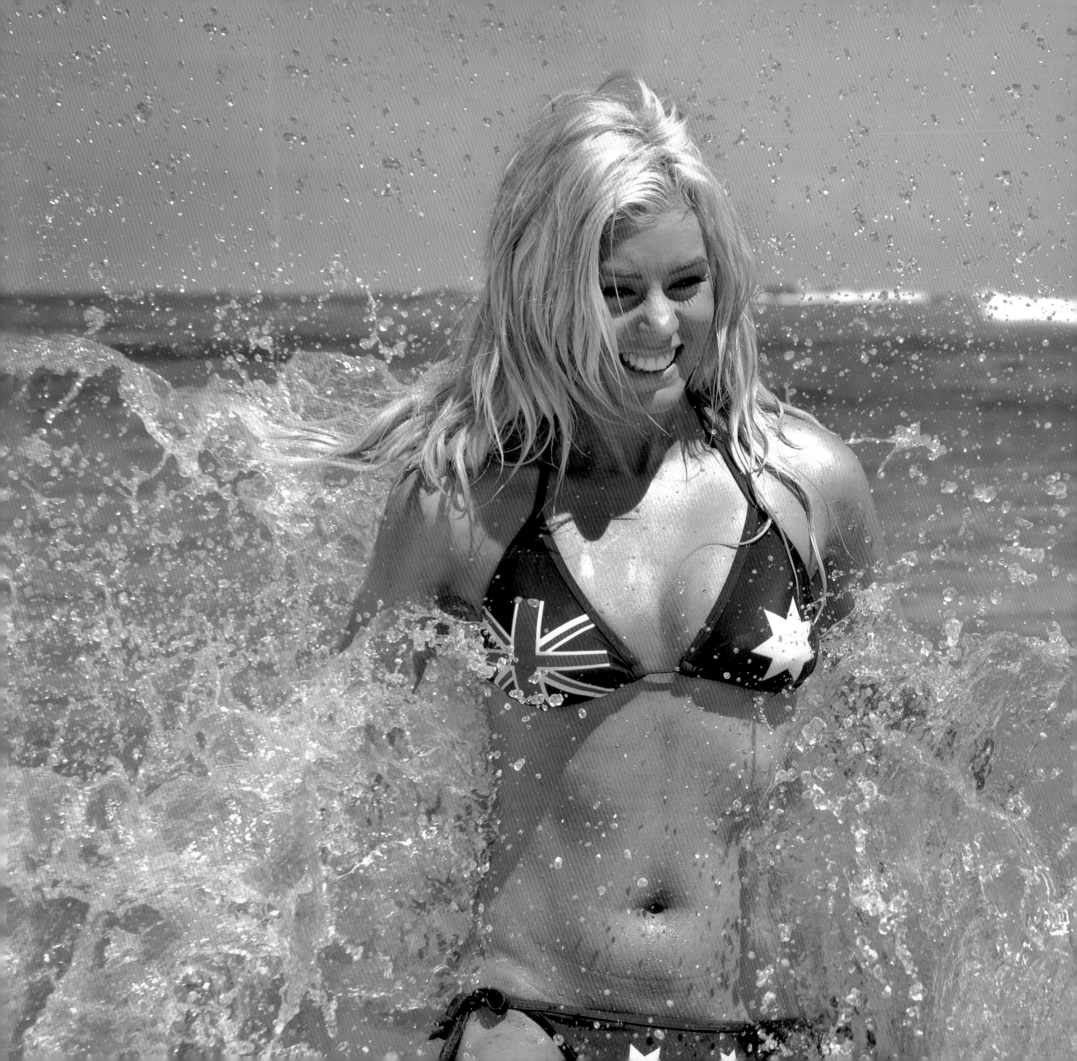

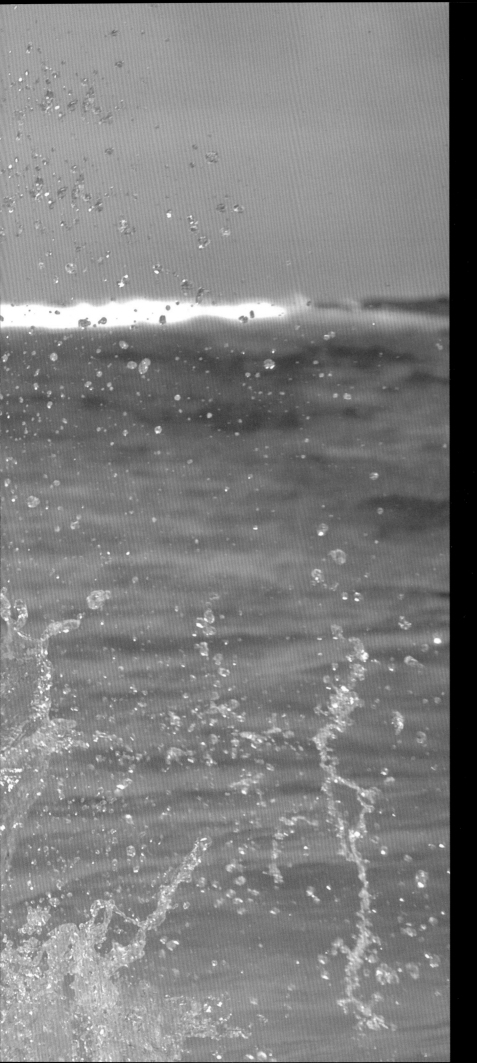

Focus
on Australia
WINNING PHOTOS FROM THE NATION'S BEST

Professionals and Amateurs using Lumix cameras

LUMIX™
life

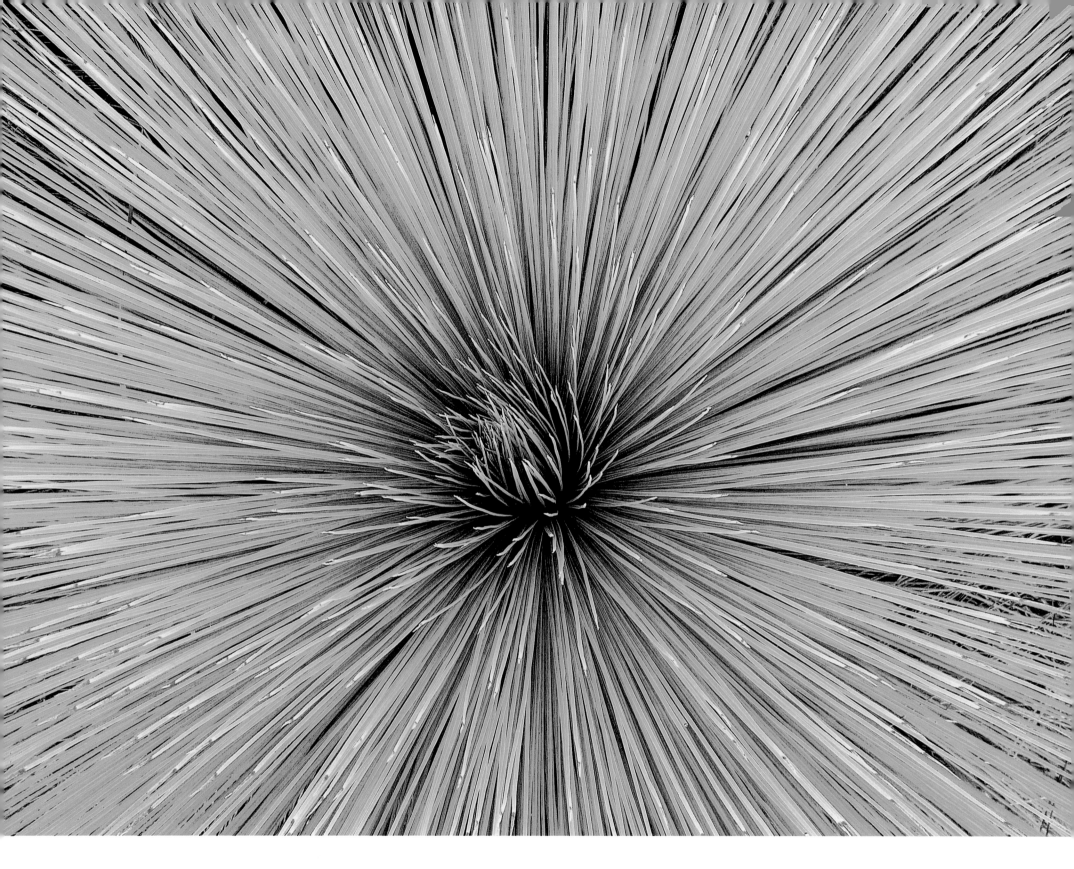

page 1

Bill Bachman *Western Grey Kangaroo (Macropus fuliginosus), WA* **Camera:** Lumix DMC-FZ35 **Aperture:** f4.4 **Shutter speed:** 1/250 **ISO:** 200

page 2 & 3

Ken Duncan *Sheridan having fun in the sun, Bateau Bay, NSW* **Camera:** Lumix DMC-G1 **Aperture:** f5 **Shutter speed:** 1/800 **ISO:** 100

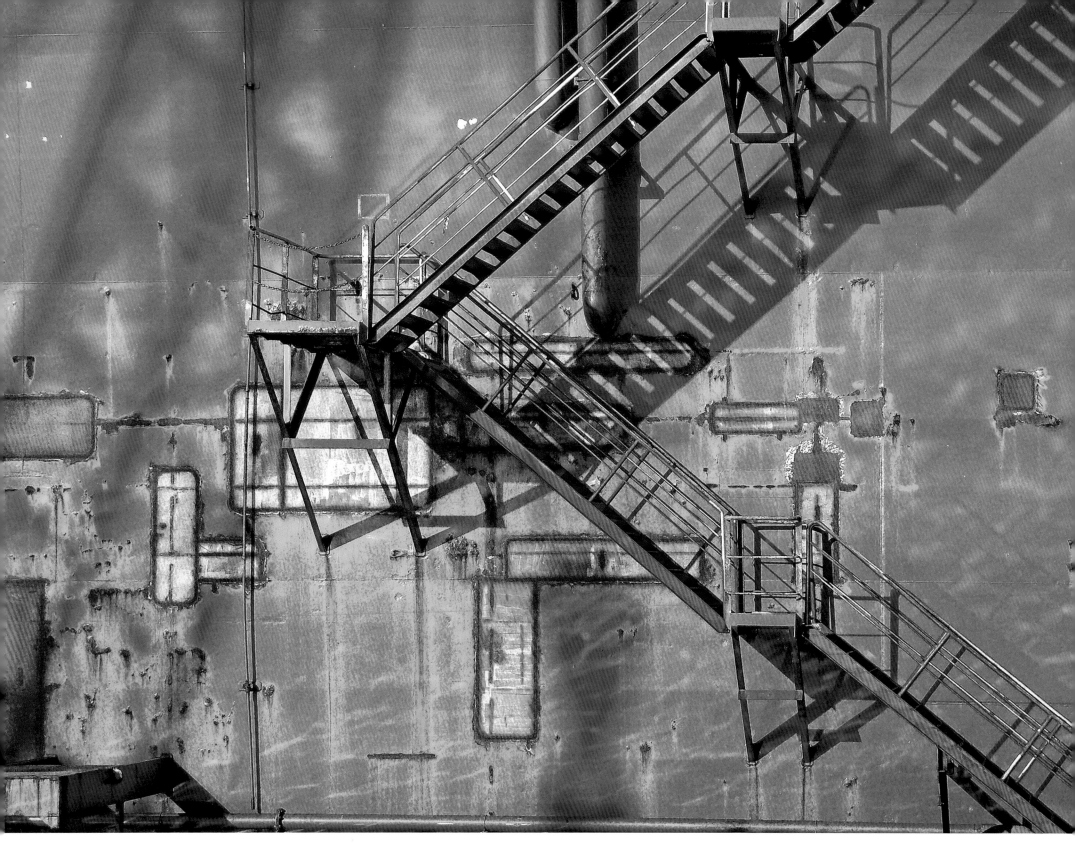

opposite

Conni Weise

Grass tree, Narawntapu National Park, Tas

Camera: Lumix DMC-FT1 **Aperture:** f3.3 **Shutter speed:** 1/160 **ISO:** 80

above

Michael Taylor

Light & shadow, Newcastle, NSW

Camera: Lumix DMC-TZ3 **Aperture:** f4.7 **Shutter speed:** 1/320 **ISO:** 100

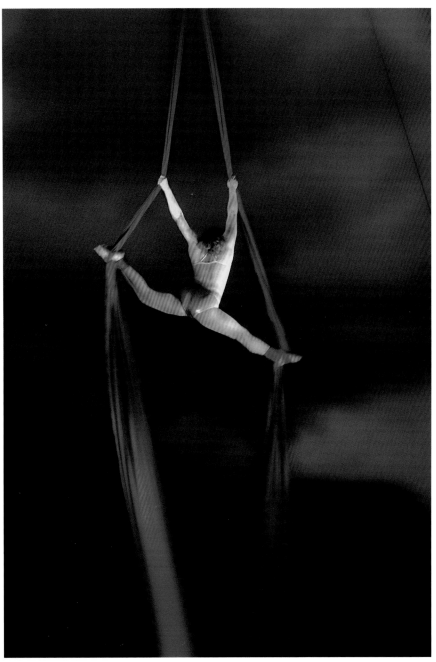

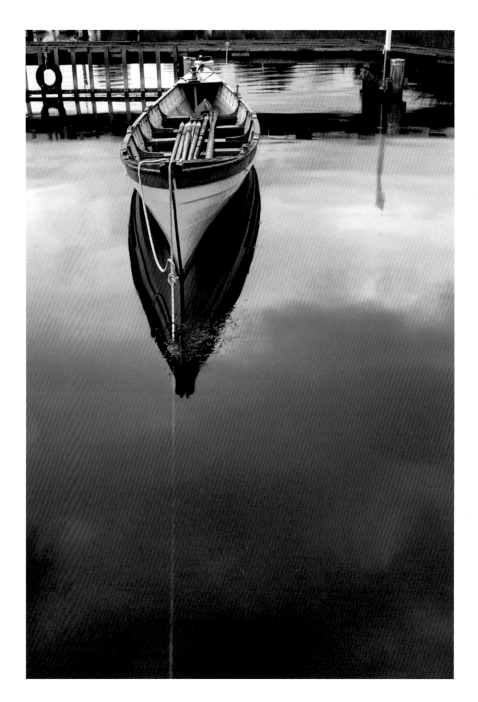

Ray Martin

*Girl on the trapeze, Arthur Boyd Estate, banks of the Shoalhaven River,
near Nowra, NSW*

This shot seemed like an optical illusion. It was taken at an indigenous
festival in late afternoon. A young gymnast worked with a single safety wire
that seemed to disappear in the dark sky behind her.

Camera: Lumix DMC-L1 **Aperture:** f3.4 **Shutter speed:** 1/15 **ISO:** 400

Ray Martin

"Blue Whaler", tiny river village of Franklin, Tas

This sleek-looking, polished-rib, egg-shell blue vessel was used in the bloody
Tasmanian whaling trade of the last century. Pictured like this, the boat looks
more like something you'd gently row – carrying ladies with colourful parasols.

Camera: Lumix DMC-GF1 **Aperture:** f4 **Shutter speed:** 1/8 **ISO:** 800

Everybody has a camera these days. Unfortunately, it's usually in their mobile phone. I'm always astonished at how people will see a great sunset, or want a quick family portrait, and whip out the mobile. But, like most things in life, if it's worth doing it's worth doing properly.

Let's be honest, even with a five megapixel phone the shots are pretty ordinary quality. Just a record of a moment. Not really worth keeping and rarely worth printing and framing. So why not get a camera that can truly capture the moment? Lumix have a vast range, no matter what your budget. There are simply no excuses anymore.

The idea of this book is to show how easy it is. No need to buy a holiday postcard anymore or apologise for a fuzzy, badly lit, mobile phone picture. You don't have to be a professional or even an obsessed amateur like me, just a "point and shoot" happy snapper. You'll be amazed at what you can capture digitally. And who knows, you may get to love it so much that you get serious, too. (It's so much more fun than stamp collecting or coins.)

I have a big SLR camera – with a bunch of heavy-weight lenses – that shoots awesome pictures. But I also have a brace of Lumix cameras – the L1, the TZ10, a G1 and for the last year I've been shooting with my current favourite, the GF1. It's a gem.

For this book I was sent to Tassie for a brief safari – not for the Term of My Natural Life, although it is an exquisite place to while away your time taking photos.

The incomparable landscape photographer, Ken Duncan, is a mate of mine. He knows that I'm a bit of a photo tragic, that I've been taking pics for over forty years and have almost been banished from taking family portraits. I'm a writer by trade, but I think I even like running around with a camera more than my word processor. I go nowhere without a camera.

That's how I became part of this book, along with some really superb photographers who actually know what they're doing. It's an honour to be part of the team.

So, I hope you enjoy the range of photos. I hope it inspires you to grab a Lumix and have some real fun. It'll make you a much happier person, I promise.

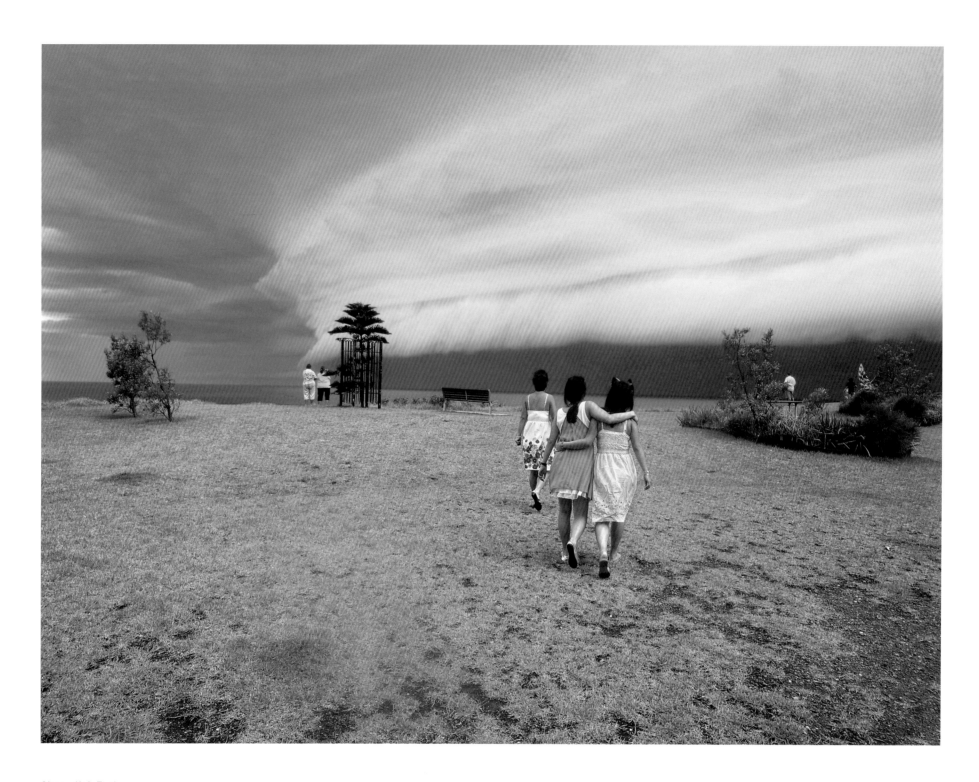

Choon Kok Teoh

Storm chasers, near Sea Cliff Bridge, south of Sydney, NSW

On the way back from a drive to Wollongong, we noticed this fearful
storm approaching us from across the sea.

Camera: Lumix DMC-ZR1 **Aperture:** f3.3 **Shutter speed:** 1/320 **ISO:** 80

Contents

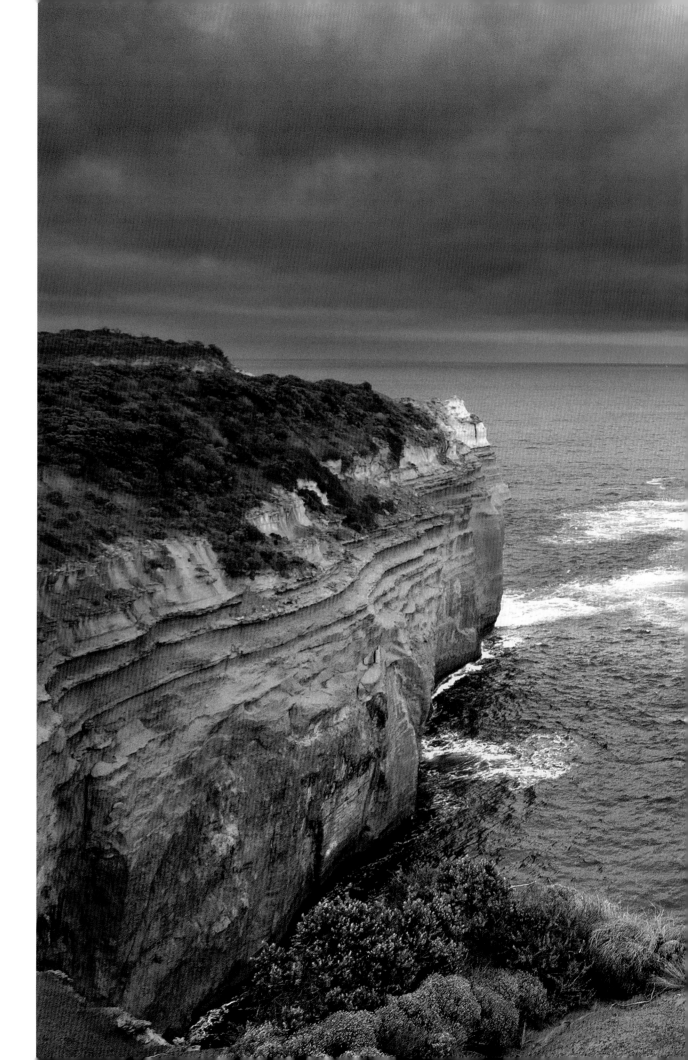

Lan Nguyen

Loch Ard Gorge, Great Ocean Road, Vic

I took this photo only a few days before the bridge collapsed.

Camera: Lumix DMC-LX3 **Aperture:** f2.8
Shutter speed: 1/800 **ISO:** 80

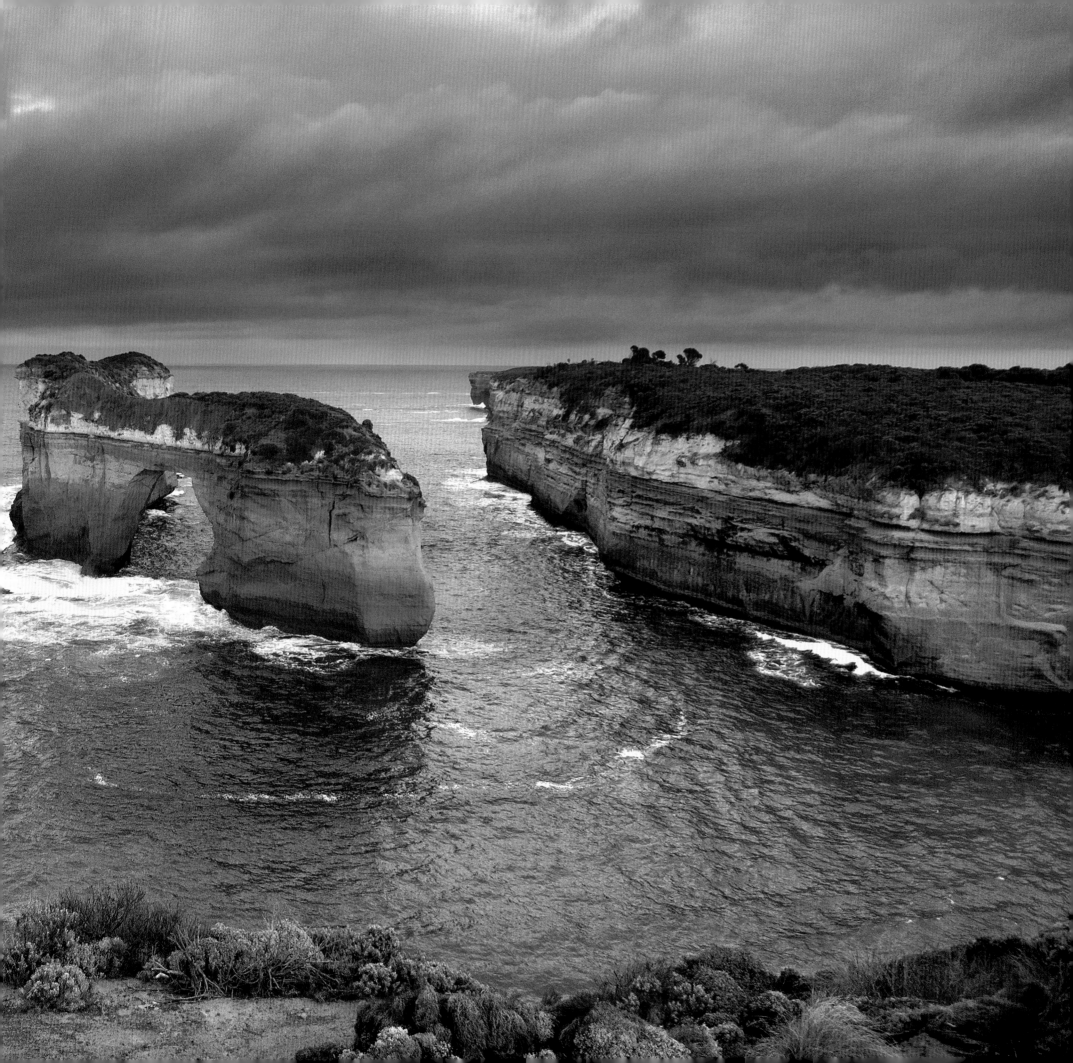

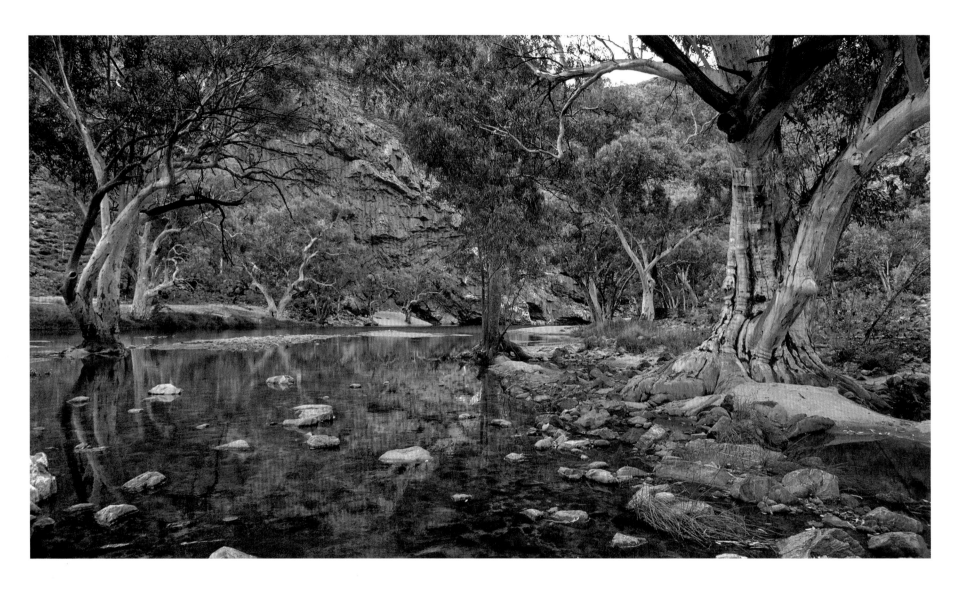

Ken Duncan

Ormiston Gorge, NT

Camera: Lumix DMC-LX3 **Aperture:** f2 **Shutter speed:** 1/30 **ISO:** 320

Introduction

Several years ago I was in Africa, leading a photographic expedition. It was a whirlwind safari through five African countries visiting many iconic locations. As usual, I was weighed down by all my professional equipment, which I was sort of used to. But there was a guy on the tour group who had a little Lumix camera with a 12x zoom. I was amazed that at so many locations he was getting exceptional shots really simply – and all on auto settings!

That was my introduction to Panasonic's exciting Lumix range. Back in Australia, at a trade show, I congratulated Panasonic, saying how impressed I had been with what I had witnessed. The upshot was that I was offered a compact Lumix – it was an LX2 – to "have a play with" out in the field.

It was an offer I was very pleased to accept. This was a camera I could stick easily into a pocket, yet it took incredible quality photos very easily. I was still using my large-format cameras too, but I found myself using the LX2 more and more to take "grab" shots. Then I moved to the newer model the LX3 and I nicknamed my new camera "Ridiculous", because it seemed ridiculous how good the images were with just a simple click!

The front cover photograph of this book is a wonderful example of this. We were in the Ragged Ranges in the Kimberley. I was shooting with my large-format camera, but then, all of a sudden, we had to leave, because our helicopter had to get back to base before dark. We were just about to take off – and all my big gear was packed away – when there was a flood of really magical light. So I leant out of the chopper with my little LX3 and snapped that photo. It ended up being of such quality that I used it in one of my major coffee table books. That's when I really knew that Lumix shots could be used for professional publications.

Thus an idea was born. If one Lumix photo could be good enough for a top quality photographic book, why not a *whole book* of Lumix photos? And why not broaden the playing field so that *anyone* with a Lumix camera could have a go at contributing? I took the idea to Panasonic, and they were really excited. We brought a bunch of other professional photographers into the project (who, like me, were quickly enamoured by the freedom of the Lumix "point and shoot" capabilities) and we launched a national competition attracting thousands of entries from other Lumix users. *Focus on Australia* is the spectacular result. It showcases the finest Lumix-shot photos from a host of contributors, both amateur and pro. And it offers a unique, glowing and vibrant vision of this land of Australia. I hope you enjoy the journey!

Ken Duncan

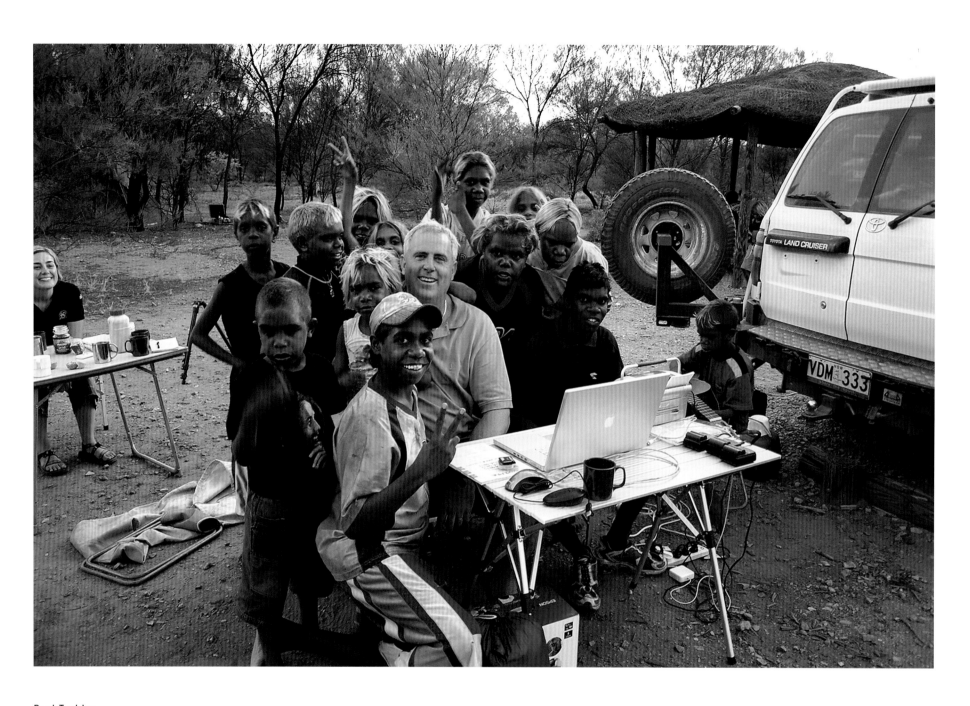

Paul Taylder

Ken Duncan with some of the Walk a While kids, Redbank Gorge, NT

This shot was taken at one of the first Walk a While photographic
workshops in an isolated part of the Northern Territory. The kids
were excited to see their own photos printed!

Walk a While

Panasonic's wonderfully generous sponsorship of the *Focus on Australia* volume (through the Lumix Life project) has meant that all proceeds from the sale of this book are able to be channelled into an exciting indigenous arts initiative called Walk a While.

The Walk a While project was pioneered by photographer Ken Duncan seven years ago, growing out of his longstanding relationship with some of Australia's remotest Aboriginal communities. Over the decades, Ken had not only built many strong friendships in these places, but had also witnessed many dire educational and vocational needs. Too often, indigenous youth were being denied access to modern opportunities because of the remoteness of their living places and the consequent lack of facilities and expertise. One of the turning points in Ken's decision to do something came from a conversation with a number of indigenous elders. Asking them what they thought of the photographers and film-makers who visited their lands, they responded that so many of these outsiders simply passed through, took what they wanted, and gave nothing back to the community in return.

So Ken started Walk a While. The name came from a concept he had learned from an indigenous elder – that "to really get to know a person you need to walk a while with them." For Ken, therefore, this new initiative was not about being a charity. It was about building mutual relationships between indigenous and non-indigenous people, where individuals from differing cultures could spend time with – and learn from – each other. Thus it was a very practical way of fostering true reconciliation at a local level.

Walk a While began in the community Ken knew best – Haasts Bluff, which lies approximately 250 kilometres north-west of Alice Springs. Over the past few years, Ken has organised groups of photographers, musicians and film-makers – including some of the nation's top practitioners – to visit the community and share their expertise with the youth. Creativity, Ken knows, is already instinctive in so many of these people (as witnessed by the many famous Aboriginal paintings). By teaching the young people to use new technologies, Ken and other visiting artists hope to equip them – over time – to tell their own stories in new and innovative ways.

It is hoped that the Walk a While project will soon be rolled out into other indigenous communities, and that it will enable many vocational opportunities for young people as they approach adulthood. The main targeted areas are photography, film, and music recording, as well as related skill-sets such as tourism and marketing. There are plans for an Arts Centre at Haasts Bluff, which will be a learning hub for the community's youth as well as housing a gallery and small theatre to showcase and sell artists' work. Ongoing public support is required.

To find out more about the exciting Walk a While project, visit:

www.kenduncan.com/index.php/walk-a-while

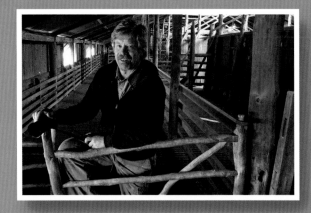

Bill Bachman

Bill Bachman was born in the United States in 1952, and has lived in Australia since 1973. He has contributed articles and photographs to a wide variety of books and magazines around the world, and his work regularly appears in *Australian Geographic* and other major publications. He is the author of *Off the Road Again* (1989), a photographic diary of his outback travels; *Animal Vegetable Mineral* (1996), a collection of abstract landscapes and nature close-ups; *Special Delivery: Aussie mailboxes & other roadside attractions* (2000); *The Murray River* (2000); and the international best-seller *Local Colour: Travels in the Other Australia*. His photographs have also been widely exhibited.

www.agpix.com/billbachman

Some tips from Bill

Photography to me has never been a mechanical act so much as an alchemical one. Anyone can figure out how to work a camera and set up a light and take a photograph. You can teach yourself, like I did. That said, very few people are actually capable of producing good photographs, much less striking or memorable ones. So the following things, I think, are very important:

Learn to see

As a photographer, you have to see, amidst all that confronts your eye, the image you want to capture – you have to find the picture within a picture, as it were. As one of the wittiest photographers of all, the great Elliot Erwitt, has stated, "Photography is just about seeing. You either see, or you don't see. The rest is academic." Once you have taken the obvious shot, look behind you, climb up on something, lie down, move closer or farther away. Often there is more than one way of looking at things.

Be prepared to stop

Many times the only difference between me and countless others who have been walking or driving along and have seen something really interesting is that I have stopped and they have not. I got the shot and they didn't. Sometimes travelling with me is a very slow affair, because I notice a lot. Remember, there are no second chances in photography. If you see something and think, "Well, it's inconvenient to stop now, I'll come back tomorrow," that shot will be gone forever. And expect the unexpected. Quite often the picture you set out to take is not the one you come back with.

Bill Bachman

Couple in bus shelter at South Beach, Fremantle, WA

Camera: Lumix DMC-GF1 **Aperture:** f5.8 **Shutter speed:** 1/100 **ISO:** 400

Bill Bachman

Carpark, Fremantle, WA

Camera: Lumix DMC-GF1 **Aperture:** f8 **Shutter speed:** 1/320 **ISO:** 200

Bill Bachman

Jim Allen inside Beaufort's Big Garage Sale, Beaufort, Vic

Jim Allen has been operating Beaufort's Big Garage Sale
– a roadside antiques and bric-a-brac emporium – since
1992. "I never go looking for the stuff I have in here," he
says. "Somehow it all just comes to me." Shot hand-held
with mid-day light coming through the front door, this was
one of the very first photographs I took with the Lumix
DMC-GF1, and I was pleasantly surprised at how well it
handled both highlights and shadows, and how crisp
the file was at ISO 400.

Camera: Lumix DMC-GF1 **Aperture:** f4
Shutter speed: 1/50 **ISO:** 400

opposite

Bill Bachman

Orna's Folk-Art & Craft, Fremantle Markets, WA

Orna Shachar's stall is crammed full of her own hand-
painted wall plaques and giftware. She also conducts class-
es in folk art and decorative painting. Established in 1897,
the Fremantle Markets operated as a wholesale food and
produce market until the 1950s and then became a packing
and distribution centre before undergoing a complete res-
toration by the Fremantle City Council in 1975, when they
were officially added to the Register of Heritage Places.
Open from Friday through Sunday, the markets have over
150 stalls and are home to a colourful collection of buskers
and street performers.

Camera: Lumix DMC-GF1 **Aperture:** f4
Shutter speed: 1/50 **ISO:** 400

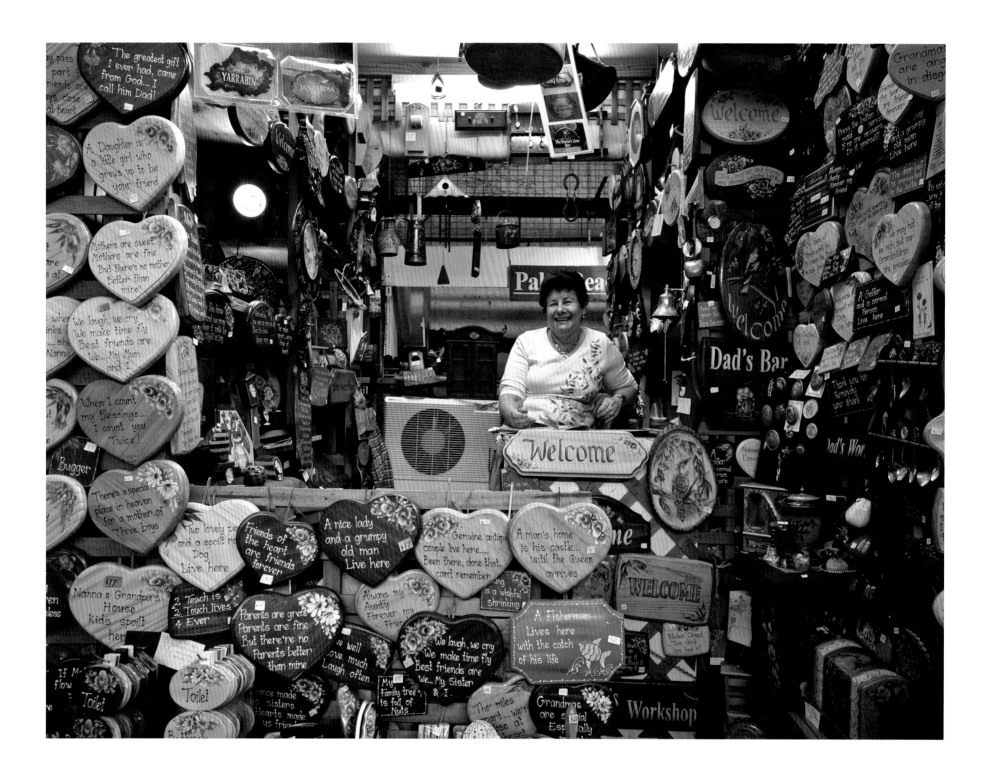

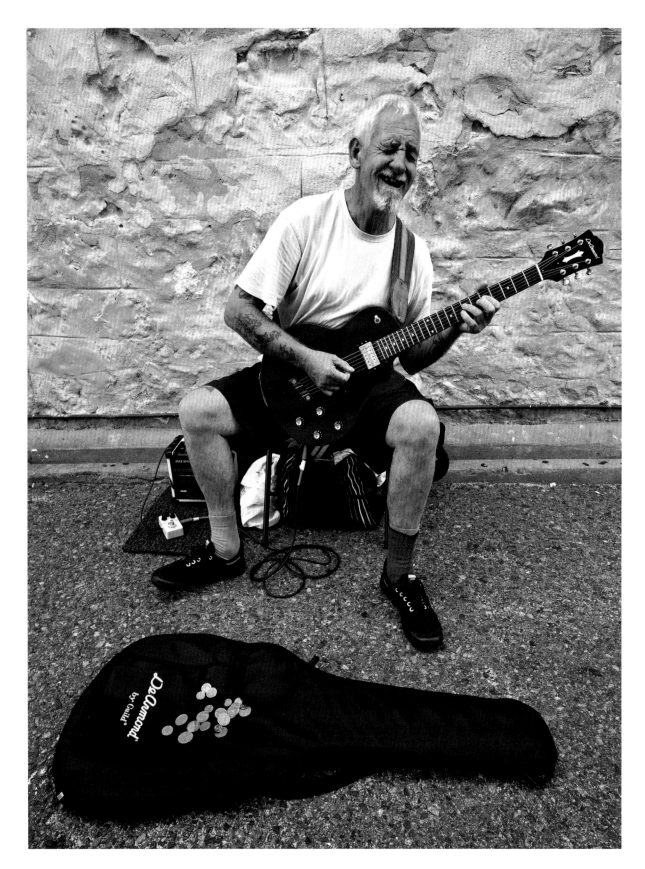

Bill Bachman

Rick Edwards, busker at Fremantle Markets, Fremantle, WA

Rick Edwards started playing guitar in the 1970s but didn't really take it seriously until the mid-90s. "I paint, and that was always my main distraction," he says, "but I probably should have been paying more attention to music a long time ago." Yet he has no regrets. "These days I busk around Fremantle to supplement my pension," he says. "It helps me survive."

Camera: Lumix DMC-GF1 **Aperture:** f5.6
Shutter speed: 1/250 **ISO:** 200

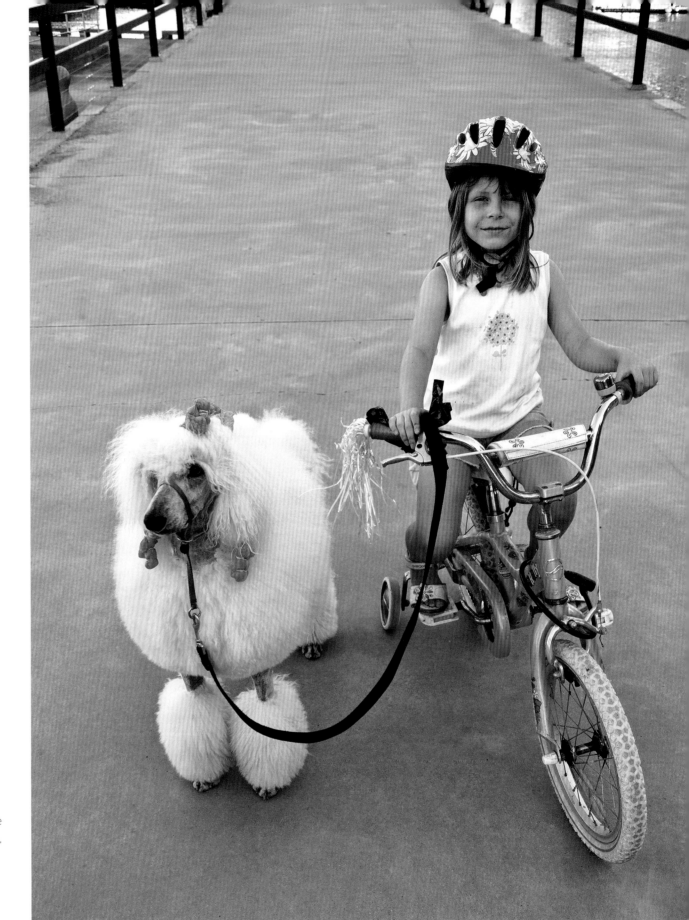

Bill Bachman

Priscilla: Queen of the Docklands, Melbourne, Vic

Here, Grace Contessi (age 5) proudly leads Australian champion standard poodle Priscilla (age 2) along Melbourne's Docklands. Priscilla's full registered name is Kateisha Just Look At Me – as you can't help doing, especially when accompanied by colour-coordinated Grace. According to owner (and Grace's mother) Leanne McLean, the champion was sired by top American poodle Just Give Me That Wink, winner of more than 100 Best-in-Shows, and imported from top New Zealand breeders John Stanton and Yvonne Smith.

Camera: Lumix DMC-GF1 **Aperture:** f4.5
Shutter speed: 1/100 **ISO:** 100

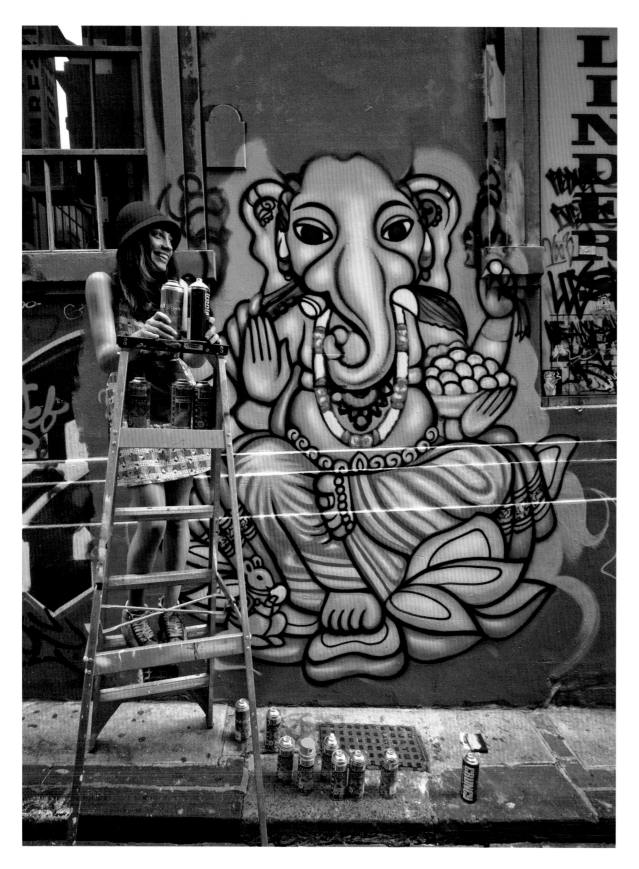

Bill Bachman
Artist Deb Fineberg, Hosier Lane, Melbourne, Vic

Artist Deb Fineberg poses with her "Ganesh" painting in progress in April 2010. This alley is a popular CBD tourist attraction and photo-shoot location because of its ever-changing wallpaper of (mostly) officially-sanctioned graffiti and street art, featuring the work of many important artists. Deb is a prominent member of the street art set, and her commissions include paintings and murals in Melbourne, Sydney and Los Angeles.

Camera: Lumix DMC-GF1 **Aperture:** f4
Shutter speed: 1/30 **ISO:** 800

opposite
Bill Bachman
Young skateboarders outside abandoned woolstores,
Cantonment St, Fremantle, WA

Camera: Lumix DMC-GF1 **Aperture:** f5.6
Shutter speed: 1/200 **ISO:** 200

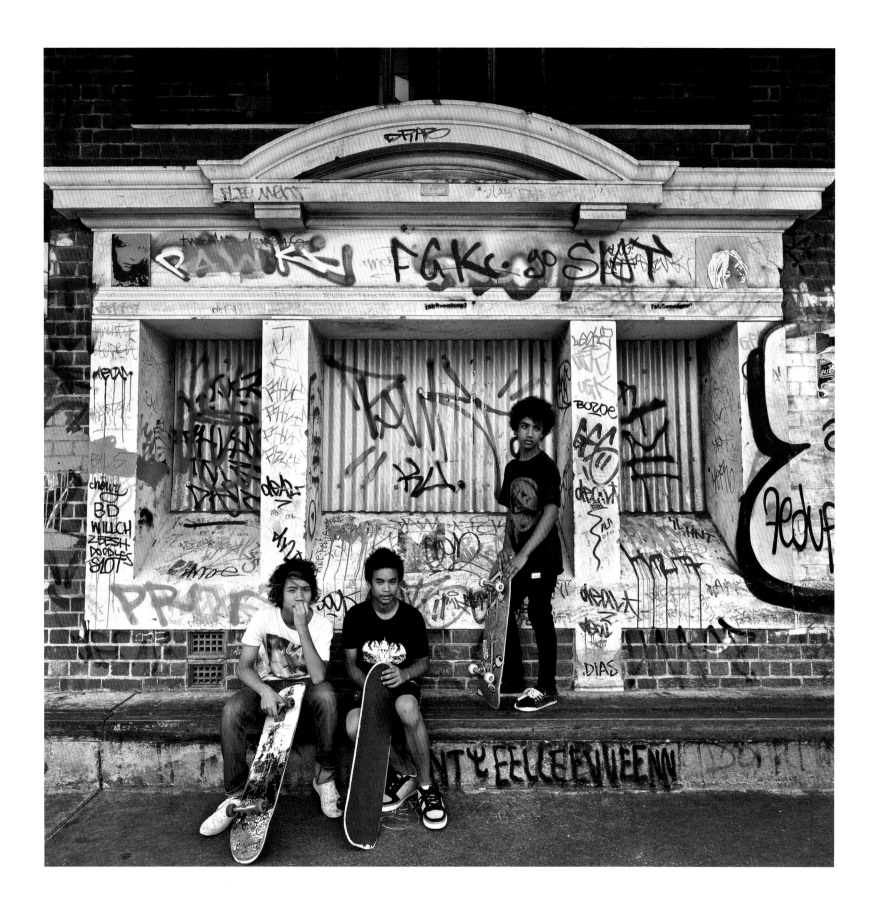

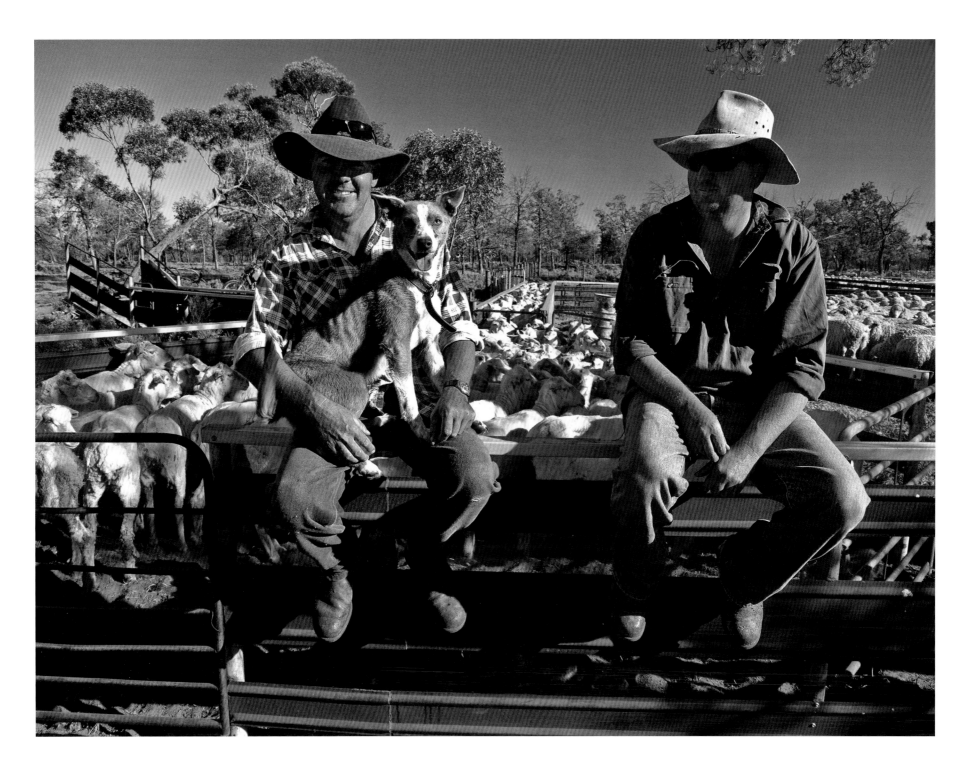

Bill Bachman

Mick and Josh Scott with kelpie-cross "Tim", Min Min Station, south-west NSW

Camera: Lumix DMC-GF1 **Aperture:** f5 **Shutter speed:** 1/200 **ISO:** 200

Bill Bachman

All hands on deck, Min Min Station, south-west NSW

Shearing at the 33,000-acre Min Min Station – located in saltbush country about 135 kilometres north of Balranald – goes on for a month. Altogether around 15,000 sheep, including the flock from 95,000-acre sister station Langley Dale, give up their fleeces, with 800–1000 merinos going under the shears on a good day. Not wanting to spoil the mood by adding flash, I just went with natural light and pushed the ISO to 1600. The Lumix GF1 coped very well with the low light and high contrast inside the shed and the noise level was surprisingly low.

Camera: Lumix DMC-GF1 **Aperture:** f4
Shutter speed: 1/100 **ISO:** 1600

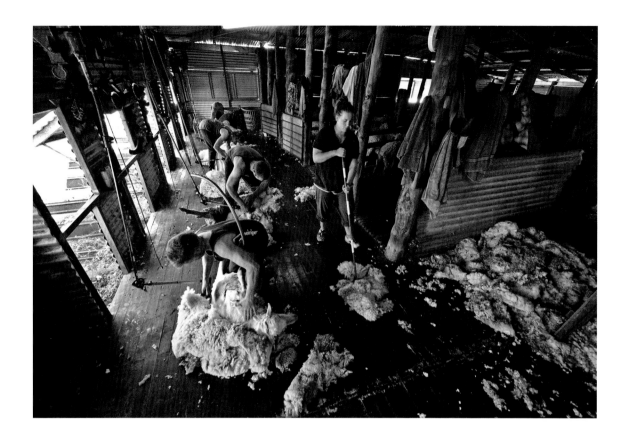

Bill Bachman

Shearer Wayne Small resting at lunchtime, Min Min Station, south-west NSW

Camera: Lumix DMC-GF1 **Aperture:** f4
Shutter speed: 1/30 **ISO:** 800

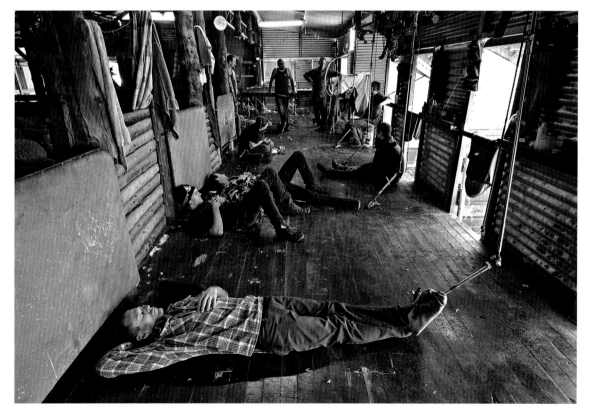

Bill Bachman

Waterwall of the National Gallery of Victoria, Melbourne, Vic

Camera: Lumix DMC-GF1 **Aperture:** f5 **Shutter speed:** 1/100 **ISO:** 200

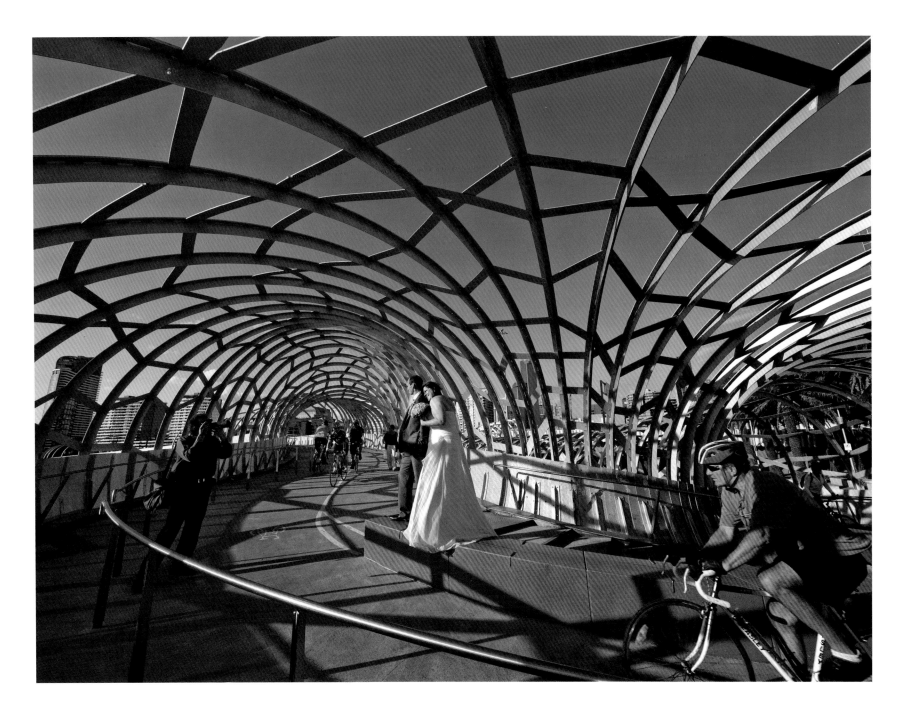

Bill Bachman

Saturday afternoon, Melbourne Docklands, Vic

Cyclists and pedestrians flow past newlyweds Gordon and Ellen Porter at
Webb Bridge, which spans the Yarra River in the Docklands area of Melbourne.
Designed by Robert Owen and Denton Corker Marshall in 2003, the sculptural
structure was the result of an art competition to transform a disused cargo link
into a functional artwork. The structure echoes the design of Koori fish traps,
drums and baskets – everyday tools used by local Aboriginal people.

Camera: Lumix DMC-GF1 **Aperture:** f7.1 **Shutter speed:** 1/320 **ISO:** 100

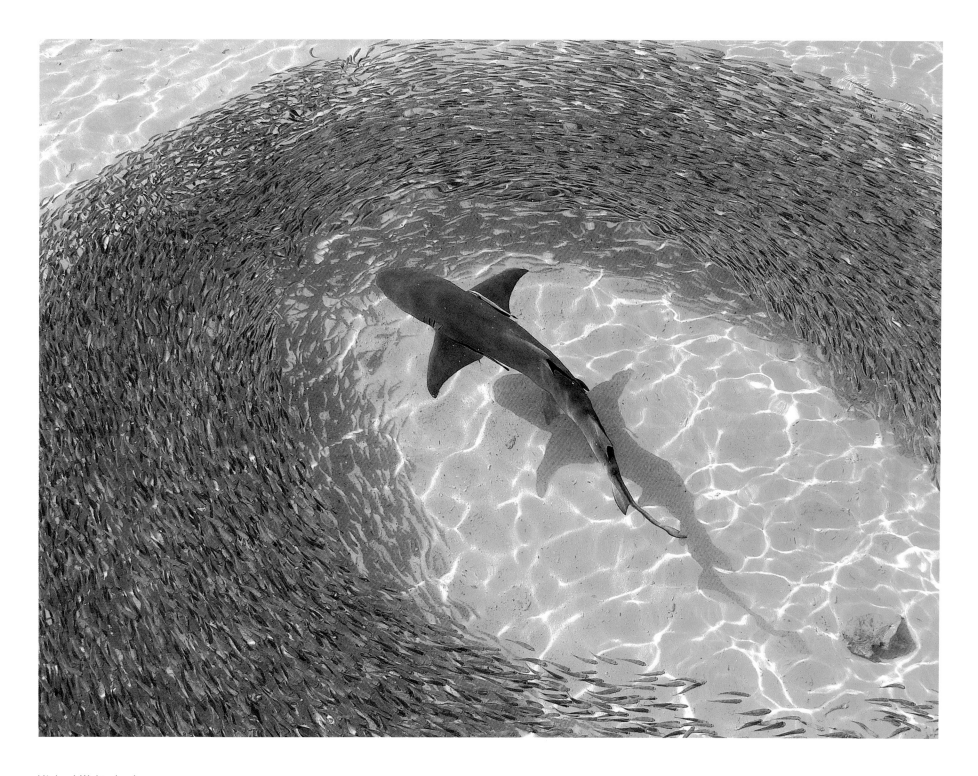

Michael Woltschenko
Lemon shark in a school of pilchards, Heron Island, Great Barrier Reef, Qld

Camera: Lumix DMC-FZ5 **Aperture:** f6.3 **Shutter speed:** 1/500 **ISO:** 100

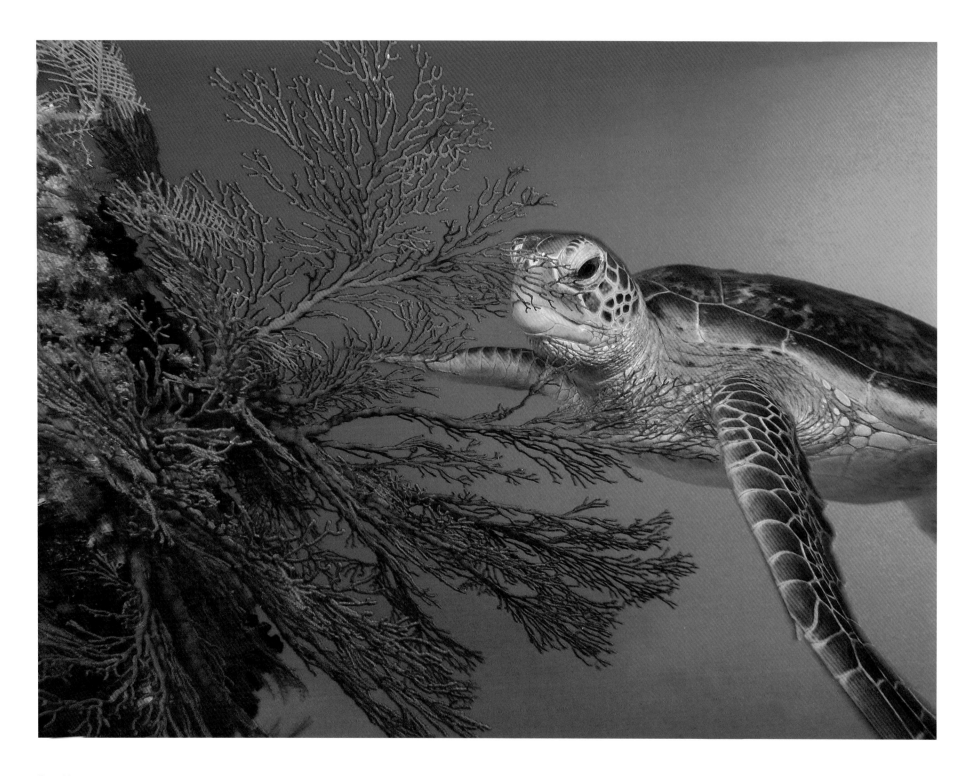

Troy Mayne
Green Turtle, Moore Reef, off Cairns, Great Barrier Reef, Qld

Camera: Lumix DMC-ZR1 **Aperture:** f3.3 **Shutter speed:** 1/30 **ISO:** 100

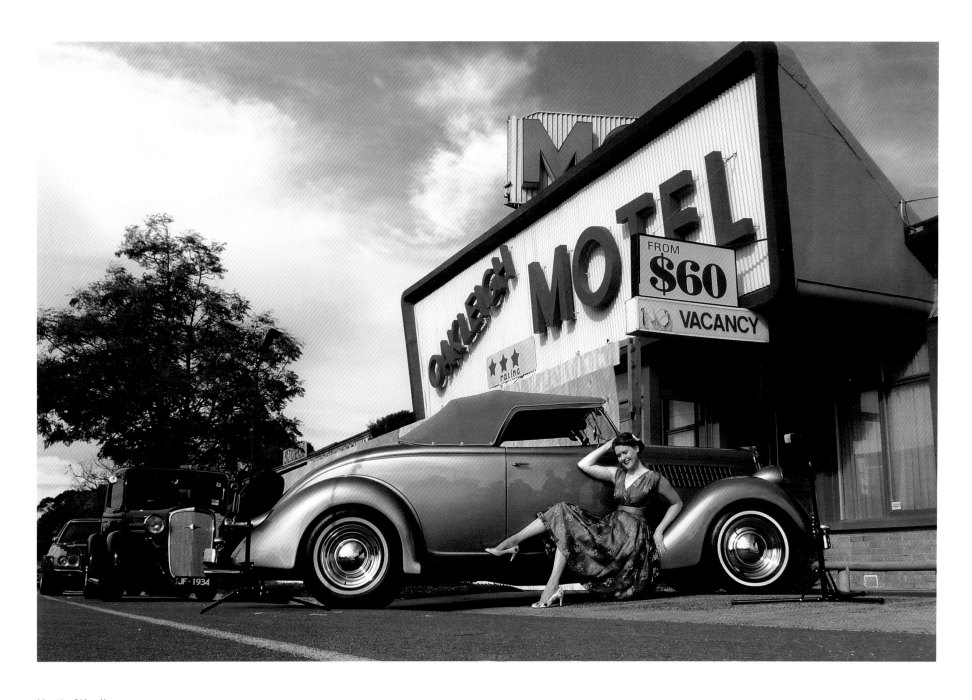

Martin Sifredi

Rockabilly photo shoot, Oakleigh Motel, Melbourne, Vic

In this shot I made the most out of a scene rarely seen these days,
and tried my hand at Black and White.

Camera: Lumix DMC-TZ2 **Aperture:** f3.9 **Shutter speed:** 1/800 **ISO:** 100

Gary Hayes
Cliff-top fishermen, Coogee, NSW

Nervously perched on rocks, these fishermen are after
a hard-to-get-at evening meal.

Camera: Lumix DMC-LX3 **Aperture:** f7.1 **Shutter speed:** 1/500 **ISO:** 80

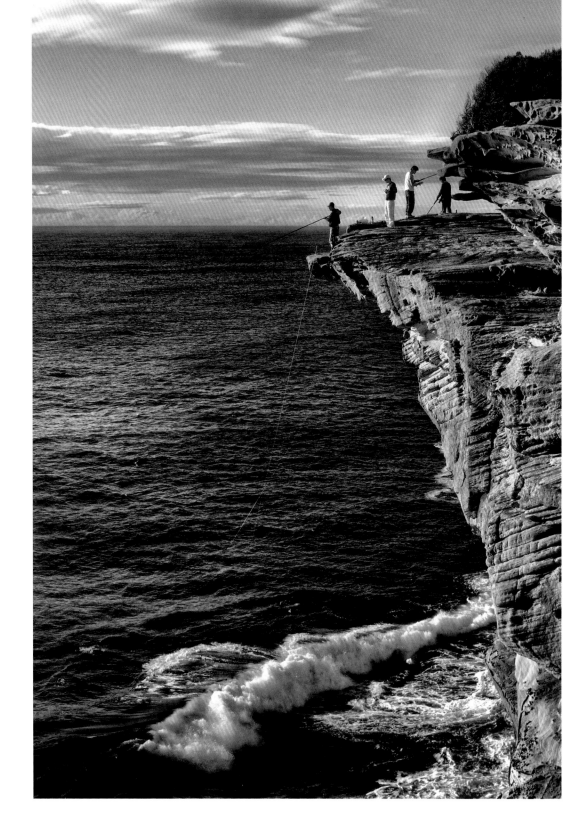

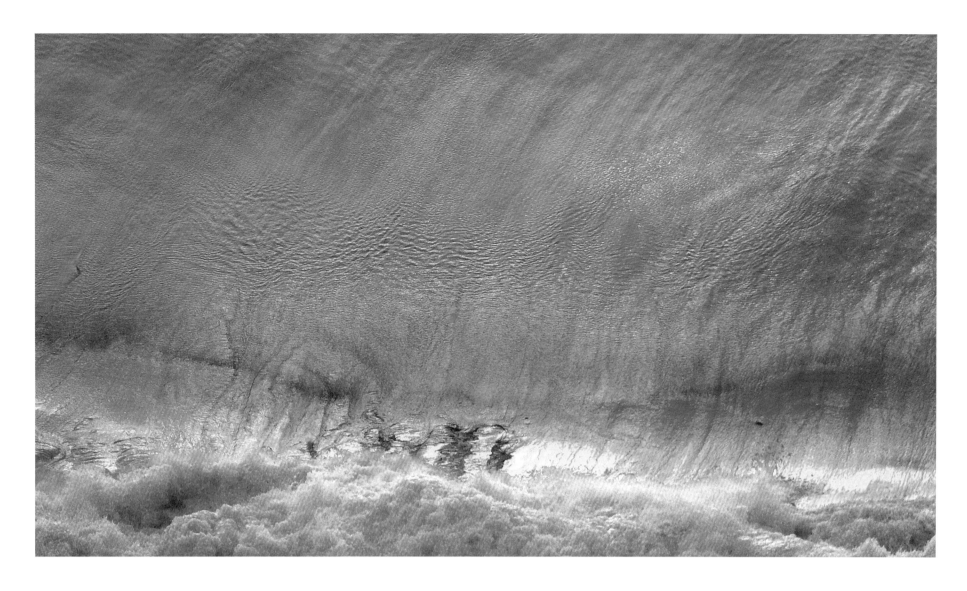

Neil Goldie

Winged radiance, Byron Bay, NSW

This image was shot from the high viewpoint of Byron Bay Lighthouse,
looking down at the waves breaking on the rocks and cliff below. The golden
light was captured at the right time (twenty minutes after sunrise) and at
the right angle (as the wave was about to break) creating an unusual wing-
shaped image. In the lower foreground is a view of the previous wave breaking
on the rocks. The upper section picks up the surface shimmer flowing
towards the right hand corner.

Camera: Lumix DMC-FZ50 **Aperture:** f3.7 **Shutter speed:** 1/125 **ISO:** 200

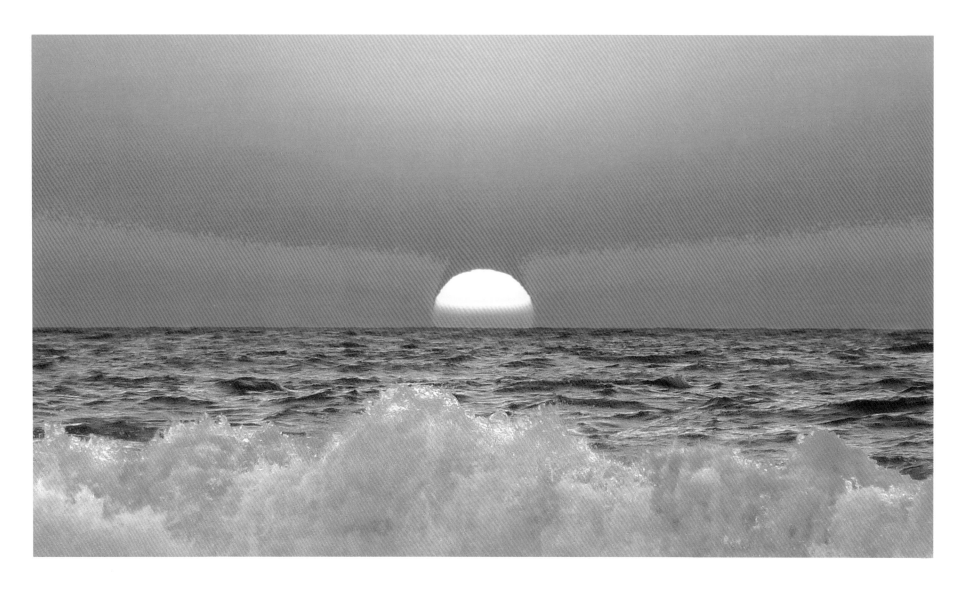

Paul Lyons
Kalbarri sunset, WA

Camera: Lumix DMC-TZ15 **Aperture:** f4.9 **Shutter speed:** 1/160 **ISO:** 160

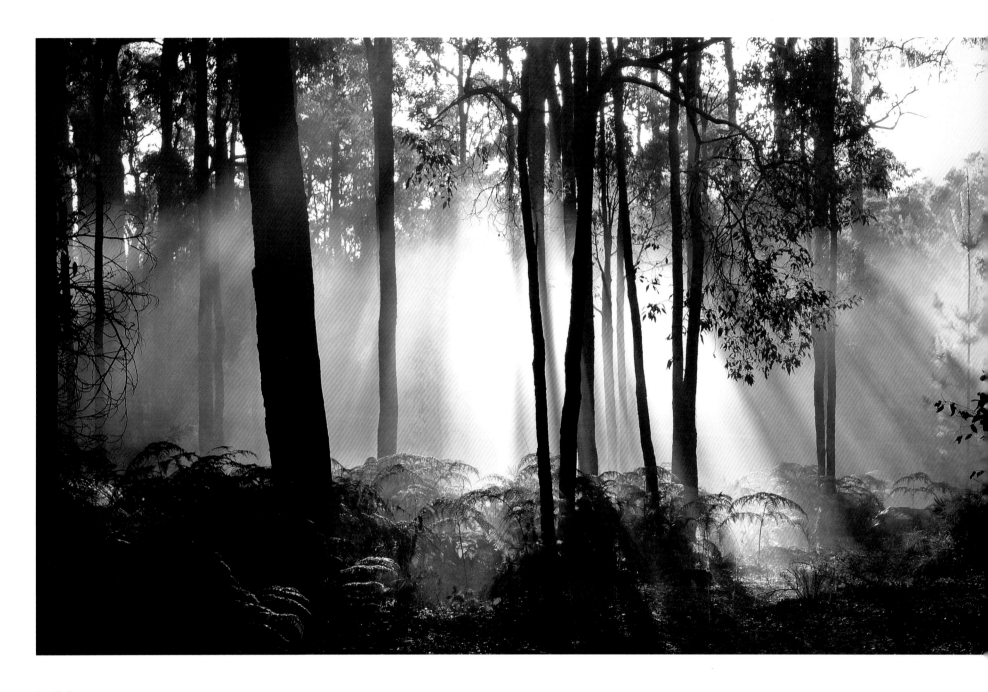

Ian Robertson

Forest enchantment, Grimwade, WA

Travelling later than expected to get to our overnight destination, we saw this location and quickly engaged our brakes. We allowed the dusty road to clear and then took in this magical forest with the light-rays streaming through the trees. Australia is fortunate to have large tracts of forest now protected from clearing. This gives the next generation the chance to not just see these images in beautiful coffee-table books, but to actually take to the road and experience them first hand – just like we did.

Camera: Lumix DMC-TZ7 **Aperture:** f4.4 **Shutter speed:** 1/50 **ISO:** 100

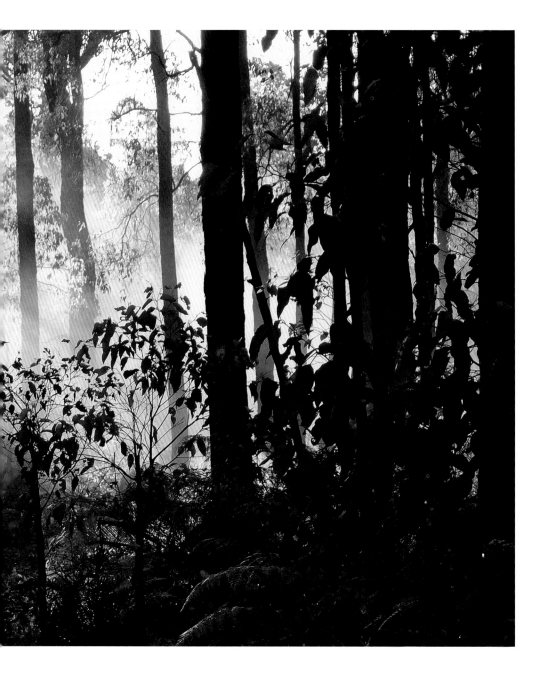

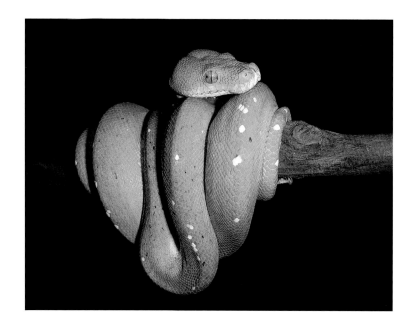

Jenny Rhind
Green tree python, Reptile Park, Childers, Qld

Camera: Lumix DMC-FT1 **Aperture:** f4 **Shutter speed:** 1/30 **ISO:** 100

Todd Fauser
Sedge frog, Mary Valley, Sunshine Coast, Qld

Camera: Lumix DMC-FZ8 **Aperture:** f8 **Shutter speed:** 5/16 **ISO:** 100

Barb Leopold
Fruit bat, Gorge Wildlife Park, SA

Camera: Lumix DMC-FZ20 **Aperture:** f2.8 **Shutter speed:** 1/50 **ISO:** 200

Gavin Marchio

Sydney Harbour, NSW

Leaving my office recently I was treated to this amazing sunset view.
Fortunately I carry my LX3 around with me, so I was able to capture
this wonderful scene.

Camera: Lumix DMC-LX3 **Aperture:** f2 **Shutter speed:** 1/30 **ISO:** 80

opposite

Sean O'Brien

Bennelong Point, Sydney, NSW

The simplicity of this image reveals what makes Australia so
unique, desirable and promotable. It also shows that, even today,
we often use simple yester-year solutions to deal with our harsh
but beautiful environment.

Camera: DMC-LX3 **Aperture:** f5 **Shutter speed:** 1/250 **ISO:** 80

Hugh Brown

Hugh Brown's background includes a past career in corporate taxation and management consulting. He has been a professional photographer and adventurer for around six years. Much of his photographic work has taken place in some of Australia's most remote areas, particularly the Kimberley and Pilbara regions. In more recent years, Hugh's work has expanded to incorporate remote areas in Africa and Papua New Guinea. His publications take in four books, including two hard-cover volumes: *The Kimberley: Tierra de mi Alma – Land of my Soul* and *The Pilbara – Australia's Ancient Heartbeat*. His passion lies in shooting those aspects of Australian and overseas life that won't be with us in years to come.

www.hughbrown.com

Some tips from Hugh

Who and what is the image for?

How would everyone else shoot that image? What can you do to make your image different? Is it a unique angle, subject matter, lighting or movement effects? Has it got some important historical value? If it hasn't got any of these things, should you take it at all? Get there early. Stay later. Climb up. Lie down. Look for that unique angle. Try talking to the locals – they often have the greatest knowledge of those "off the beaten track" secret spots.

Put in the hard yards

If there's 8/8 cloud when you wake up of a morning, don't go back to sleep. Go out anyway. It can be on these days that some of the best images are taken. Give yourself the best chance of getting a photograph. On this front, and particularly for landscape photographers, there is generally no substitute for time in the field. I've negotiated many an electric or barbed wire fence to gain the perspective needed to get that "wow" factor in a shot.

Work the subject

What detail can you pull out close up? What mid-range compositions will work? And, for me, most importantly, how do you give context to the image? What is the environment in which it exists? What is the subject's relationship to its environment? What is interesting about the subject in its environment? I often find that colour is best shown when shooting at a ninety degree angle to the sun. When taking photos close to the ocean, also expect the unexpected! (But be careful: I've nearly lost my gear on several occasions with a rough wave.)

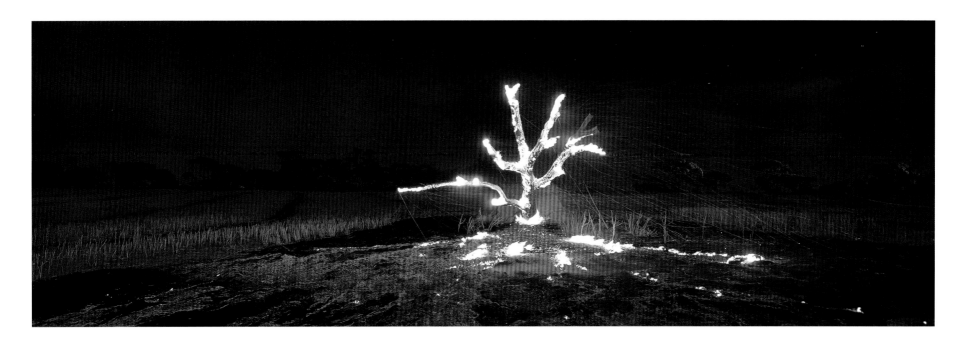

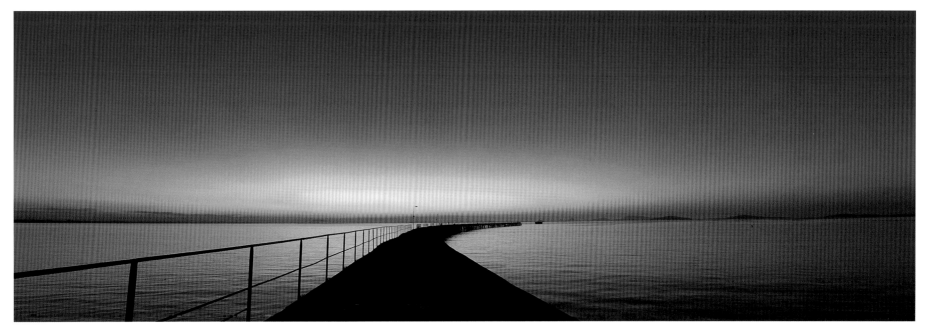

top
Hugh Brown
Collateral damage, burning of the wheat stubble, Wubin, Wheatbelt, WA

Camera: Lumix DMC-G1 **Aperture:** f4.0 **Shutter speed:** 8 seconds **ISO:** 200

bottom
Hugh Brown
Dawn, Esperance jetty, WA

Camera: Lumix DMC-G1 **Aperture:** f9.0 **Shutter speed:** 6 seconds **ISO:** 100

Hugh Brown

Prince Leonard, Hutt River Province, mid-west, WA

The story behind this image is a fantastic one. In 1970, following a disagreement with the State over wheat quotas, Prince Leonard elected to secede from Australia. The "Province" has its own passport, currency and even military. This was shot with the G1 in low light. The result was a crisp image with minimal grain.

Camera: Lumix DMC-G1 **Aperture:** f6.8
Shutter speed: 1/250 **ISO:** 100

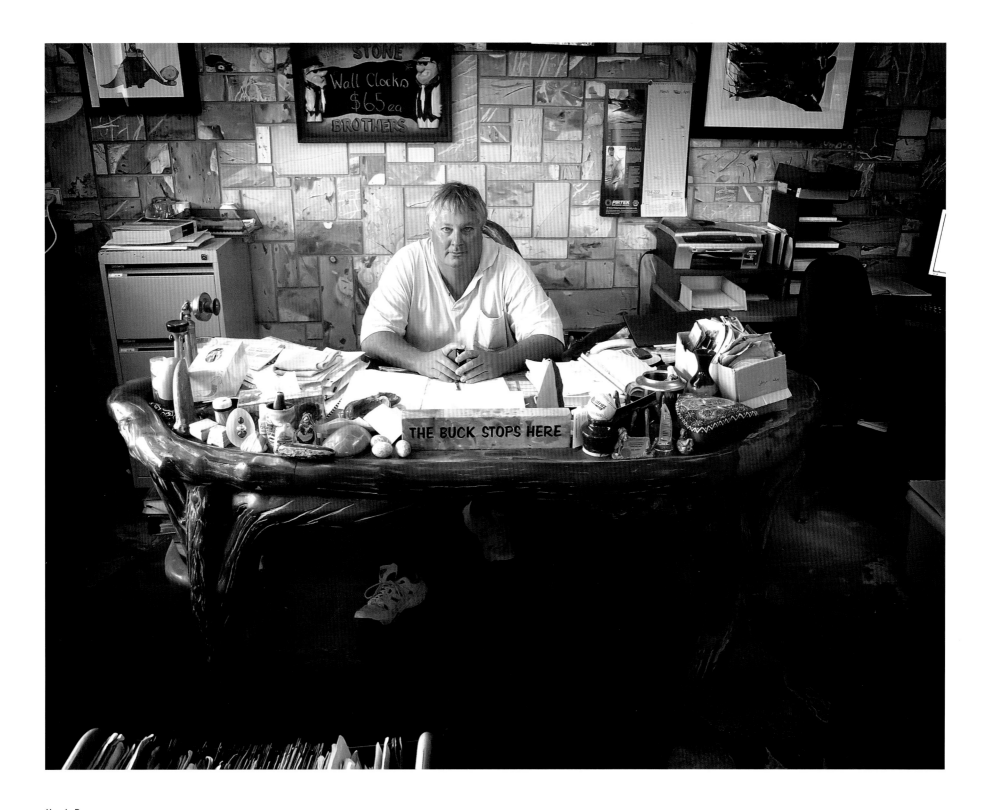

Hugh Brown

"The buck stops here", Stuart Highway, Darwin, WA

Camera: Lumix DMC-G1 **Aperture:** f4.5 **Shutter speed:** 1/100 **ISO:** 1600

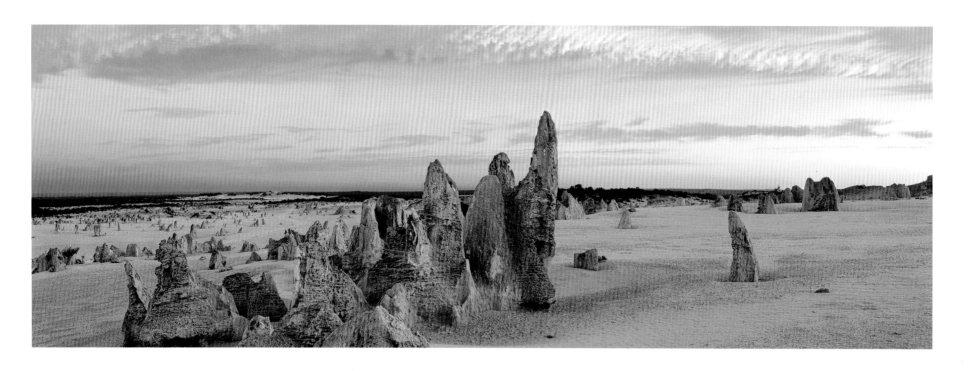

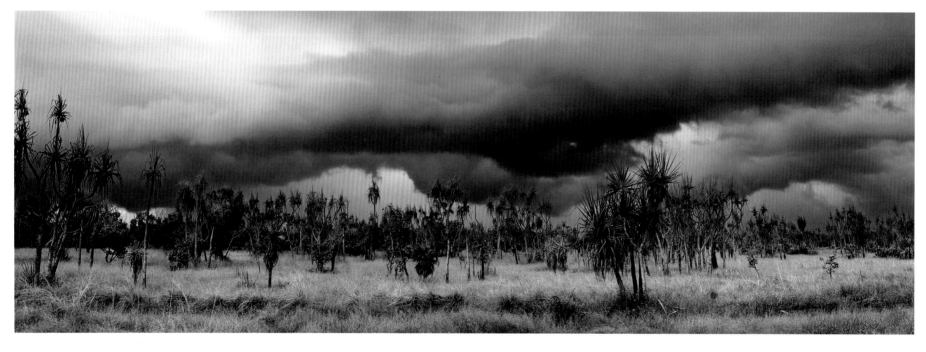

top

Hugh Brown

Dawn, The Pinnacles, Nambung National Park, WA

Camera: Lumix DMC-G1 **Aperture:** f10.0
Shutter speed: 1/10 **ISO:** 100

bottom

Hugh Brown

Late afternoon thunderstorm, Kakadu National Park, NT

Camera: Lumix DMC-G1 **Aperture:** f5.0
Shutter speed: 1/125 **ISO:** 200

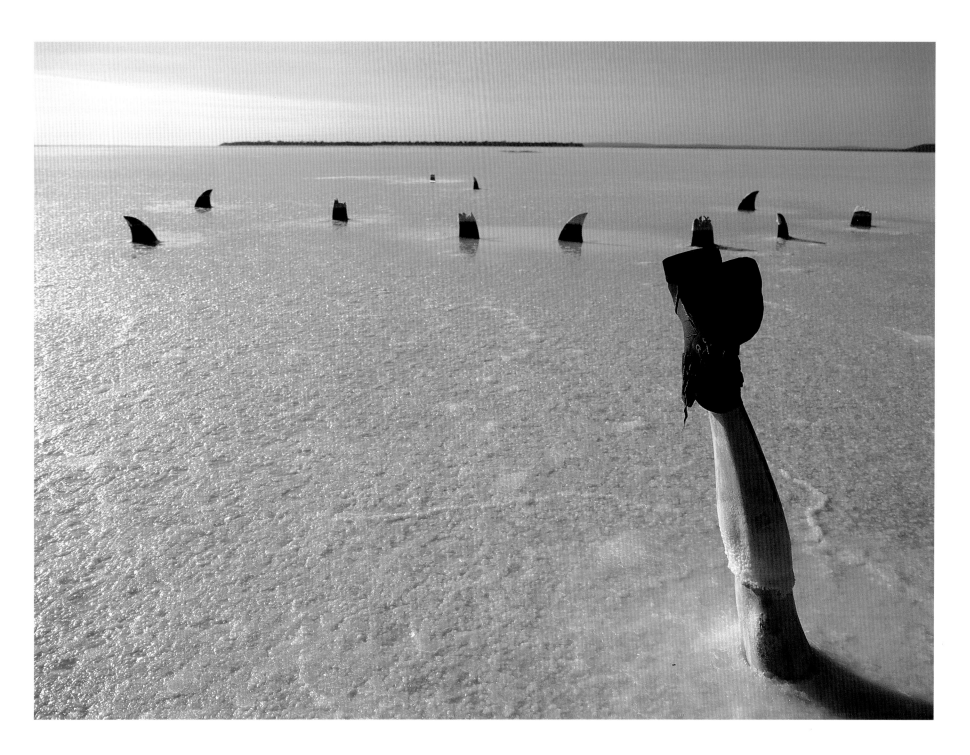

Hugh Brown

Watch out for sharks, Lake Lefroy, Goldfields, WA

Camera: Lumix DMC-G1 **Aperture:** f5.6 **Shutter speed:** 1/1250 **ISO:** 100

MEET OUR CELEBRITY PHOTOGRAPHER

R ay Martin has been a journalist for forty-five years, mostly in television and radio. He's been seriously taking photographs – some would say "obsessively" – almost as long. After spending the turbulent 1970s as the ABC's New York Correspondent, Ray was one of the original *60 Minutes* reporters and went on to host *The Midday Show, A Current Affair,* the *Sunday* program and countless news and variety specials for the Nine Network. He has been awarded five Gold Logies and a host of other awards including an Order of Australia (AM) in the 2010 Australia Day honours list for his work in journalism and numerous charities.

Some tips from Ray

Taking great photos is a bit like good journalism. It's about being curious and enthusiastic, about observing and about story telling – with pictures, rather than words.

To do that effectively, you often have to convince people to talk openly, and to take you to those out-of-the-way places that others often don't get to see or hear about.

There's no substitute for good manners and common courtesies. A smile and a brief word about what you're doing often opens doors.

Asking permission to take someone's photo – before you start snapping away – is usually met with a nod of approval. Then showing them that first digital image usually guarantees even greater access – especially with children, and in Third World countries.

Having a heavy-duty camera, with a bag of lenses and lights, can sometimes convince people positively that you must be a serious professional. But sometimes it can intimidate, or even frighten them. Then you may opt to use an innocuous "point and shoot" camera. You have to quickly sum up the moment, so that you get the trust rather than the trepidation.

The simple fact is that there are many places in the world – even in Australia – where the locals "don't want to be photographed, thanks very much". If in doubt, put the camera away and join them over a cup of tea instead.

I've certainly found with my Lumix GF1 that I get the best of both worlds – from Tassie farmers and fishermen to Soweto slums. It's small enough so that people don't feel they're undergoing a proctology – or that you're filming their soul – yet, they're always impressed when you show them the photos.

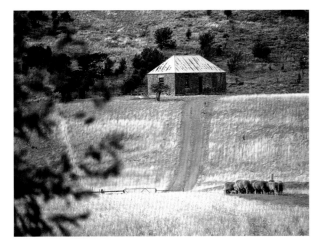

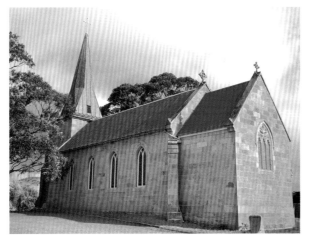

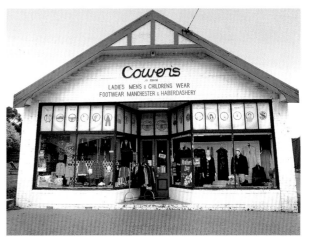

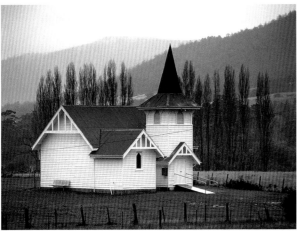

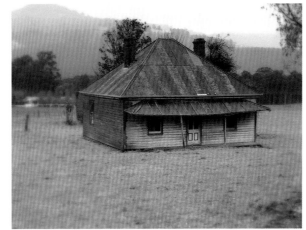

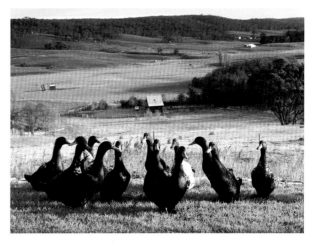

Ray Martin

Colonial cottage with sheep, Tas

Camera: Lumix DMC-L1 **Aperture:** f5.6
Shutter speed: 1/320 **ISO:** 100

Ray Martin

Catholic church, Richmond, Tas

Camera: Lumix DMC-GF1 **Aperture:** f2.2
Shutter speed: 1/1600 **ISO:** 100

Ray Martin

Cowen's Drapery Store, Cygnet, Huon Valley, Tas

Camera: Lumix DMC-GF1 **Aperture:** f4
Shutter speed: 1/125 **ISO:** 100

Ray Martin

Green roofed church, Tas

Camera: Lumix DMC-GF1 **Aperture:** f4.6
Shutter speed: 1/125 **ISO:** 160

Ray Martin

Abandoned by time, Tas

Camera: Lumix DMC-GF1 **Aperture:** f5.3
Shutter speed: 1/40 **ISO:** 250

Ray Martin

*Wood and black ducks, high above Mulloon Creek,
near Braidwood, NSW*

Camera: Lumix DMC-GF1 **Aperture:** f6.3
Shutter speed: 1/125 **ISO:** 100

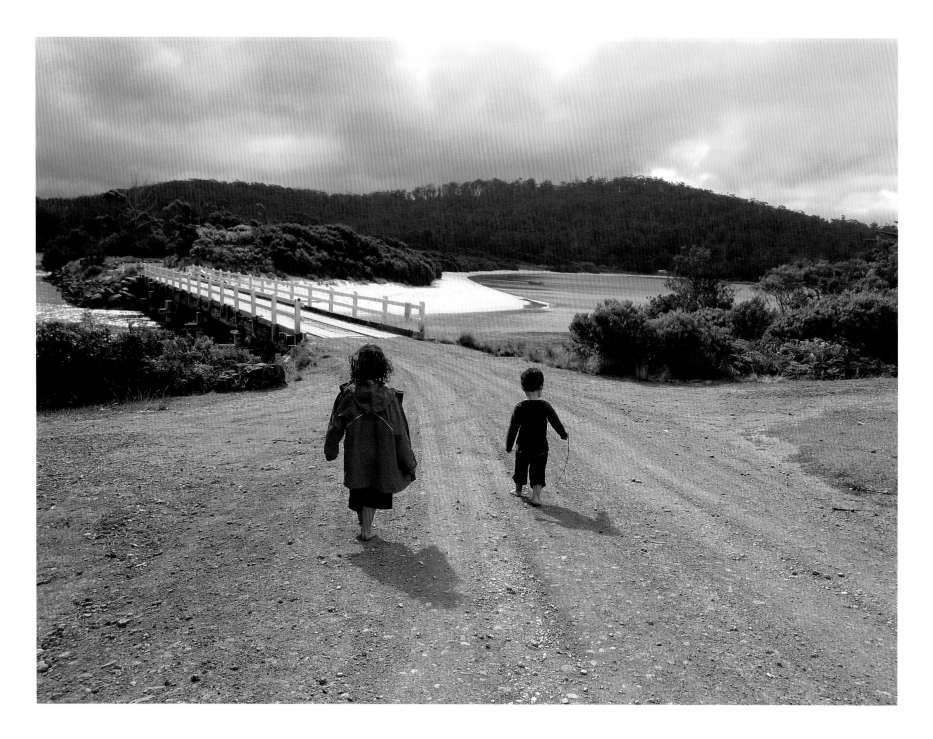

Stu Farrant

Olive & Felix, Cockle Creek, Southwest National Park, Tas

At the southernmost extremity of the Australian road network, the rugged beauty and simplistic summertime ideal is encapsulated by Olive (5) and Felix (3) as they meander towards "The Bridge".

Camera: Lumix DMC-TZ7 **Aperture:** f4.5 **Shutter speed:** 1/500 **ISO:** 80

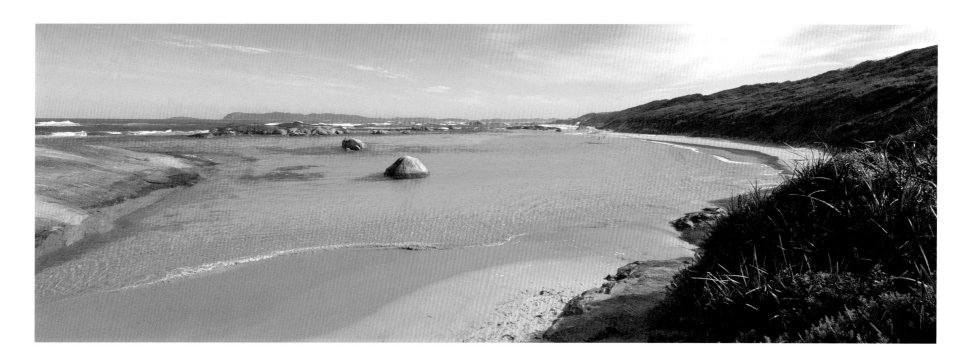

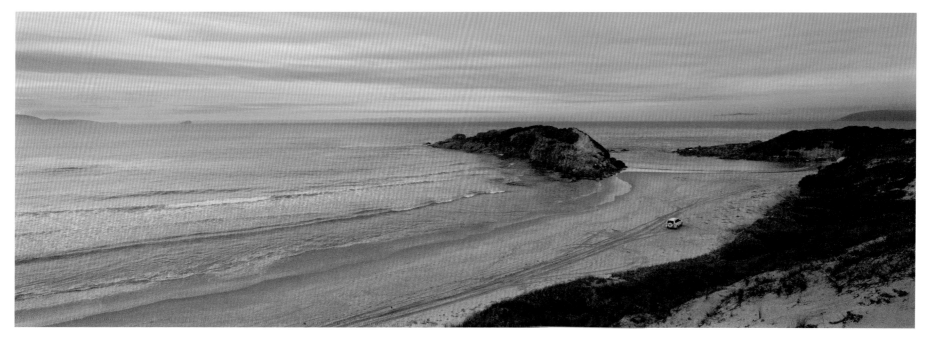

top
Steve Fraser
Greens Pool, Denmark, WA

Camera: Lumix DMC-GF1 **Aperture:** f9 **Shutter speed:** 1/1250 **ISO:** 160

bottom
Steve Fraser
Sunrise, Nanarup Beach, WA

Camera: Lumix DMC-GF1 **Aperture:** f9 **Shutter speed:** 1/60 **ISO:** 160

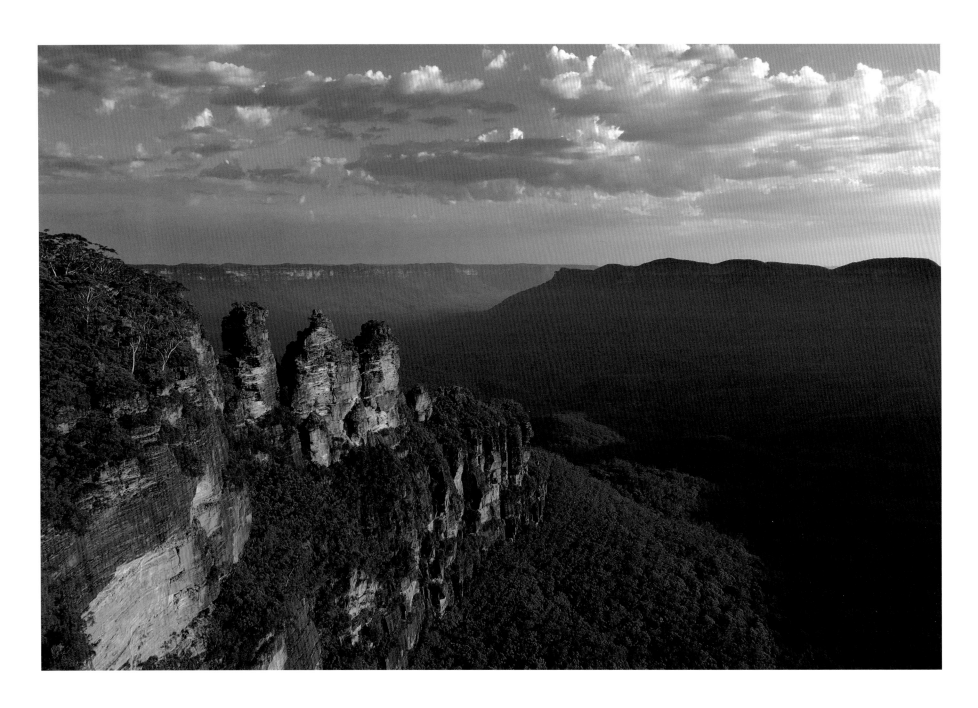

Gary Hayes

The Three Sisters, Katoomba, NSW

Yes, those famous sisters again. But nice dramatic clouds and lovely
light produced a postcard to be proud of!

Camera: Lumix DMC-LX3 **Aperture:** f6.3 **Shutter speed:** 1/160 **ISO:** 80

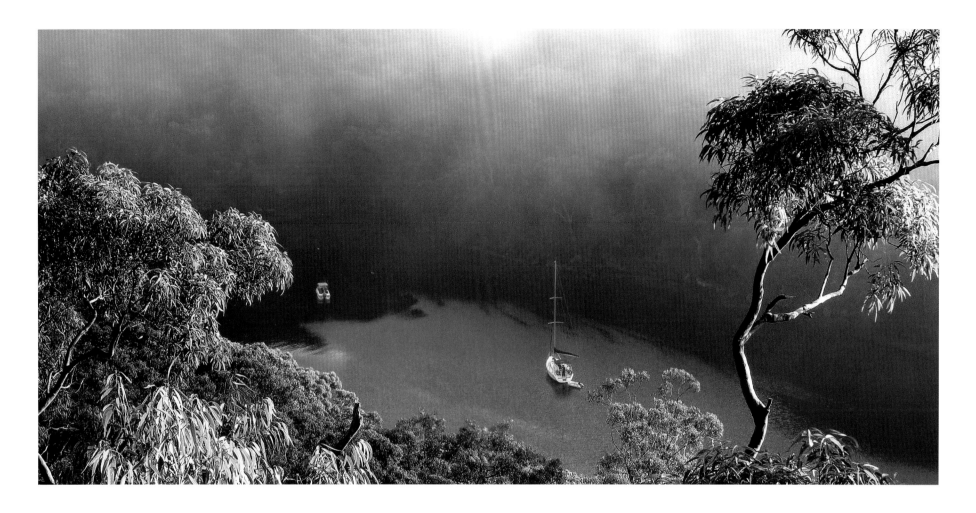

David Bentley
Sugarloaf Bay, Sydney, NSW

The autumn sun accentuates the green of the gum trees, while in the bay below, as a morning mist lifts, a sailor greets the day. Located in the upper reaches of Middle Harbour, Sugarloaf Bay is a popular spot for boating, fishing and canoeing.

Camera: Lumix DMC-FT1 **Aperture:** f5.3 **Shutter speed:** 1/80 **ISO:** 80

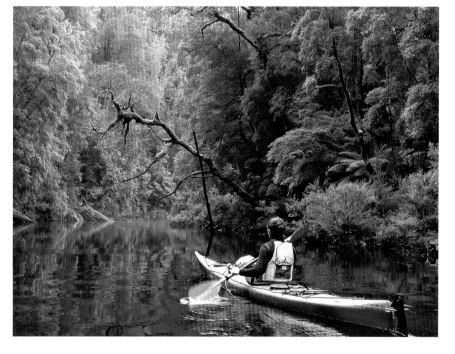

Wendy Runciman
Kayaking on the Douglas River, west coast, Tas

The stunning beauty and peaceful tranquillity of Tasmania's wild places are addictive. Their unpredictable and ever-changing conditions continue to surprise, ensuring an unforgettable experience.

Camera: Lumix DMC-FT1 **Aperture:** f4 **Shutter speed:** 1/40 **ISO:** 400

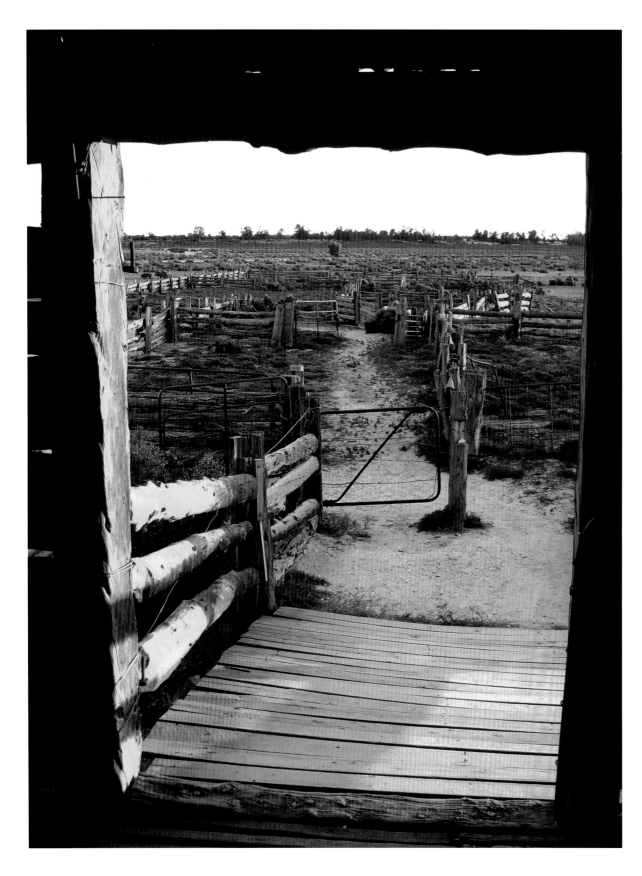

Kathryn Purcell
Old sheep yards, Mungo National Park, NSW

Camera: Lumix DMC-FZ50 **Aperture:** f2.8
Shutter speed: 1/40 **ISO:** 200

opposite
Gary Hayes
"Should we jump?", Tamarama, NSW

As part of the annual *Sculpture by the Sea* show,
two girls wonder whether to jump the two feet
drop onto the sand.

Camera: Lumix DMC-LX3 **Aperture:** f6.3
Shutter speed: 1/1300 **ISO:** 125

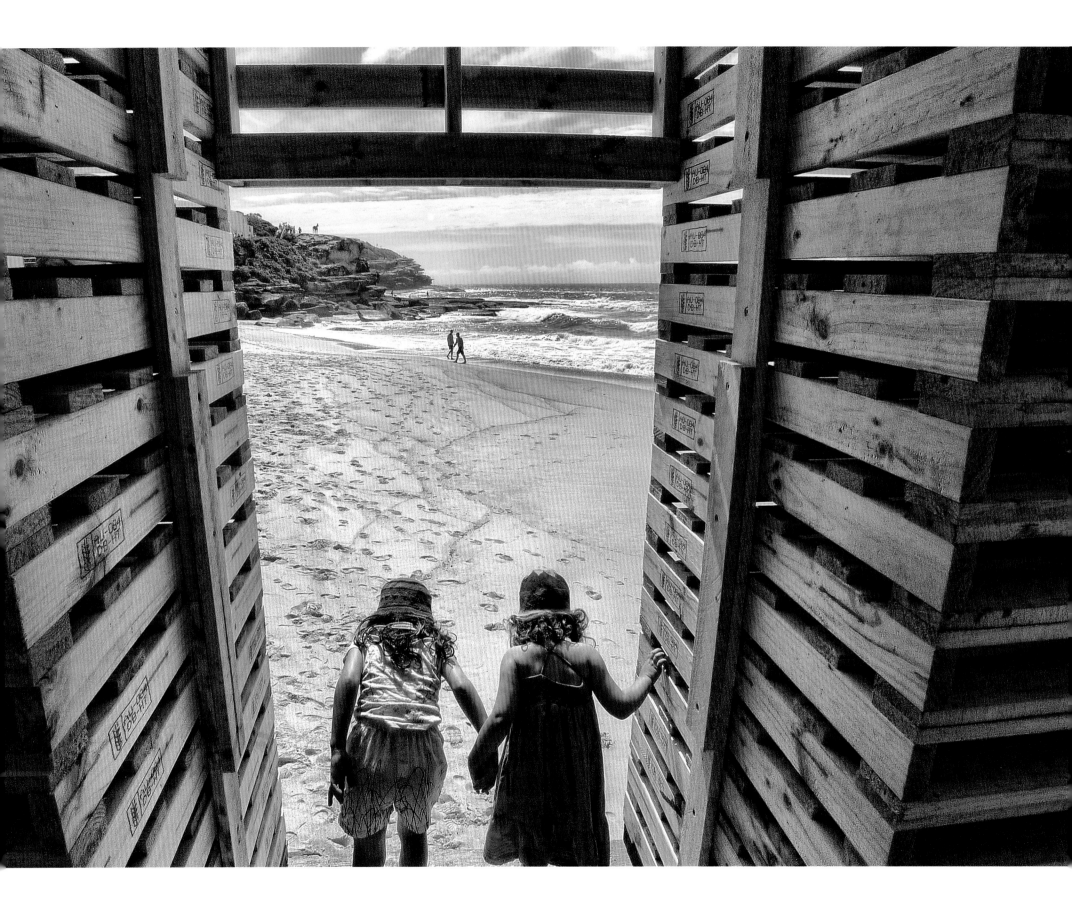

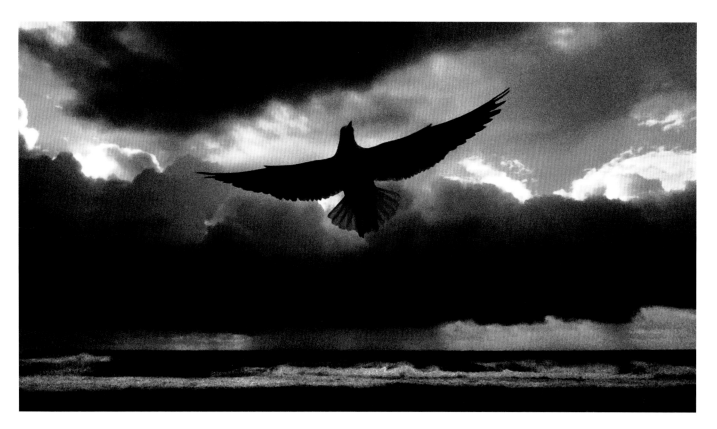

Lyndsey Hughes
A humble seagull, Bronte Beach, Sydney, NSW

Shot with the Film Grain option on my trusty compact Lumix.

Camera: Lumix DMC-FX38 **Aperture:** f8
Shutter speed: 1/1600 **ISO:** 1600

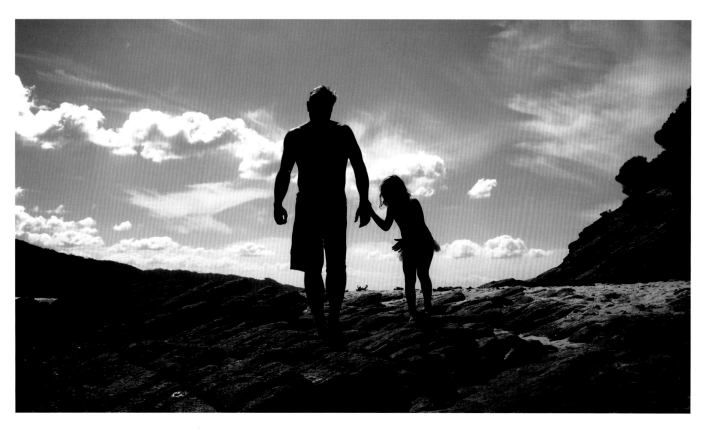

Sam Edmonds
Father & daughter, Seal Rocks, NSW

To me, this scene represents the guidance and bonding that seem to be so strongly present when learning about the ocean.

Camera: Lumix DMC-TZ15 **Aperture:** f10
Shutter speed: 1/500 **ISO:** 100

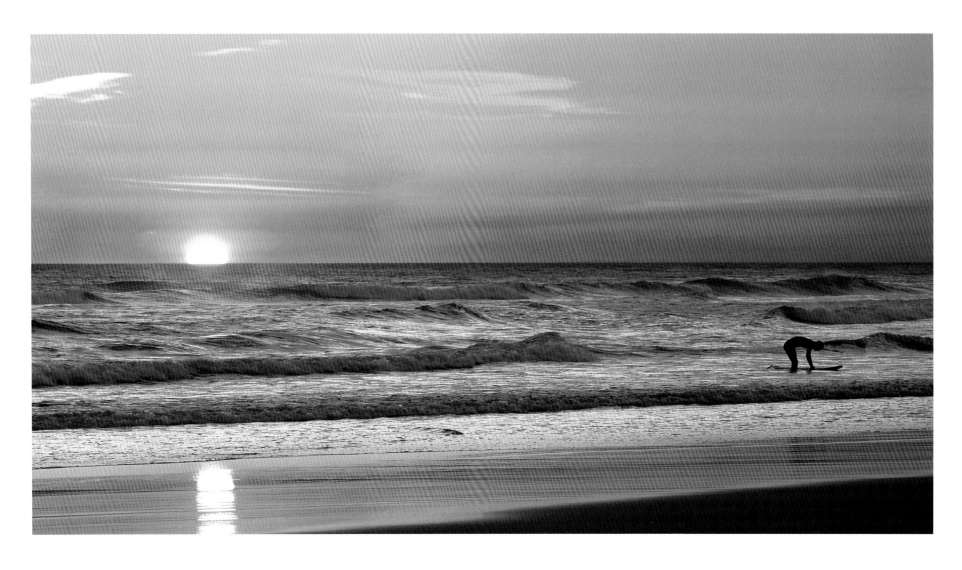

Roy Hunter

Day's end, Gunnamatta, Mornington Peninsula, Vic

As the day ended, I caught one of the last surfers to leave the beach.

Camera: Lumix DMC-G1 **Aperture:** f5 **Shutter speed:** 1/250 **ISO:** 125

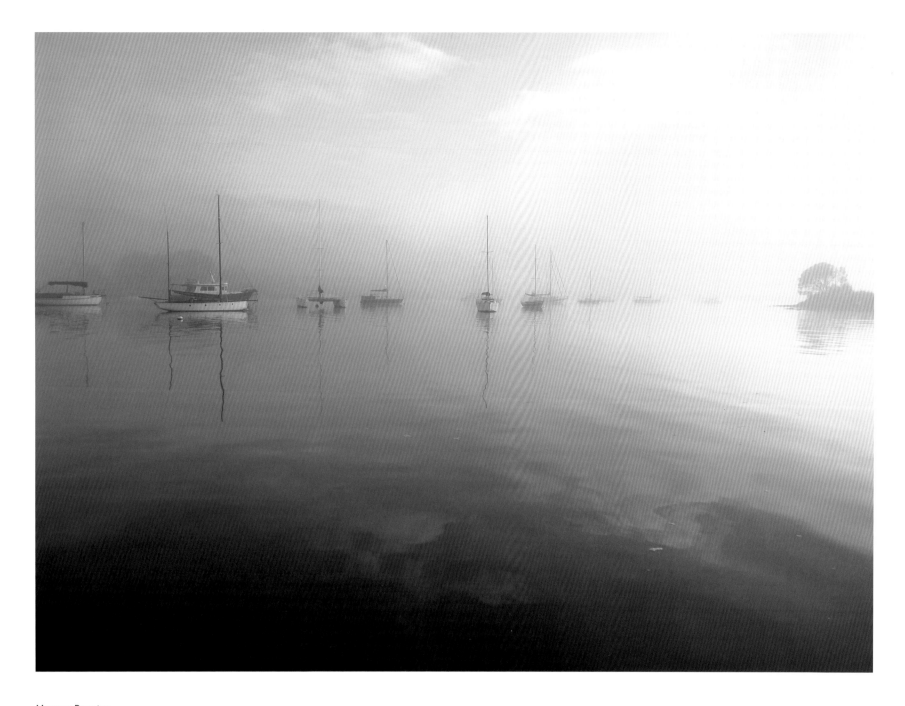

Murray Proctor
Heavy fog on a frosty morning, Lindisfarne Bay, Tas

Camera: Lumix DMC-FT1 **Aperture:** f3.3 **Shutter speed:** 1/320 **ISO:** 125

opposite
Chris Brier-Mills
Sun peeping through early morning fog, Mersey River, Quoiba, Tas

Camera: Lumix DMC-TZ7 **Aperture:** f4.5 **Shutter speed:** 1/400 **ISO:** 80

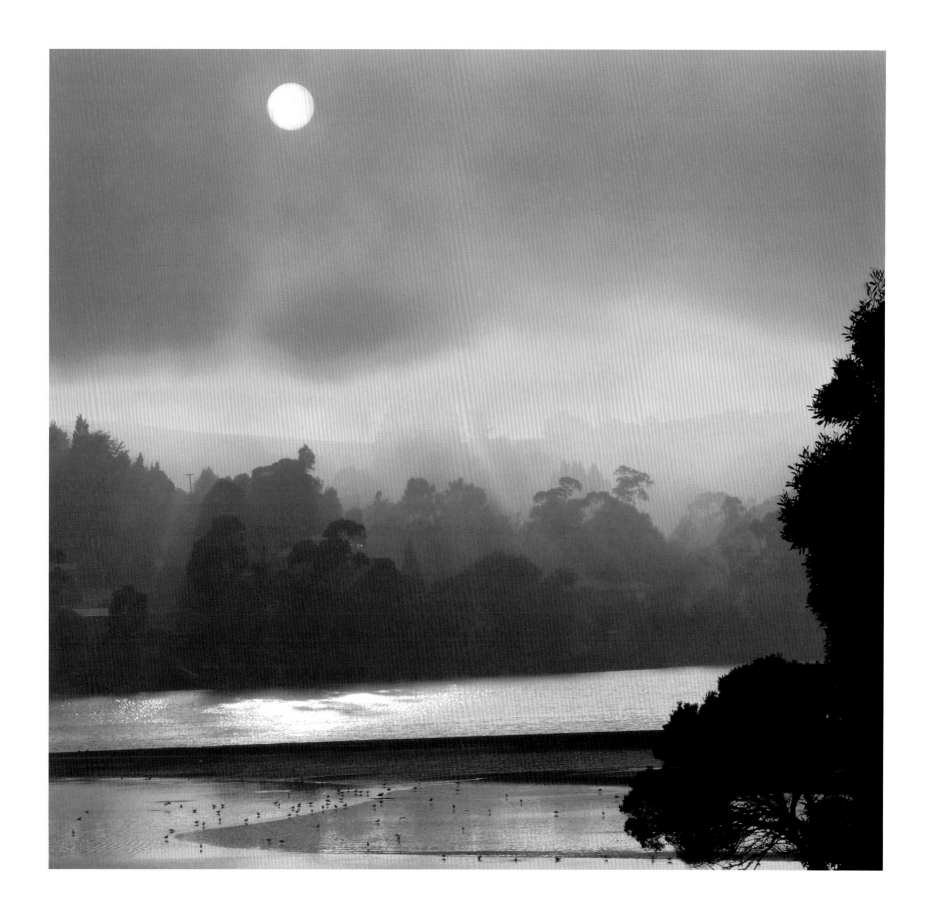

Alen Sayed
Amazing natural colours, Qld

Camera: Lumix DMC-FZ30 **Aperture:** f4 **Shutter speed:** 1/80 **ISO:** 80

Alen Sayed
Nature's beauty, backyard, Vic

Camera: Lumix DMC-FZ30 **Aperture:** f11 **Shutter speed:** 1/160 **ISO:** 100

Julia Thompson
Frangipani, Lord Howe Island, NSW

Camera: Lumix DMC-TZ11 **Aperture:** f4.6 **Shutter speed:** 1/250 **ISO:** 100

Stuart Townsend
Pink-flowering gum, North Turramurra, NSW

Camera: Lumix DMC-FT1 **Aperture:** f3.3 **Shutter speed:** 1/320 **ISO:** 80

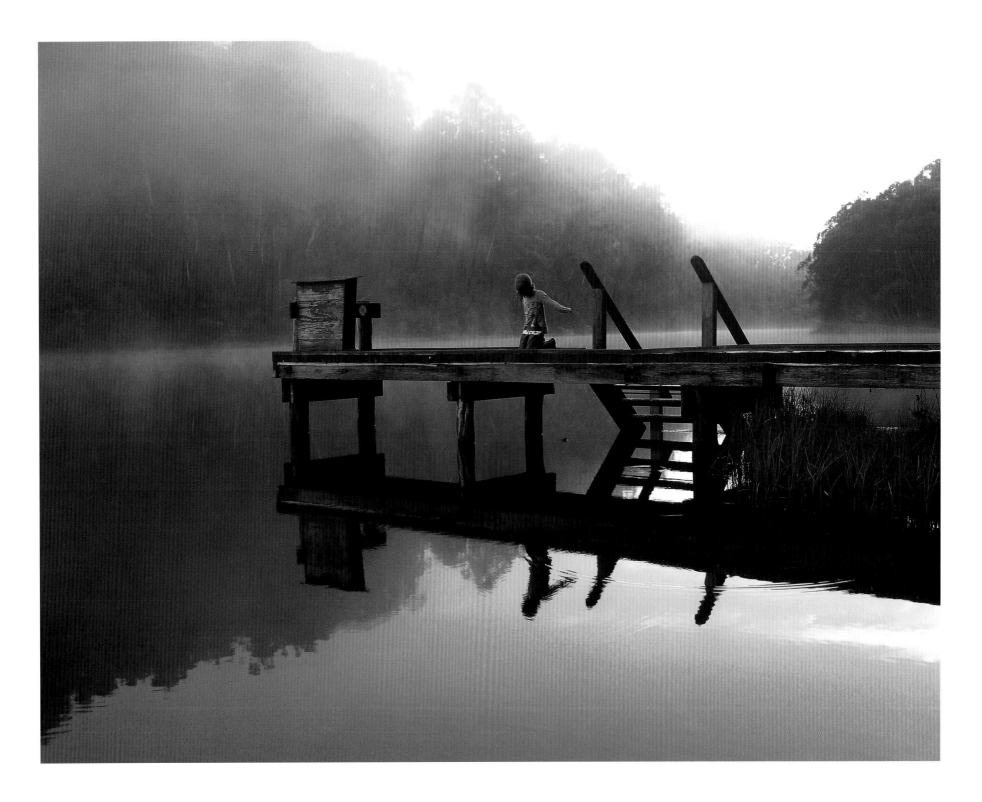

Stu Farrant

Contemplation, Lake Catani, Mount Buffalo National Park, Vic

Camera: Lumix DMC-TZ7 **Aperture:** f3.7 **Shutter speed:** 1/60 **ISO:** 80

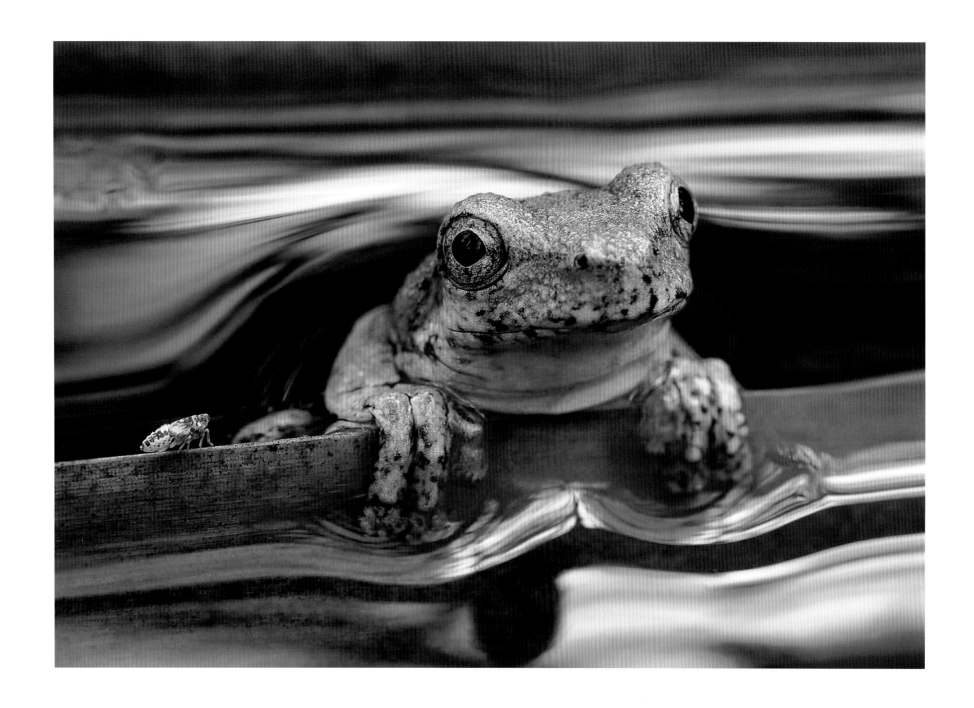

Leo Meier

Popping up, Macleay river valley, NSW

My first shot of this frog using flash had lost the interesting play of light reflecting off the water's surface tension. Shooting without flash in the low light required a high ISO and a slow 1/60. Despite this technical quality compromise, I prefer this picture, shot only with available light.

Camera: Lumix DMC-GH1 **Aperture:** f8 **Shutter speed:** 1/60 **ISO:** 1000

Leo Meier

Leo Meier is recognised as one of Australia's leading photographers. His expertise spans twenty-five years and covers photography, printing, graphic arts, design, digital imaging, teaching and publishing. To date he has photographed more than thirty books, many of which have necessitated epic journeys into some of the world's most remote regions. His work has also appeared in over thirty international volumes, as well as in many worldwide publications such as *National Geographic, Focus* and *GEO*. Leo has also been Chief Photographer for the NSW National Parks and Wildlife Service and a panel judge for the Sydney International Exhibition of Photography.

www.leomeier.com

Some macro tips from Leo

Macro photography begins when a lens is focused closer than its focusing ring allows by attaching screw-in close-up filters or extension tubes. Dedicated macro lenses are highly advisable.

As magnification increases, the area in focus (depth of field) is reduced to just a few millimetres. For greatest depth of field, apertures of $f11$ or $f16$ are recommended (avoid $f22$ or smaller because of the detrimental effects of diffraction). For precise control use Manual or Aperture Priority.

Manual focusing is recommended for macro. Loosely focus the subject with the focus ring to obtain the desired magnification and composition, then rock the camera back and forth to find perfect focus. It takes practice, patience, perseverance and fitness to steadily hold a camera in precise focus at high magnification.

With high magnification photography, camera shake becomes a tough challenge. Tripods or other supports are a solution for static subjects, but even then, subject movement, wind and vibration can easily destroy sharpness. A shutter speed of 1/500 or faster is recommended. In open shade, cloudy days and low light, such high shutter speed and small aperture combinations can only be achieved by increasing the sensitivity of the camera (ISO). But be aware that there is a proportionate quality penalty when increasing ISO. For the best quality digital files, always use the lowest ISO that a situation allows.

Electronic flash units emit very bright and extremely short bursts of light that can freeze even moving subjects. This makes them eminently suitable for macro photography. Flash units make small apertures and low ISO combinations possible. Use multiple flashes to avoid flat and harsh lighting.

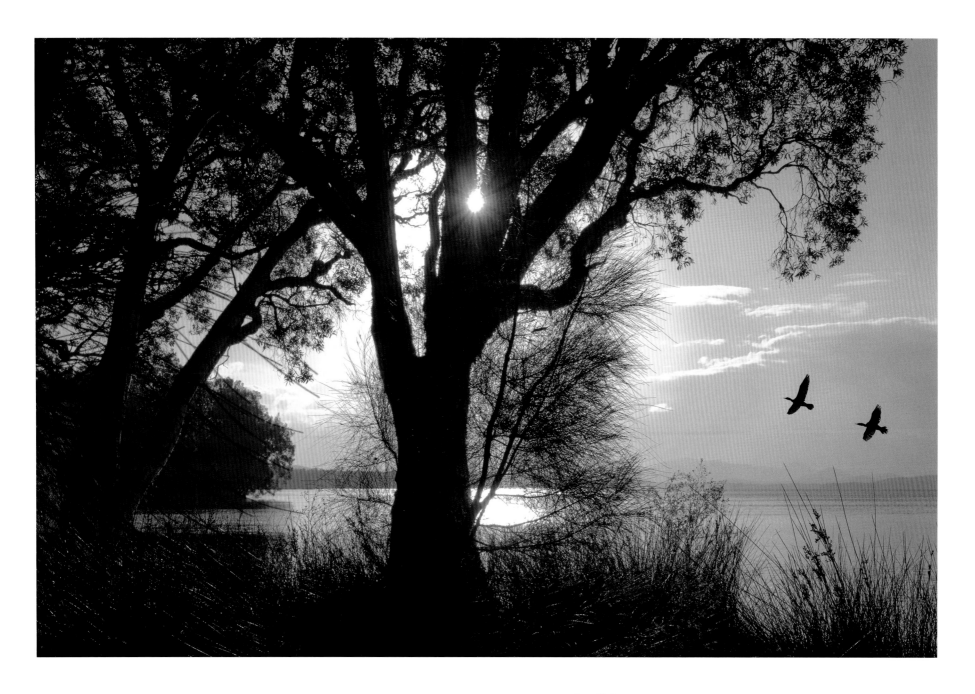

Leo Meier

Cormorants' home run, Mungo Brush, Myall Lakes National Park, NSW

Shooting into the light is always difficult to do, but when it works, the results are often rewarding. I aligned the sun and tree to allow a slither of rays to flare through the lens to a just acceptable degree. It was a very windy afternoon, but shooting into the sun allowed me to set a fast shutter speed to arrest move-ment – even fast enough to freeze the cormorants' wings in flight.

Camera: Lumix DMC-GH1 **Aperture:** f11 **Shutter speed:** 1/500 **ISO:** 100

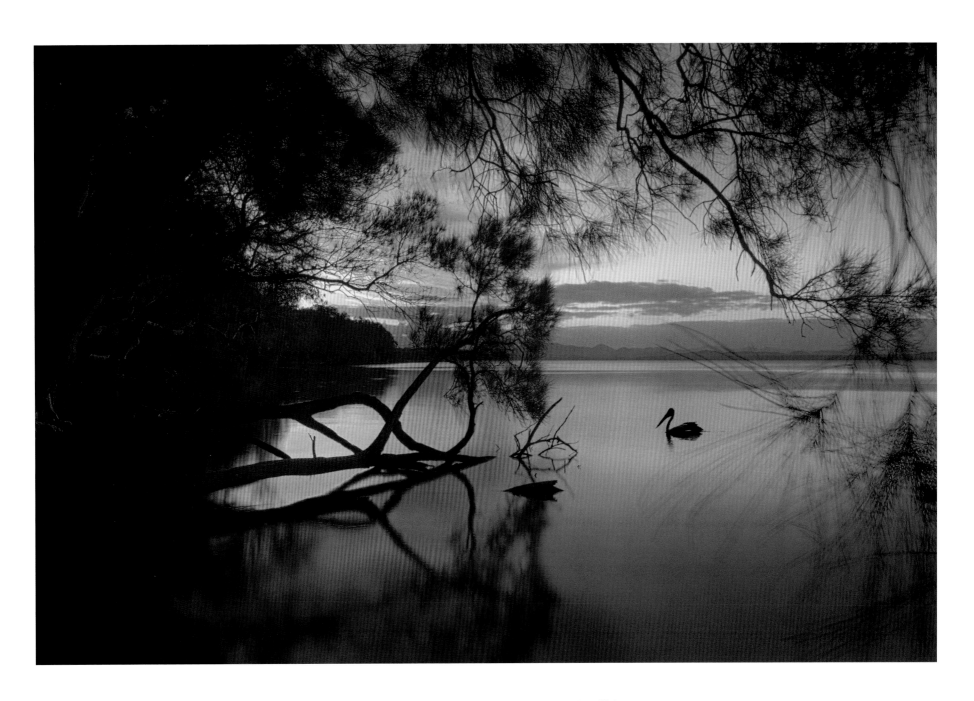

Leo Meier

Pelican on evening rounds, Mungo Brush, Myall Lakes National Park, NSW

For a few precious moments the setting sun transformed the grey clouds into a luminous curtain of colours. To photograph this ethereal and moody scene reflected in the tranquil waters as my eyes and mind perceived it, I exposed a series of pictures at different settings and merged them into one with software. This technique preserves detail in high contrast areas that cannot be recorded in just one exposure by current imaging sensors.

Camera: Lumix DMC-GH1 **Aperture:** f14
Shutter speed: 5 various (merged) **ISO:** 100

Leo Meier

Dragonfly laying eggs, Goolawah lagoon, mid-north coast, NSW

My eyes caught a dragonfly, flaunting its extravagant, iridescent green livery. To my delight, it landed on a submerged reed only metres away. I put on my longest lens and gingerly nudged closer. The dragonfly began to poke its tail into the water in search for a suitable place to lay its eggs. I could not get close enough to fill the frame without disturbing the water and decided to keep shooting, rather than risk losing my wary and twitchy subject. I'm amazed at the quality and sharpness of this picture, despite being cropped to only 1/4 of its full size.

Camera: Lumix DMC-GH1 **Aperture:** f5.8
Shutter speed: 1/400 **ISO:** 125

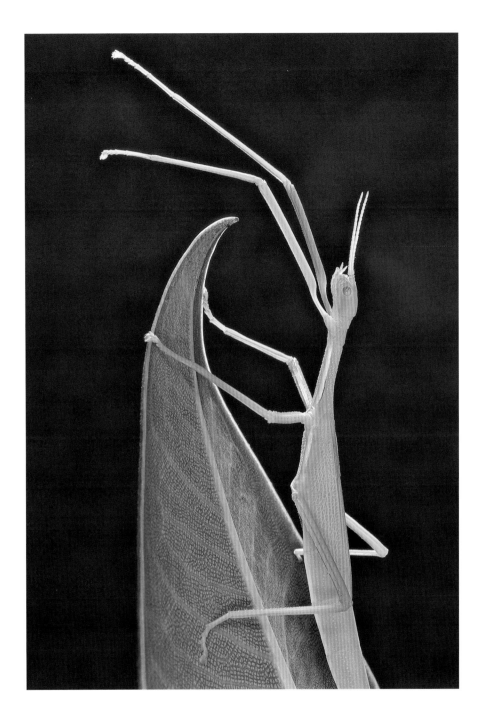

Leo Meier

A stick insect (Phasmatidae), Macleay river valley, Sherwood, NSW

Camera: Lumix DMC-GH1 **Aperture:** f16 **Shutter speed:** 1/16 **ISO:** 100

Leo Meier

A crusader bug (Coreidae) stalks the underside of a Magnolia grandiflora *leaf, Sherwood, NSW*

Camera: Lumix DMC-GH1 **Aperture:** f11 **Shutter speed:** 1/30 **ISO:** 100 **Flash:** flash fired

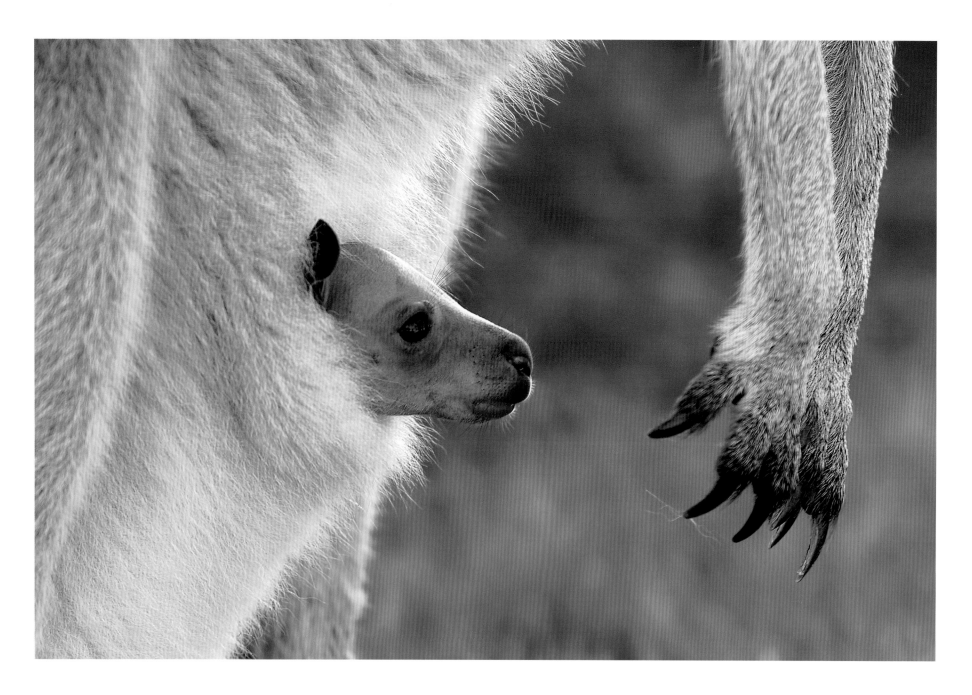

Leo Meier

View from the balcony, Yuraygir National Park, NSW

Stalking this grey kangaroo, I noticed its joey peeping from its pouch for just
a blink of time. It was still pink, too young to leave its comfy cradle. A noise
alarmed its mum and she stood erect. Joey was curious enough to have another
peek at the world from its balcony and offered me a second chance to steal a
shot, lens fully open and ISO at 200 to shoot handheld.

Camera: Lumix DMC-GH1 **Aperture:** f5.6 **Shutter speed:** 1/250 **ISO:** 200

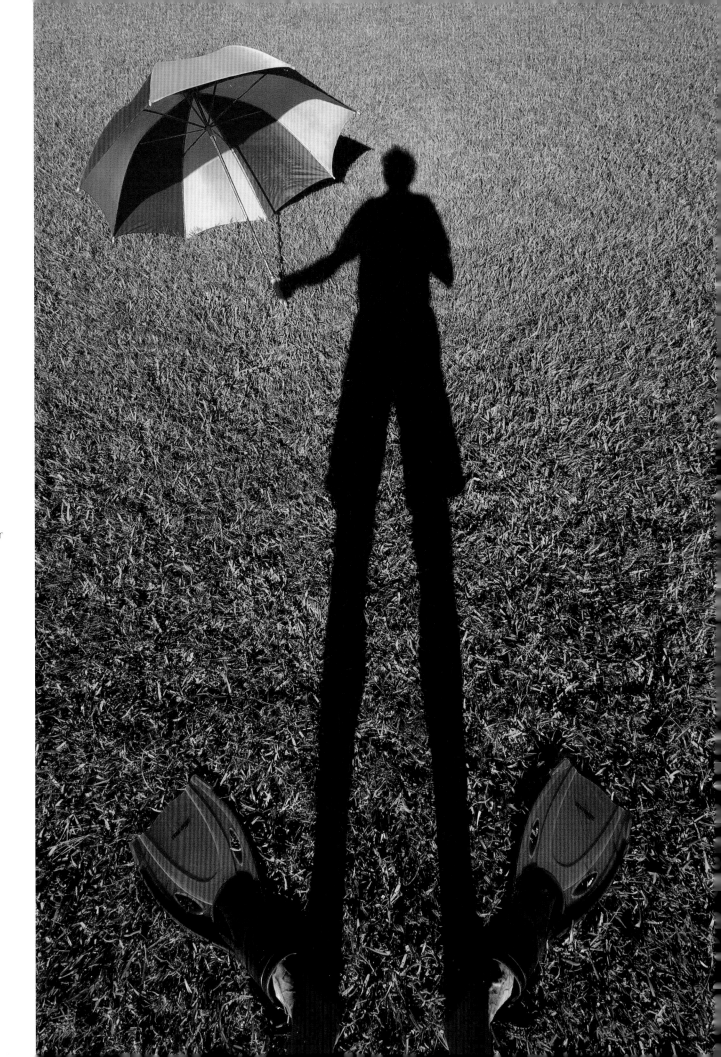

Leo Meier

Where's the beach? Dondingalong, NSW

When it arrived from Panasonic one late afternoon,
I was eager to see how the world looked through this super
wide angle lens. Too late to go anywhere far, I explored the
surroundings of our home. I noticed the long and sharp
shadows on the lawn painted by the late sun and had fun
mucking around making shadow plays. Too boring!
I needed props. I found my sister's bright pink flippers and
a brightly coloured umbrella I'd found half submerged in
a swamp. It took me some time to find suitable positions
for everything to create this 3D-2D puzzle.

Camera: Lumix DMC-GH1 **Aperture:** f7.1
Shutter speed: 1/250 **ISO:** 100

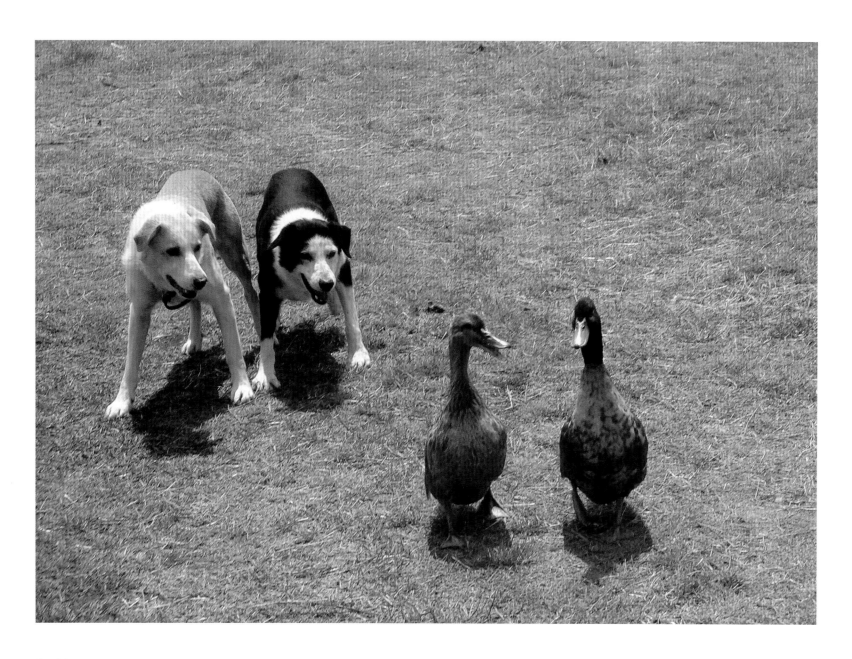

Keith Law

Trepidation, Armidale, NSW

The first duck seems to be saying to his mate, "Don't look now but I think we are being followed."

Camera: DMC-FX2 **Aperture:** f10 **Shutter speed:** 1/125 **ISO:** 64

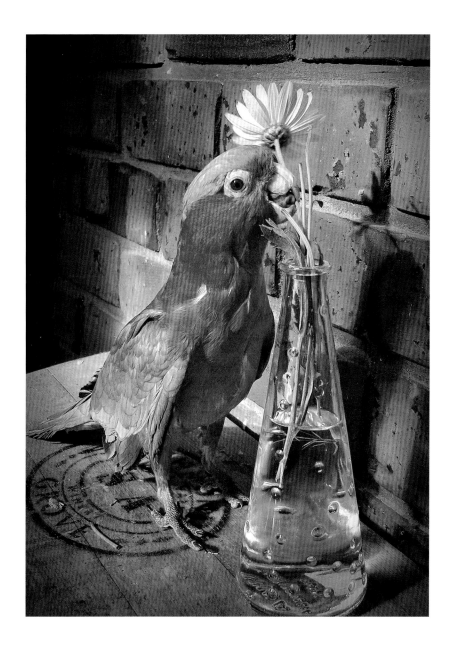

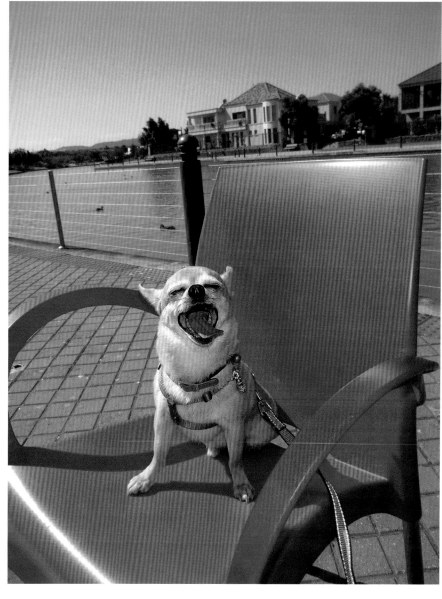

Barb Leopold
The wrecker, Nairne, SA

The rose-breasted galah is the quintessential Aussie bird – and a bit of a larrikin too. This is our Miss CB ("Cocky Boy" – a girl!) who loves nothing better than roaming around the house wrecking flower arrangements.

Camera: Lumix DMC-FZ20 **Aperture:** f2.8 **Shutter speed:** 1/60 **ISO:** 80

Barb Leopold
Eating out, Mawson Lakes, SA

My little Chihuahua loves to come out to the cafe on a Sunday morning – you can see the enjoyment on his face!

Camera: Lumix DMC-FT1 **Aperture:** f10 **Shutter speed:** 1/200 **ISO:** 100

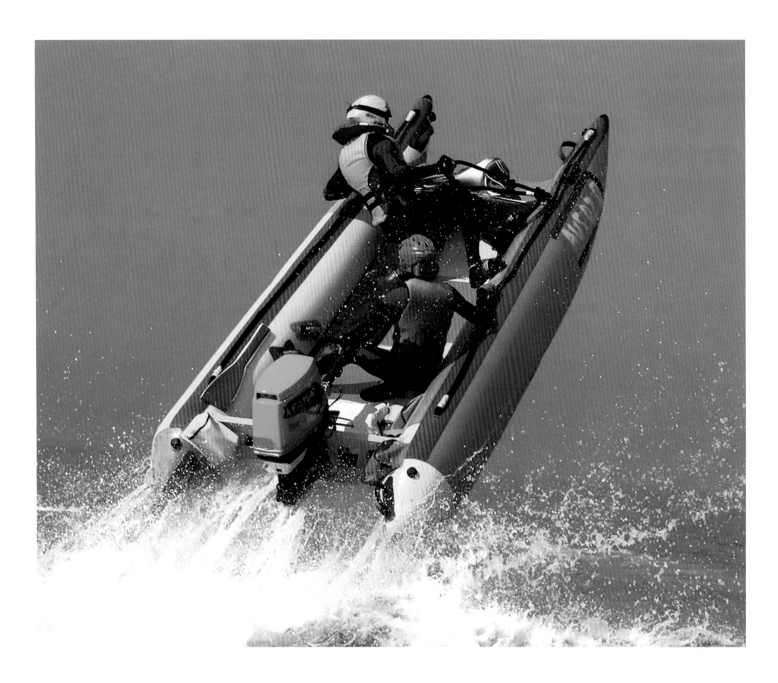

Weldon Thompson

IRB contest, Mudjimba, Qld

This race at high speed was in the shallows of the beach.

Camera: Lumix DMC-FZ30 **Aperture:** f9 **Shutter speed:** 1/1000 **ISO:** 200

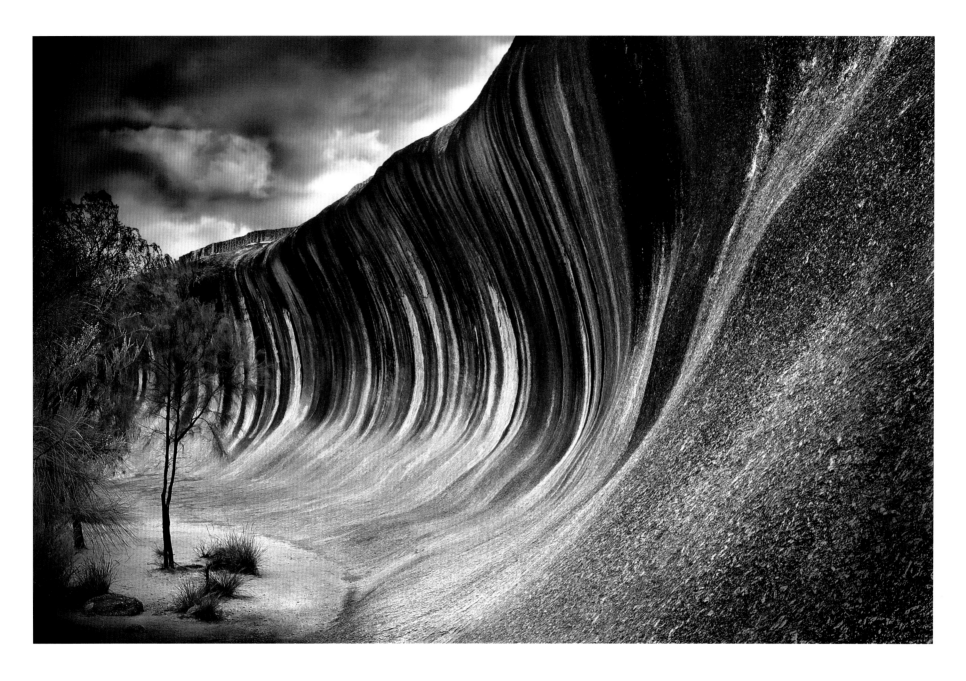

Reza Behjat
Wave Rock, Hyden, WA

Camera: Lumix DMC-FZ30 **Aperture:** f5.6 **Shutter speed:** 1/100 **ISO:** 80

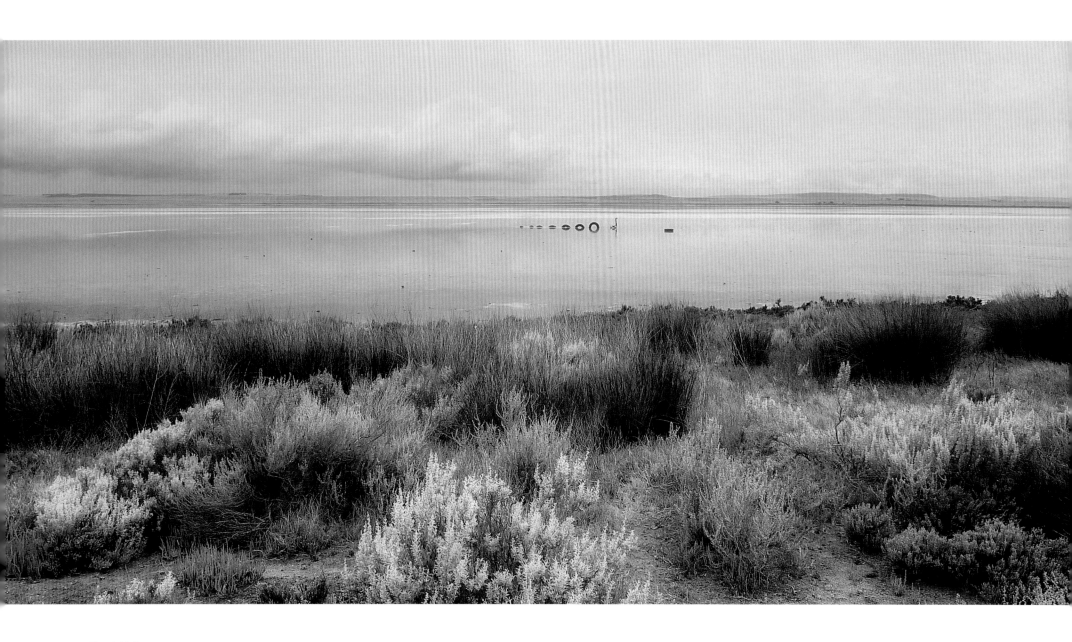

Nigel Millett

Lochiel, SA

Camera: Lumix DMC-TZ7 **Aperture:** f4.5 **Shutter speed:** 1/500 **ISO:** 125

Kerrie Hammell
Perfect wave, Cronulla, NSW

Taken on a Lumix TZ2, this photo captured the "perfect wave" behind the rock pool at Cronulla. It was just in time for our morning swim.

Camera: Lumix DMC-TZ2 **Aperture:** f11
Shutter speed: 1/2000 **ISO:** 1250

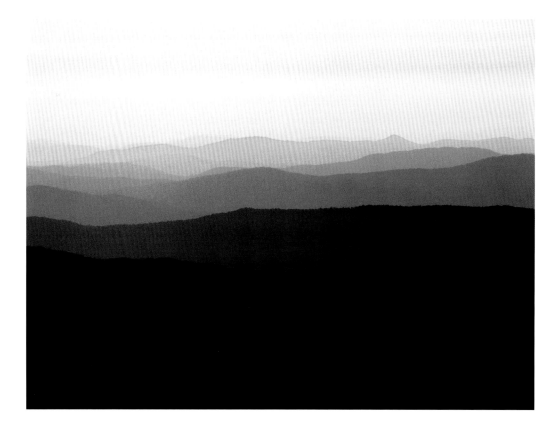

Rachel Jones
Main Range, Kosciuszko National Park, NSW

Camera: Lumix DMC-FZ10 **Aperture:** f5.6
Shutter speed: 1/1000 **ISO:** 100

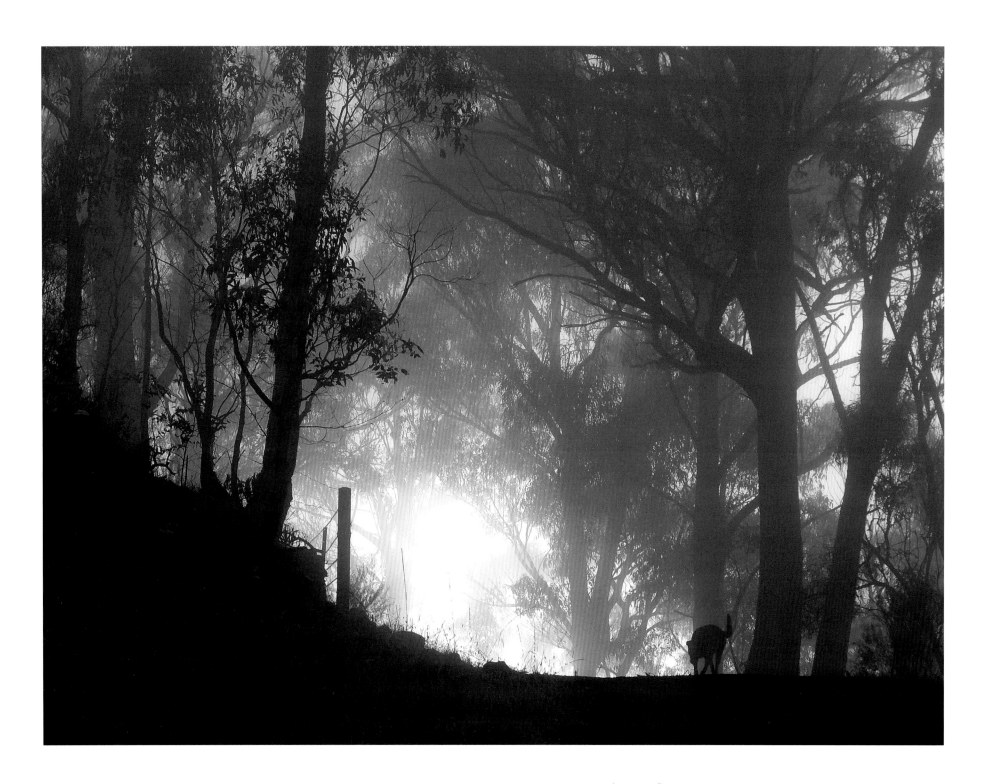

Jeanette Berman

Dog walking through morning mist, Armidale, NSW

Camera: Lumix DMC-FZ8 **Aperture:** f4 **Shutter speed:** 1/200 **ISO:** 100

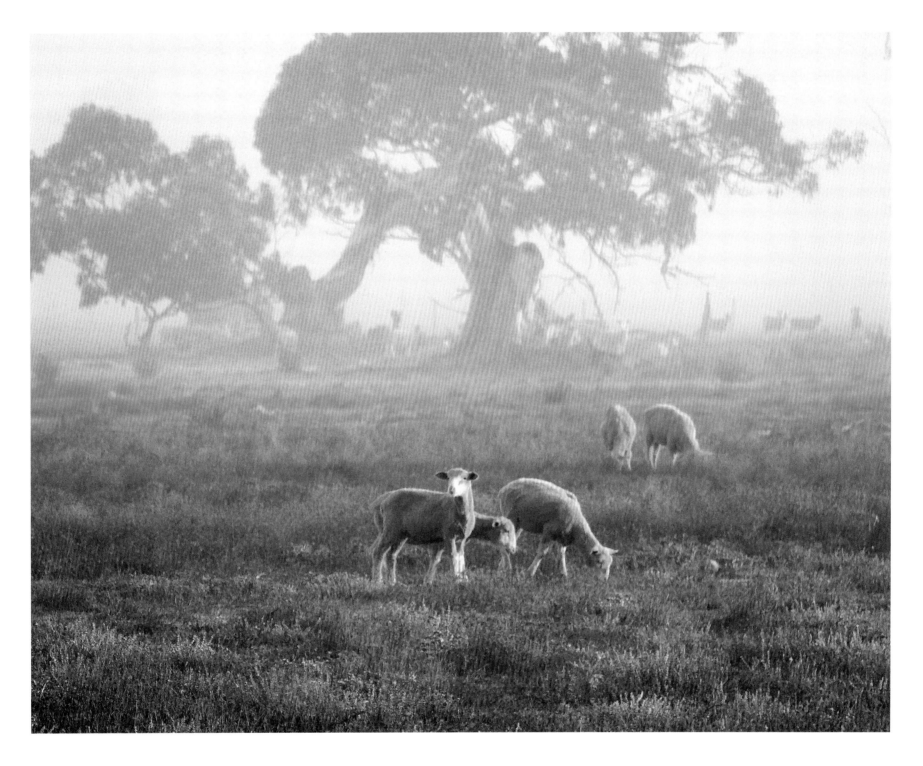

Kevin Fairley
Day's beginning, near Clay Wells, SA

Camera: Lumix DMC-FZ50 **Aperture:** f3.7 **Shutter speed:** 1/125 **ISO:** 200

Nick Rains

Nick Rains has been a professional photographer for over twenty-six years. In the past twenty, he has driven over 500,000 kilometres through Australia in search of fine landscape images, which are published around the world as calendars, books, and limited edition prints. In 2001, he won Australian Geographic Photographer of the Year and he has been a regular contributor to that journal ever since. In 2007, Nick was recognised by the Australian Institute of Professional Photography, attaining his Master of Photography, and is currently a National Judge with the Institute. Moving also into writing, he has recently become editor of *Better Digital Camera* magazine.

www.nickrains.com

Some tips from Nick

Stay sharp

Getting a sharp image should be a priority. Unless you are after a creative blur, like my bull riding image in this book, then pay attention to your shutter speed. This is displayed on the rear screen or in the viewfinder, depending on which model you have. This readout, shown in fractions of a second, will be red if the shutter speed is too low to be hand held and there is a likelihood of a wobbly picture. Change the aperture if you can, or raise the ISO setting until the shutter speed readout is no longer red.

Focus point

If you are photographing two people it's quite a common error to end up focussing between their heads on the background and ending up with out of focus faces. Use the camera's "face recognition" setting if there is one, or if not, point the centre focussing point at one face, gently hold the shutter release down slightly to lock the focus (you should hear a beep), re-frame the shot to include both heads and finish pressing the shutter button. This is far quicker to do than to explain!

Auto White Balance (AWB)

When you are shooting a scene with strong, bold colours like a red sunset or an intensely blue seascape you may find that the results don't turn out as good as you expected. Turning off the Auto White Balance (usually set by default) and setting the camera to "Daylight" will often help capture those dominant colours. AWB causes the camera to see a strong colour as a cast to be removed, when in fact you want to keep them.

Nick Rains

Meter Maids, Gold Coast, Qld

No coverage of Queensland would be complete without portraying some of the glitter of the Gold Coast. Originally introduced in 1965 to counter the bad publicity following the introduction of parking meters, today's meter maids are very much an icon of the Gold Coast. They can be found strolling the streets around Cavill Avenue, being photographed by visitors and generally looking wonderful. I arranged a quick shoot for this project; my Lumix GH1 handled the midday light very well and the 45–200mm lens proved perfect for framing a shot to include the beach but not the pedestrians on the busy street.

Camera: Lumix DMC-GH1 **Aperture:** f16 **Shutter speed:** 1/100 **ISO:** 100

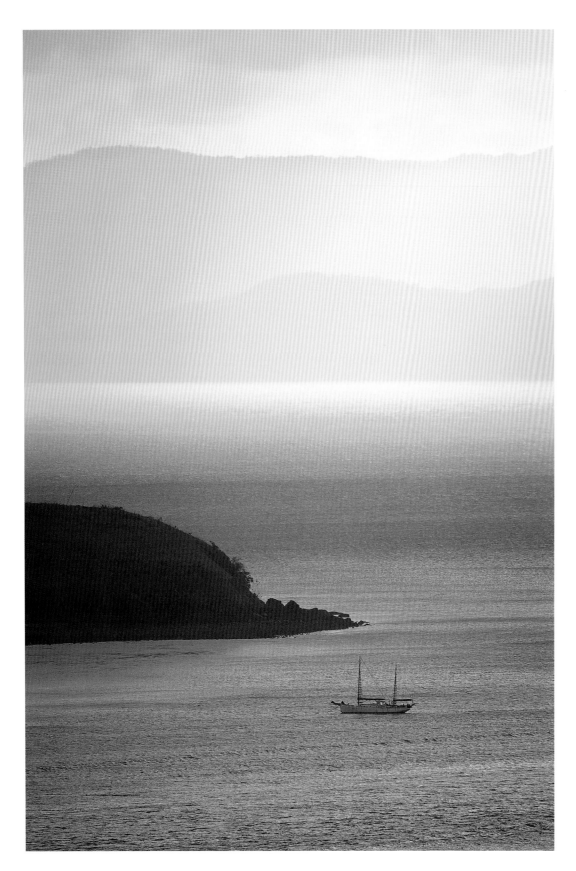

Nick Rains
Dusk over the Whitsunday Islands, Qld

Whilst working on the *Focus on Australia* project I was fortunate to spend a few days on Hamilton Island, one of the best known of the Whitsunday Islands. At dusk, I headed up to One Tree Hill where there is a vast westward looking panorama looking back towards the mainland. I often like to use a telephoto lens, in this case a 45–200mm zoom, to pick out parts of larger scenes, and picking out a single yacht, looking directly into the late afternoon light, resulted in an image that captured the tranquillity of sailing in these tropical waters.

Camera: Lumix DMC-GH1 **Aperture:** f6.3 **Shutter speed:** 1/500 **ISO:** 100

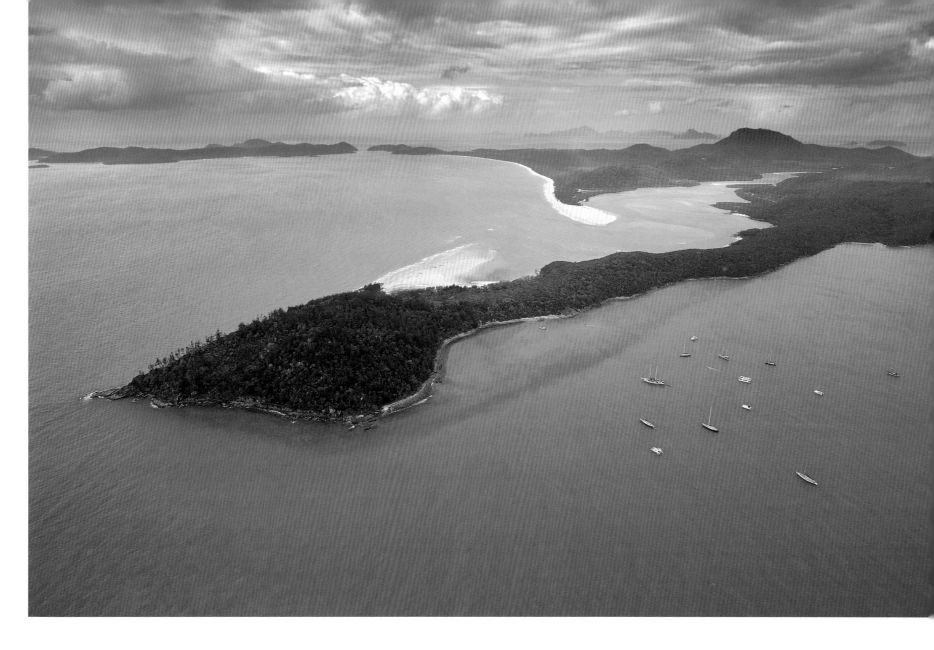

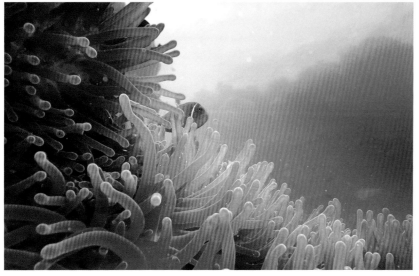

Nick Rains

Tongue Point, Whitsunday Island, Qld

This image looks south, over boats moored in Tongue Bay, towards the well known expanse of Whitehaven Beach in the distance and Hill Inlet to the right. Whitehaven Beach is a wonderful place to visit on the ground, but for the most impressive view you need to get into the air.

Camera: Lumix DMC-GH1 **Aperture:** f5.6 **Speed:** 1/1000 **ISO:** 200

Nick Rains

Sea anemone with Clown Fish, Whitsunday Island, Qld

Taken whilst diving off the Fantasea Pontoon on Hook Reef.

Camera: Lumix DMC-ZR1 **Aperture:** f3.3 **Shutter speed:** 1/125 **ISO:** 100

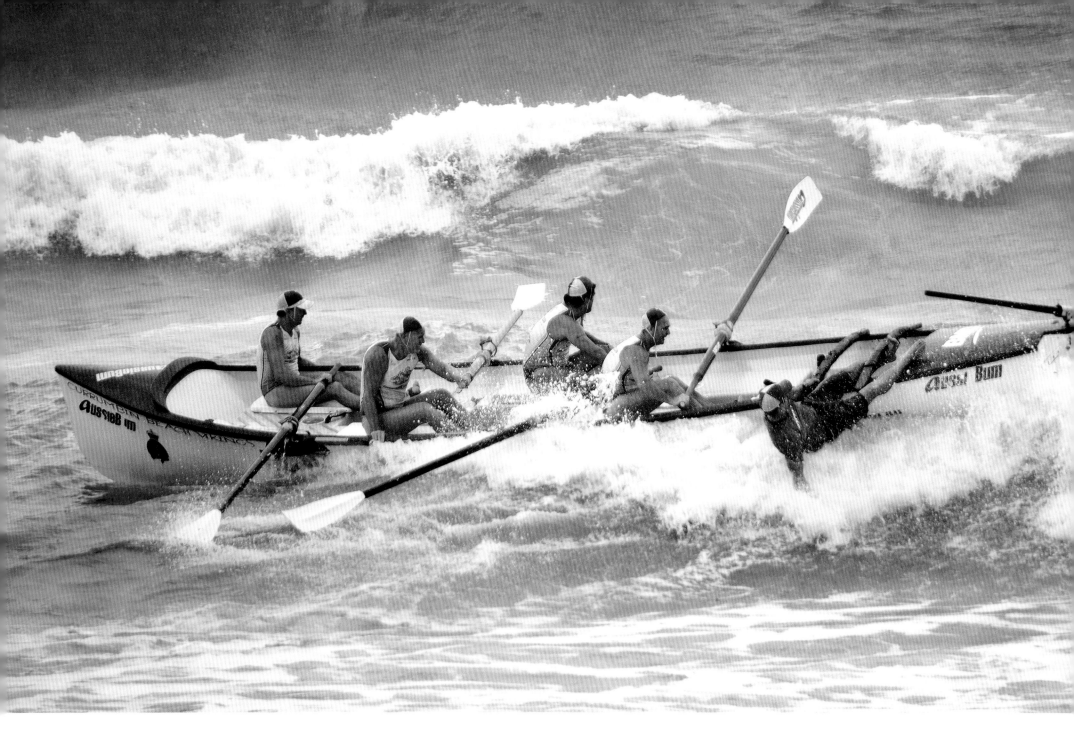

Nick Rains

Surf Lifesavers in action, Kurrawa Beach, Qld

Surf Lifesaving is both a sport and a means of keeping swimmers safe on the sometimes treacherous ocean beaches. Each year the clubs gather to compete in various events. The surf boat races are the most spectacular, with teams of five men and women battling through the surf. It's not all plain sailing as this image shows.

Camera: Lumix DMC-GH1 **Aperture:** f6.3 **Shutter speed:** 1/250 **ISO:** 200

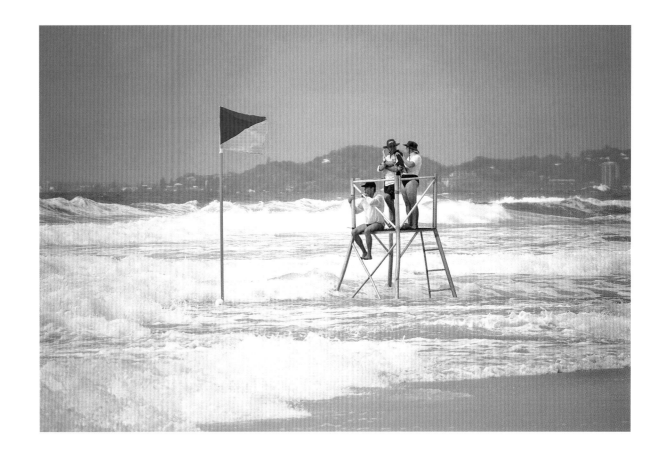

Nick Rains

Surf Carnival, Kurrawa Beach, Qld

Surf carnivals can be massive events – at the Nationals in 2010 over 100 surf boats competed for the title and this takes some organising. The start line has to be in the water, so the boats can be afloat, ready to go. These platforms are set up in the raging surf so that the marshals can see that the competitors are lined up properly. From the safety of the beach they look very precarious, and not a little incongruous. The bright flag against the blue sky added some extra colour.

Camera: Lumix DMC-GH1 **Aperture:** f5.6 **Shutter speed:** 1/1600 **ISO:** 200

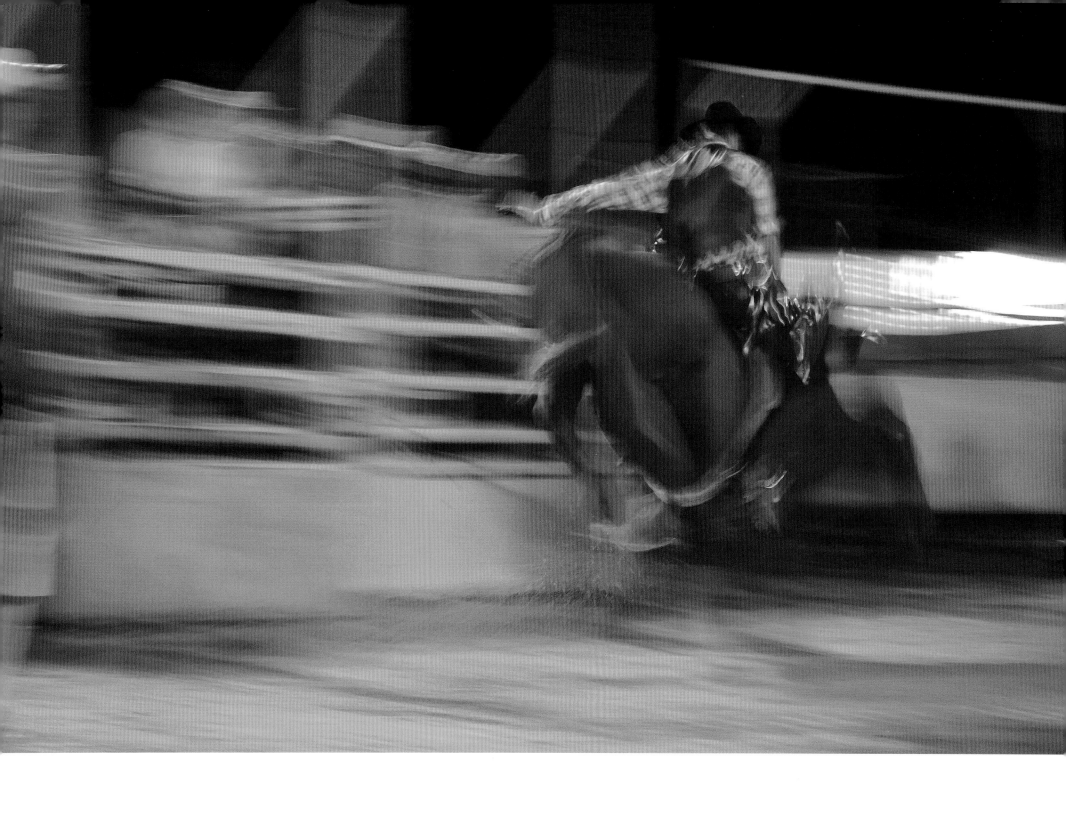

opposite

Nick Rains

Rodeo, Murgon Show, Qld

Country shows in Queensland often feature professional bull riding rodeos as one of the many attractions. From a photographic point of view these are exciting but challenging because they usually take place in the evening under floodlights. Freezing the action is almost impossible, even at a high ISO of 1600, so I chose to work with the movement rather than against it. The blurring of the bright red clown and the madly bucking bull capture some of the frantic action in a way that a sharp, frozen image cannot.

Camera: Lumix DMC-GH1 **Aperture:** f4 **Shutter speed:** 1/13 **ISO:** 1600

Nick Rains

Corey Wease, aged eleven, Murgon Show, Qld

They start them young in the rodeo circuit. I came across Corey preparing for his ride, complete with massive shiny belt buckle, leather chaps and all the accoutrements of a fully-fledged bull rider. Even at eleven he was a man of few words and took the whole thing very seriously – even having his photo taken did not soften his dead-pan expression. I saw this image as a black and white from the outset; a certain nostalgic look seemed appropriate, harking back to the old American Wild West days with sepia tones and equally serious expressions.

Camera: Lumix DMC-GH1 **Aperture:** f5.6 **Speed:** 1/13 **ISO:** 800

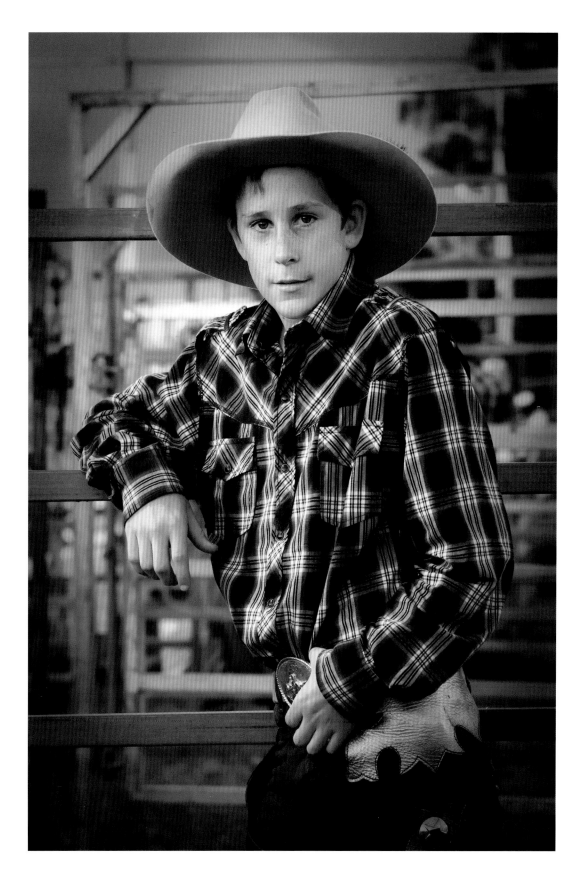

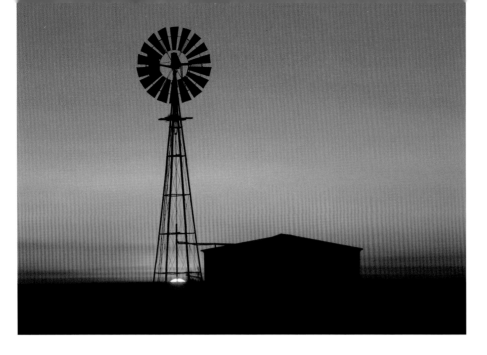

Dianne Mckenzie
Old windmill, Cobb Highway, near Hay, NSW

There were miles of flat land, and not a drop of water for the cattle roaming this long paddock, save for this windmill.

Camera: Lumix DMC-FZ5 **Aperture:** f4 **Shutter speed:** 1/500 **ISO:** 80

Helen O'Grady
Boab tree at sunset, Derby, WA

Here, the structure of the tree against the setting sun was just lovely.

Camera: Lumix DMC-FZ18 **Aperture:** f4.5 **Shutter speed:** 1/200 **ISO:** 100

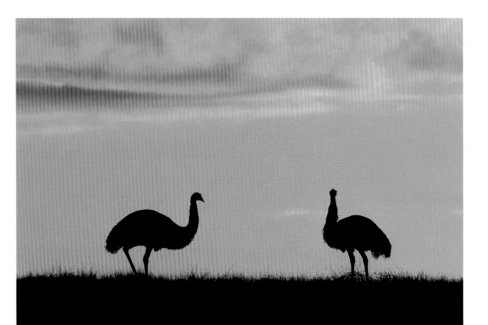

Dianne Mckenzie
Emus, Milparinka, NSW

Just on dawn, as we were travelling home, these emus appeared on the horizon. We only had a second to get a photo of them. The cold low morning light and the moving emus made for a very difficult shot.

Camera: Lumix DMC-FZ50 **Aperture:** f6.3 **Shutter speed:** 1/500 **ISO:** 100

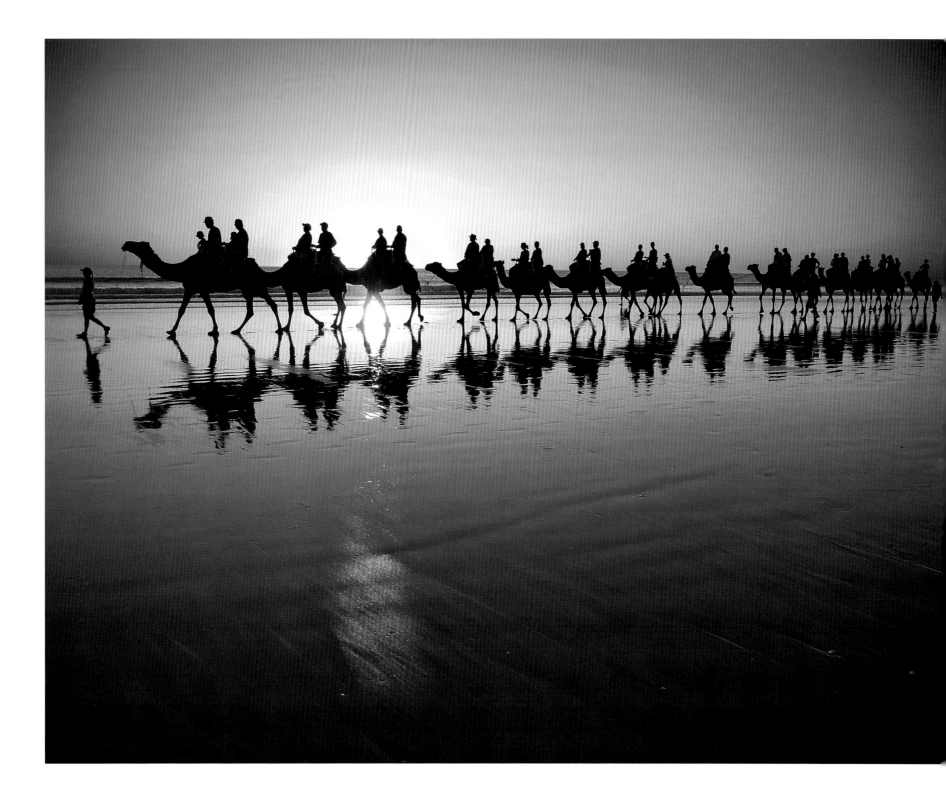

Georgina Bowden

Camels at sunset, Cable Beach, Broome, WA

Camera: Lumix DMC-FT1 **Aperture:** f3.3 **Shutter speed:** 1/200 **ISO:** 125

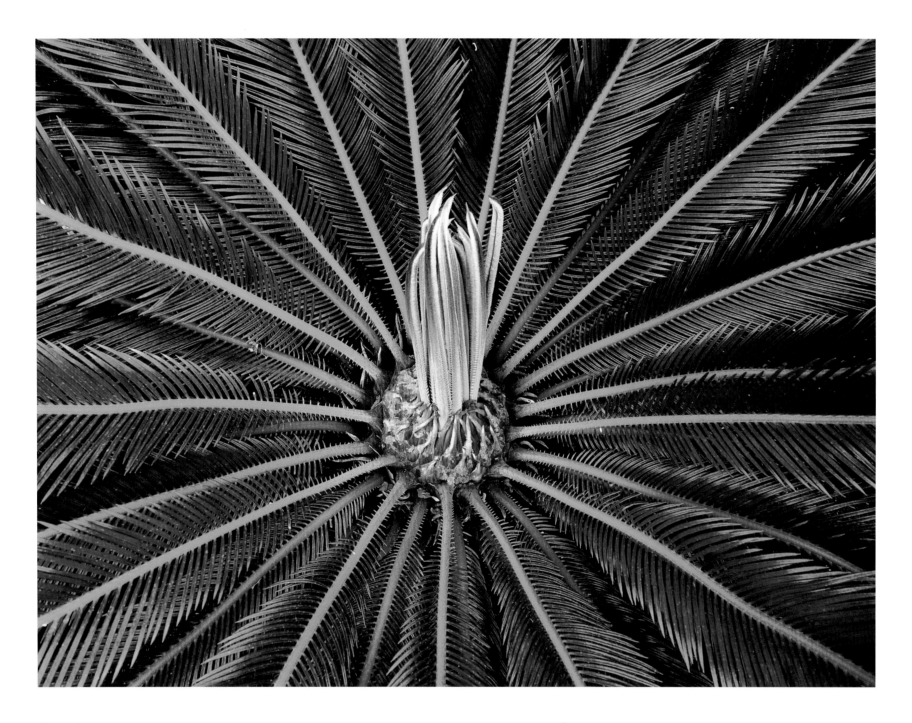

Christa Drysdale
Cycad, Ulladulla, NSW

Cycads grow throughout the forests of the south coast. This one is about
to open new fronds.

Camera: Lumix DMC-FZ28 **Aperture:** f2.8 **Shutter speed:** 1/40 **ISO:** 200

opposite

Laura Warman
Firewheel Tree, Royal Botanic Gardens, Sydney, NSW

Possibly my most favourite tree, this Firewheel (*Stenocarpus sinuatus*)
was in full bloom when I saw it at the Botanic Gardens.

Camera: Lumix DMC-FZ35 **Aperture:** f2.8 **Shutter speed:** 1/30 **ISO:** 80

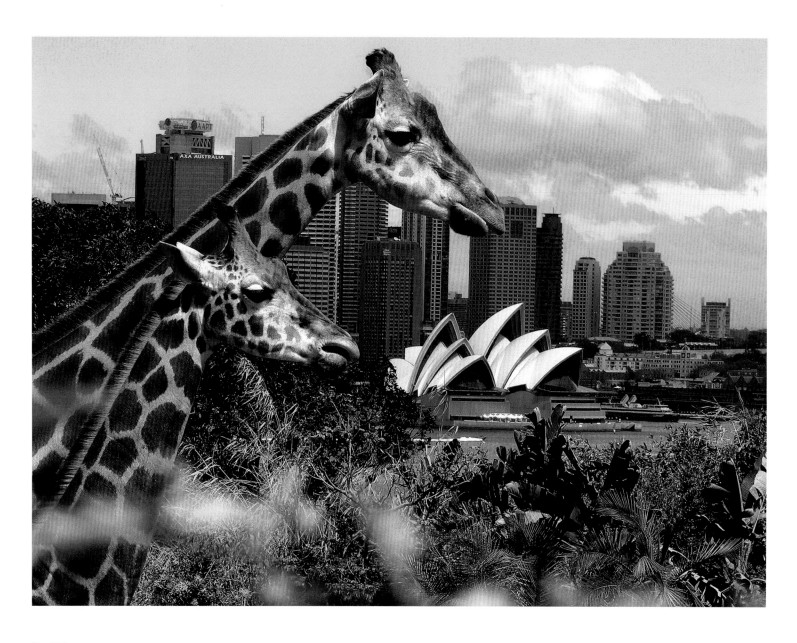

David Ismay

Giraffes, Taronga Zoo, Sydney, NSW

Camera: Lumix DMC-FZ20 **Aperture:** f5.6 **Shutter speed:** 1/50 **ISO:** 80

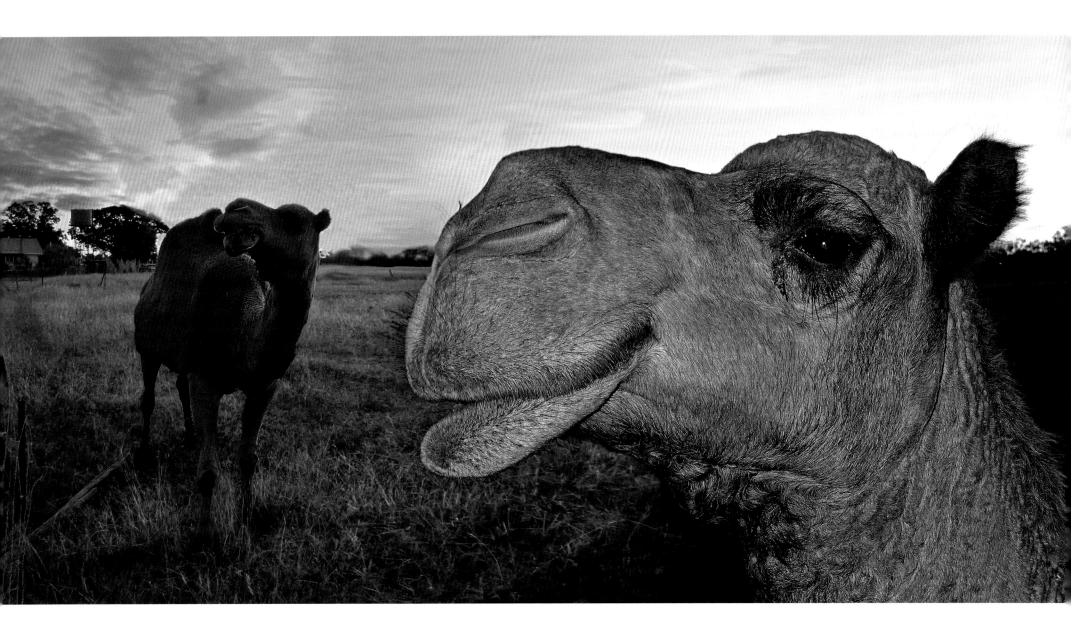

Amanda Neilson

Camels, Balfes Creek, Qld

Balfes Creek is not just a one pub town; its one pub *is* the town. You will find it – and the animals out the back – in rural North Queensland.

Camera: Lumix DMC-TZ7 **Aperture:** f3.3 **Shutter speed:** 1/60 **ISO:** 125

Lan Nguyen

Checking the waves, Torquay, Vic

Camera: Lumix DMC-LX3 **Aperture:** f6.3 **Shutter speed:** 1/200 **ISO:** 80

Sam Edmonds

Ready to surf, Celito Beach, NSW

I took this photo just before we entered the water; gorgeous autumn morning light was pouring onto the beach and a surfer's silhouette caught my attention. I thought the yellow and gold hues represented Australian imagery rather well.

Camera: Lumix DMC-TZ15 **Aperture:** f3.3 **Shutter speed:** 1/800 **ISO:** 100

Frances Mocnik

Frances Mocnik is an editorial photographer producing reportage projects for print media and exhibition. Her work has taken her across Australia to capture iconic images of people and places. She is a regular contributor to the *Australian Geographic Journal* and the *Australian Financial Review Magazine*. Her series *The Night that Follows Day* has seen her nominated for the prestigious Walkley award and the Leica Documentary award. In 2004 a retrospective of her portrait work, *The Power Elite, Business, Politics and Photography,* was held at the State Library of New South Wales and she co-curated the *Reportage Photographic Festival* in 2005 and 2006.

www.mocnik.com

Some tips from Frances

When I was thirteen, I won a trip. The ticket afforded me passage to every Australian capital city, bar Perth and Hobart. I set off with my camera and at each location eagerly sought photographs of key attractions; not my own shots but postcards purchased from airport newsagents. With these in hand I headed off to shoot something different.

Digital technology has delivered photographers fantastic freedom. You can choose to master the manual operation of your camera or simply enjoy selecting from the technically sophisticated program modes. Technical knowledge no longer takes a lifetime to master, equipment is affordable and the distribution of images can be immediate and global; the playing field has levelled.

Our strength as image makers lies in how we interpret the world. Our greatest challenge is to continue to create images of scenes whose likeness already exists in many other photographs.

It is well documented that frequent viewing of similar images quickly becomes boring. While it might be technically satisfying to emulate well-known images, it is through the development of a personal style that you mature as a photographer.

What you choose to shoot, how you frame a shot or the mood and emotion carried in an image are the cornerstones of your visual signature. Focus on what is of interest to you; don't be concerned with the directions on a tourist signpost or what others herald as significant.

If you're ready to start exploring your personal style, try the challenge I set myself as a thirteen year old: buy a postcard, go to the location and leave with your own different, unique image.

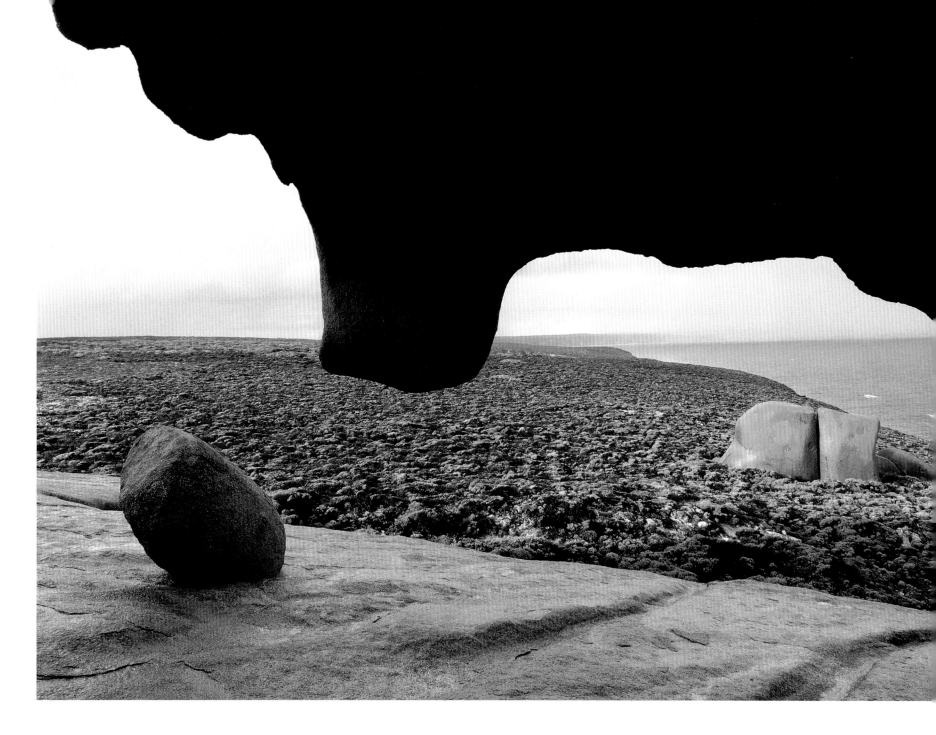

Frances Mocnik

Rain falls on the Remarkable Rocks, Kangaroo Island, SA

It might be a picture perfect postcard that initially draws us to a location, but when we arrive we often see a different view. My first sighting of the Remarkable Rocks was through driving sheets of rain. The raging storm whipped the rock, demonstrating firsthand the forces that sculpt these famous forms. There's no sign of the storm in this tranquil image, just a sense of rugged endurance.

Camera: Lumix DMC-GF1 **Aperture:** f4.1 **Shutter speed:** 1/30 **ISO:** 400

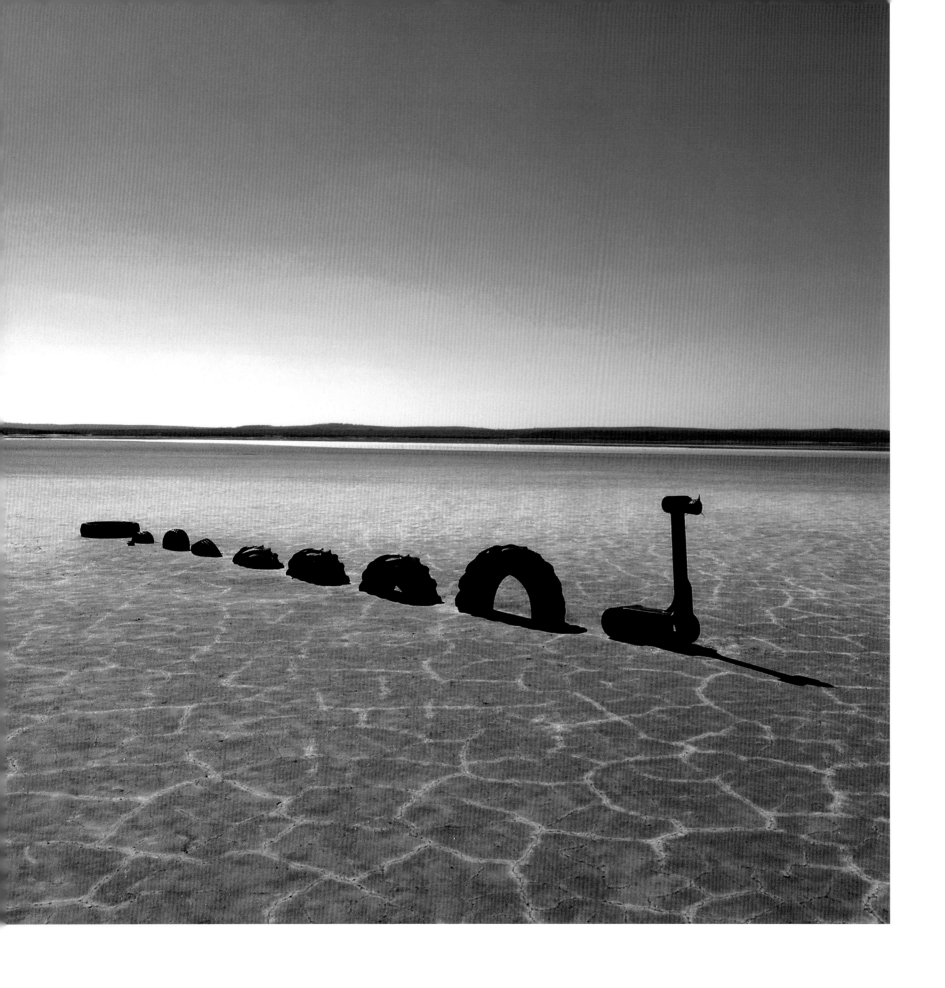

opposite
Frances Mocnik

The infamous Loch Eel overlooking the salt lake, Lochiel, National Highway One, SA

At around 14,500 kilometres – or "clicks" as Truckies say – Australia's Highway 1 is the longest highway in the world. This network of roads circumnavigates the continent, connecting major capital cities but bypassing many small towns. Lochiel is one of these small towns. Situated just off our National Highway between Port Wakefield and Snowtown, it's known for its nearby saltworks and famed mythical creature, the Loch Eel. You'll need a keen eye to spot Loch Eel; if the day's hot, he's lost within a mirage. Get off the highway, out of your air-conditioned car, smell the salt, walk the dry lake and find him for yourself.

Camera: Lumix DMC-GF1 **Aperture:** f20
Shutter speed: 1/60 **ISO:** 100

Frances Mocnik

Sunset view from Glenelg over Holdfast Bay, SA

A cacophony of camera-toting tourists had farewelled the setting sun at Glenelg Pier. They quickly disappeared. Here I am left with the afterglow, a sky of saturated colour and a group of silhouetted locals who quietly continue about their business. The first street light flickers on, a boy looks down, his attention caught by something in the sea; here is my decisive moment, my shot.

Camera: Lumix DMC-GF1 **Aperture:** f11
Shutter speed: 1/40 **ISO:** 400

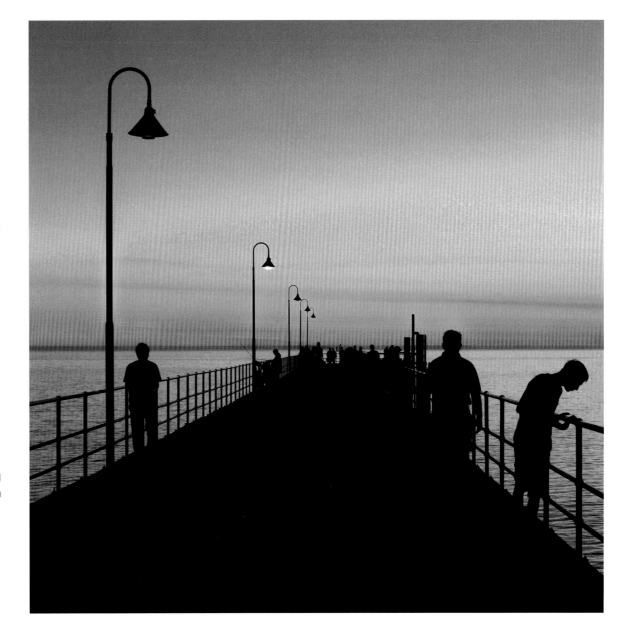

overleaf
Frances Mocnik

Highway winding through a corridor of eucalypt, Barossa Valley, SA

Camera: Lumix DMC-GF1 **Aperture:** f5.7 **Shutter speed:** 1/200 **ISO:** 200

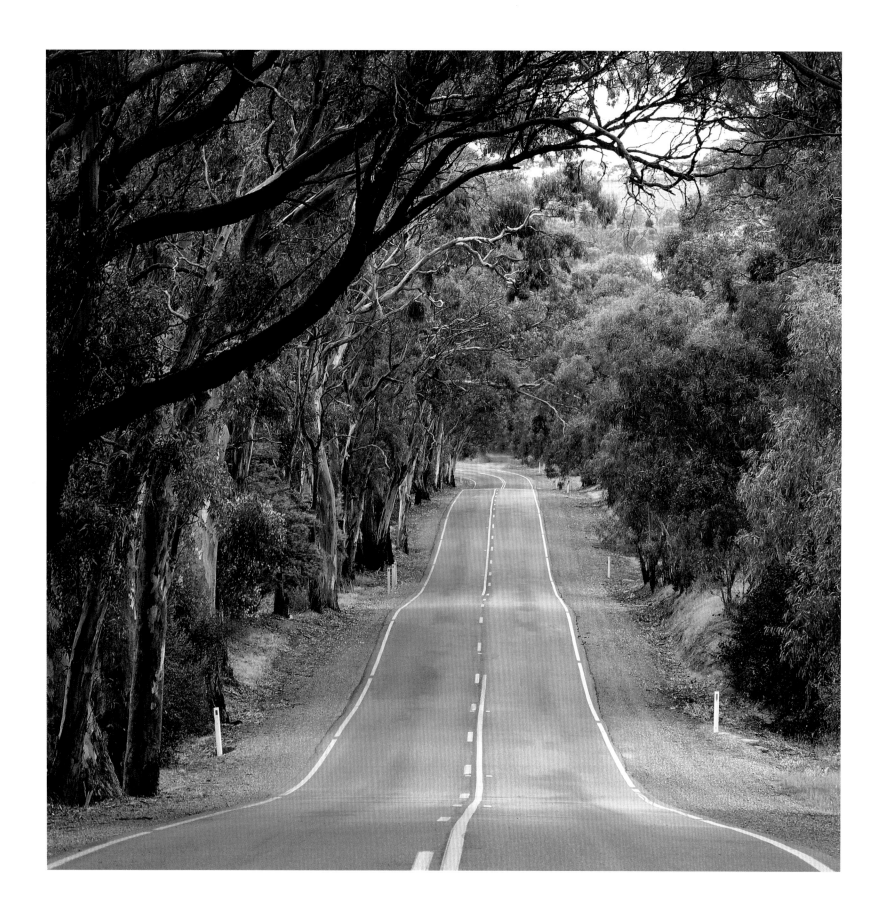

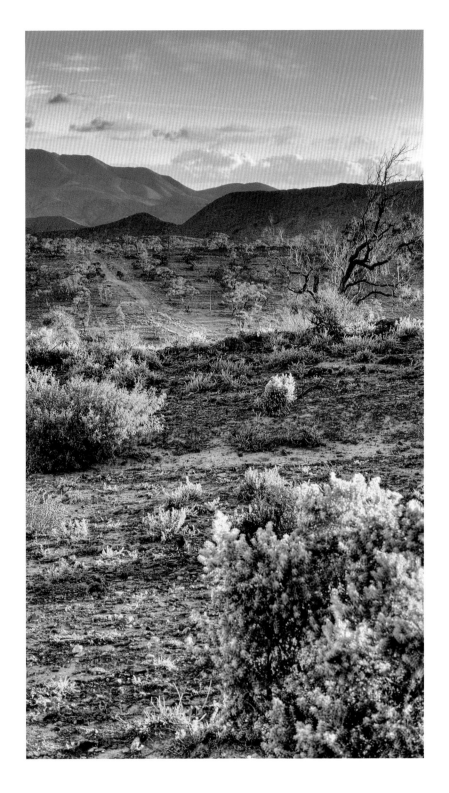

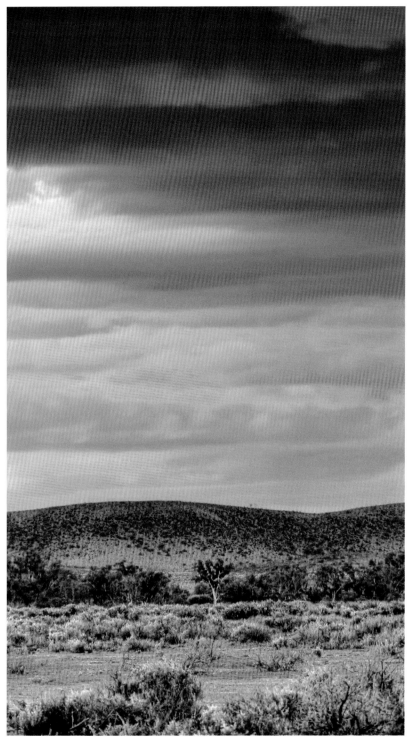

Pamela Inverarity
Back of Aroona, Flinders Ranges, SA

Camera: Lumix DMC-GH1 **Aperture:** f9 **Shutter speed:** 1/40 **ISO:** 100

Pamela Inverarity
Sunset glory, Flinders Ranges, SA

Camera: Lumix DMC-GH1 **Aperture:** f8 **Shutter speed:** 1/30 **ISO:** 400

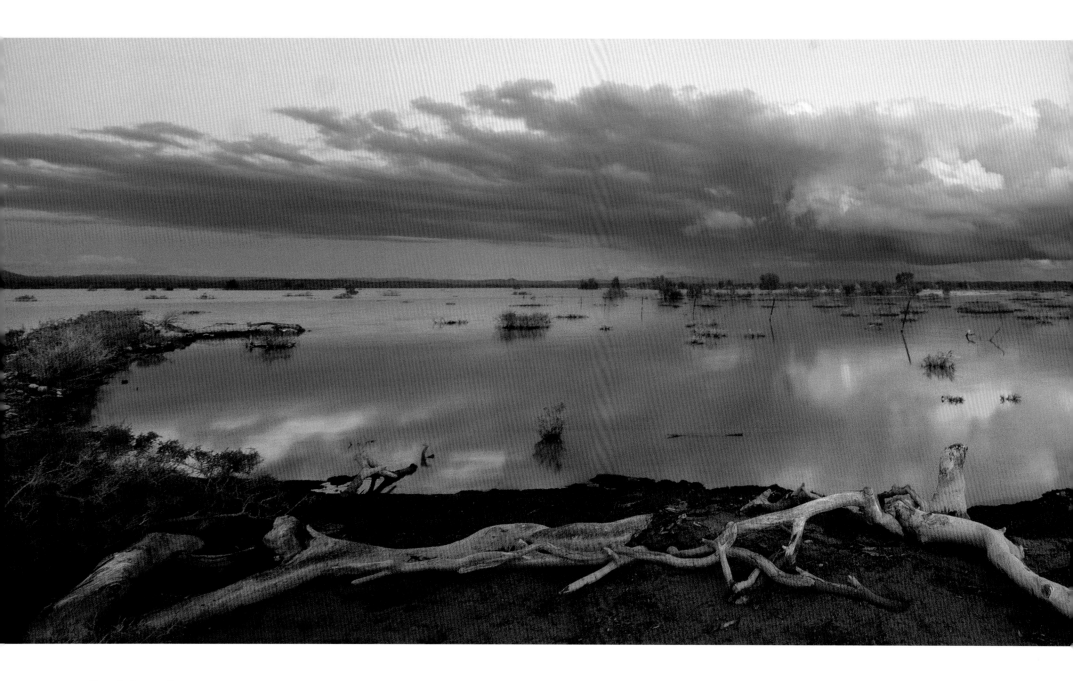

Pamela Inverarity

Dusk over the dam, Flinders Ranges, SA

The Retention Dam was created to keep water out of the coal mine at Leigh
Creek. It has become a wetland that teems with life, including native fish,
eagles, pelicans, ducks, snakes and everything in between. The recent flood
waters have filled it to record levels, covering the road and the fence.

Camera: Lumix DMC-GH1 **Aperture:** f20 **Shutter speed:** 1 second **ISO:** 100

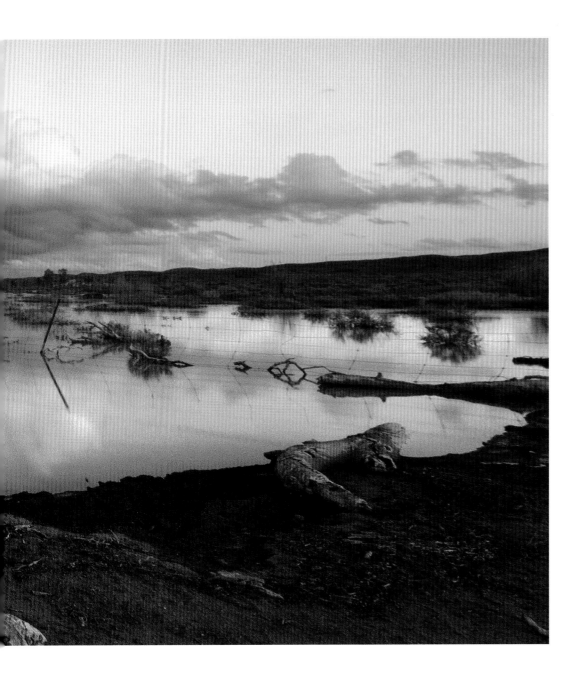

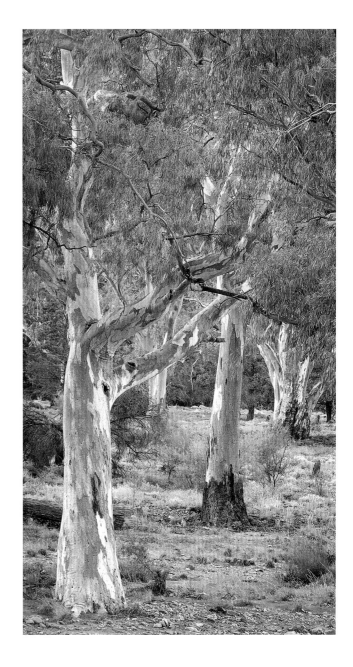

Pamela Inverarity

River Red Gums in Sliding Rock Creek, Flinders Ranges, SA

Sliding Rock is a ghost copper mining town in a spectacular setting in the northern Flinders Ranges. The broad creek bed by the ruins of the town is currently more verdant than I have ever seen it, following an amazing amount of rain for this normally dry part of the country. I would not have expected to be able to capture an image so dominated by the colour green.

Camera: Lumix DMC-GH1 **Aperture:** f10
Shutter speed: 1/8 **ISO:** 100

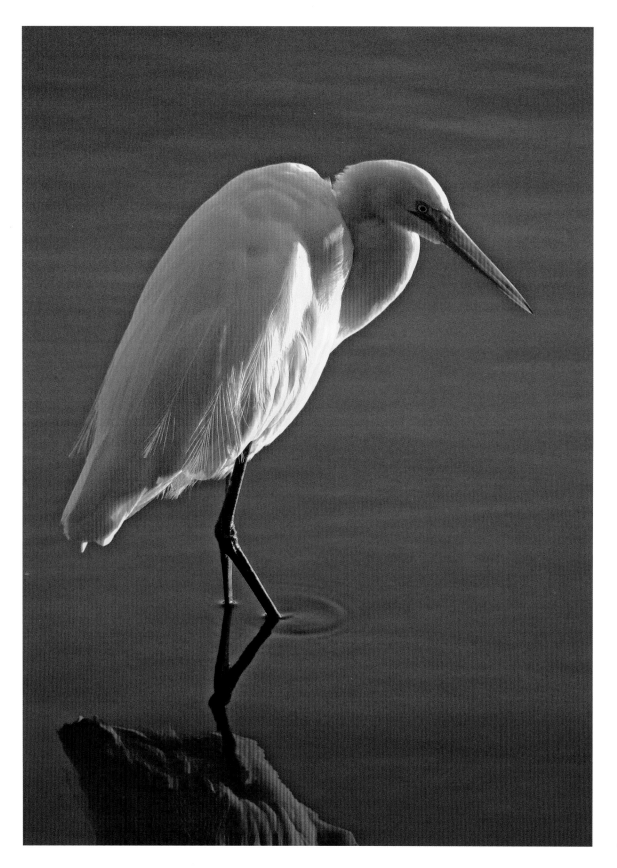

Dianne Mckenzie

Greater Egret, Noosa, Sunshine Coast, Qld

It was a very still morning on the river at Noosa when I snapped this egret looking for its breakfast. This location is a great place for bird photography, with many different types of waterbirds occurring throughout the year.

Camera: Lumix DMC-FZ50
Aperture: f4 **Shutter speed:** 1/160 **ISO:** 200

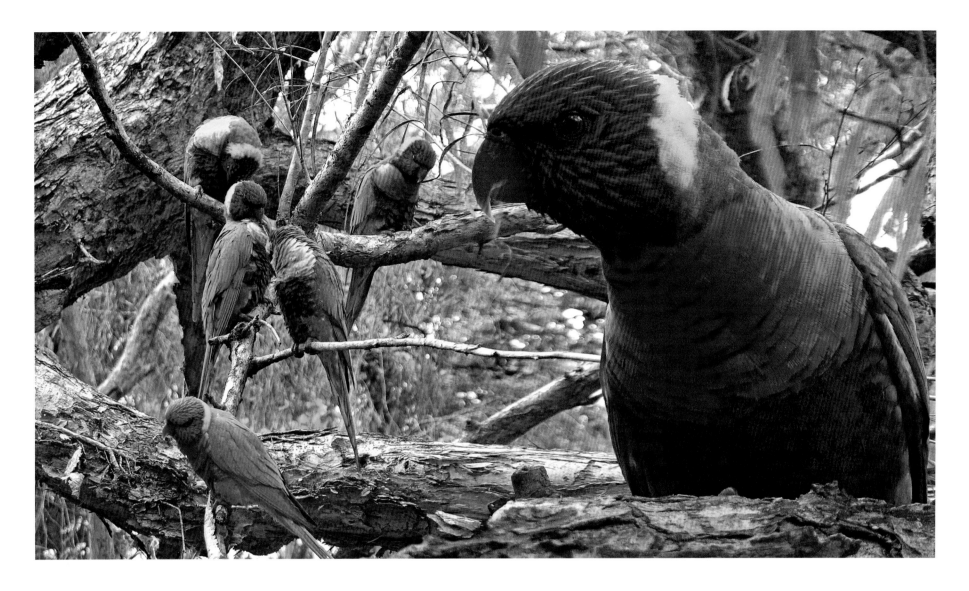

Amanda Neilson

Rainbow Lorikeets, Charters Towers, Qld

These cheeky lorikeets provide vivid splashes of colour in the native
trees of Lisner Park in Charters Towers. When you go to feed the ducks,
they swoop in to steal your attention – and your crusts.

Camera: Lumix DMC-TZ7 **Aperture:** f4.5 **Shutter speed:** 1/50 **ISO.** 125

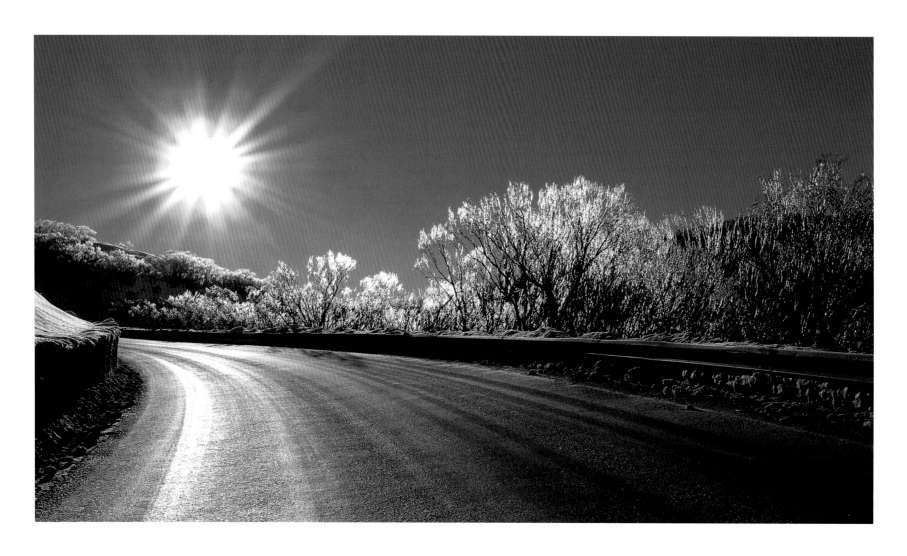

James Francis

Ice road, Mount Hotham, Vic

Camera: Lumix DMC-LX1 **Aperture:** f5.6 **Shutter speed:** 1/1000 **ISO:** 80

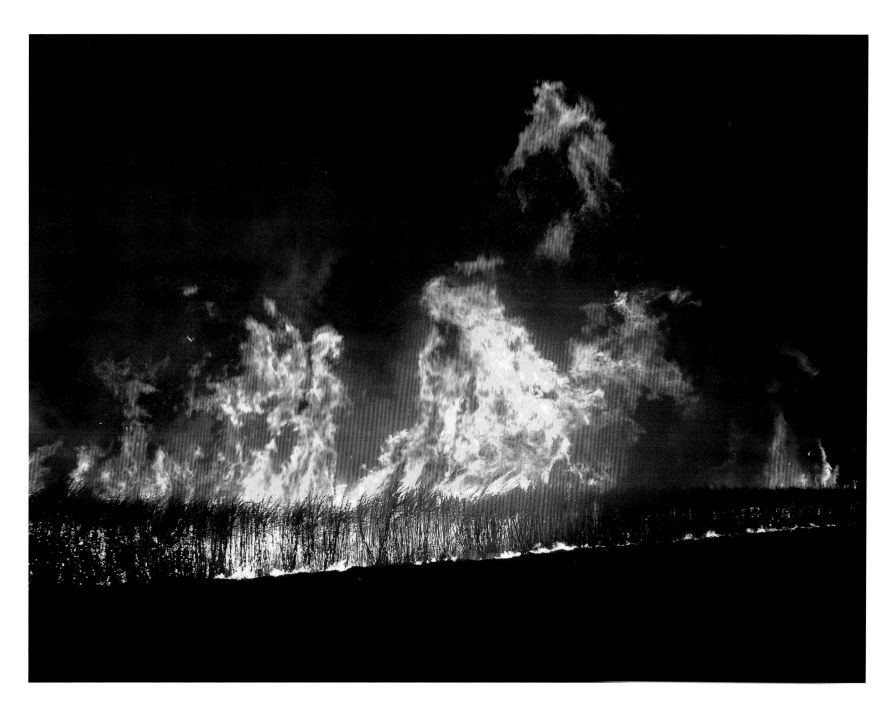

Tanya Rossi
Cane fire, Aloomba, far north Qld

Camera: Lumix DMC-FZ50 **Aperture:** f3.6 **Shutter speed:** 1/100 **ISO:** 100

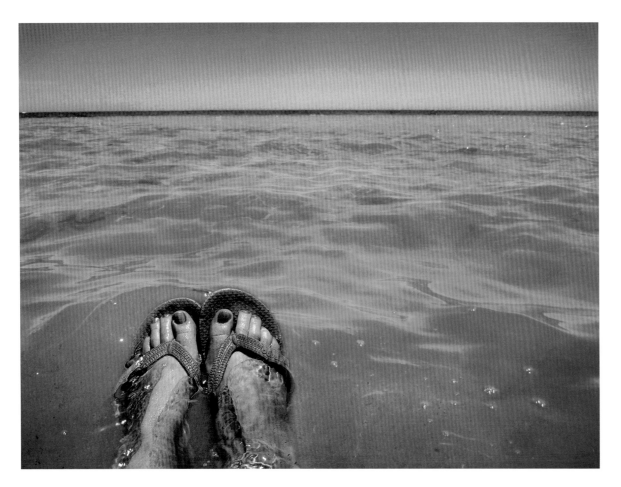

Barb Leopold

Aussie summer, Port Noarlunga, SA

I snapped this image of my thonged feet while floating at the beach. I love the Lumix's waterproof ability. It makes summer so much fun. This image says: "Australia. Summer. Perfect!"

Camera: Lumix DMC-FT1 **Aperture:** f10 **Shutter speed:** 1/200 **ISO:** 80

Casey Ripper

Hayden Cervi from inside the barrel, Sunshine Beach, Qld

Camera: Lumix DMC-FT2 **Aperture:** f10 **Shutter speed:** 1/250 **ISO:** 500

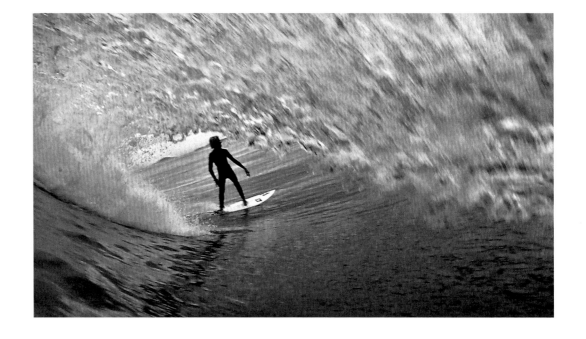

Jo Quinn

Exploring, Jervis Bay, NSW

Here my daughter explores the underwater world,
whilst I follow with my new underwater Lumix!

Camera: Lumix DMC-FT1 **Aperture:** f3.3 **Shutter
speed:** 1/160 **ISO:** 80

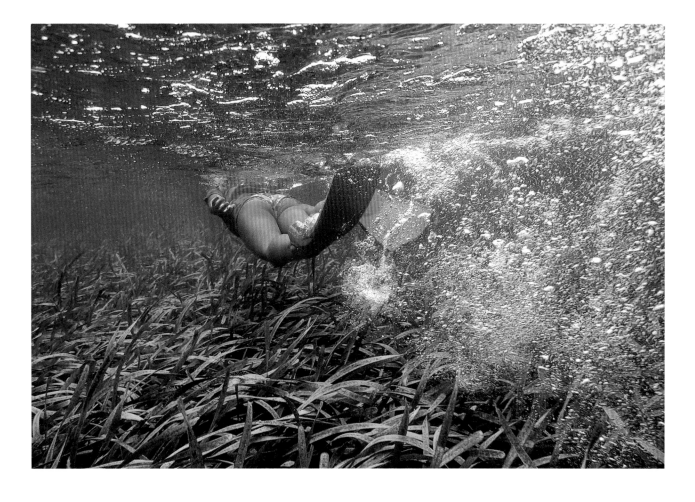

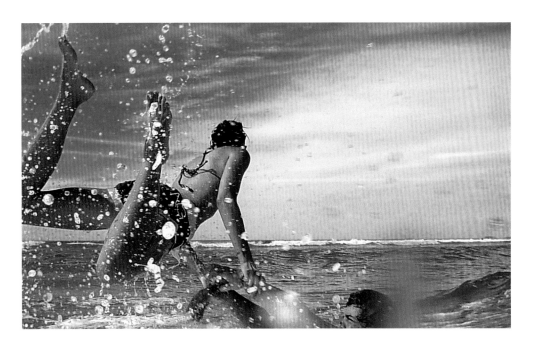

Louisa Bloomer

Surf diving, Mullaway, NSW

I would run full pelt at my friend, who would grab me as I
jumped and help to propel me up, up, and over a breaking wave.

Camera: Lumix DMC-FT1 **Aperture:** f10
Shutter speed: 1/400 **ISO:** 200

Lance Leopold

Coast view, Port Noarlunga, SA

Australia is known for its great coastline, and this beach at Port Noarlunga is no exception.

Camera: Lumix DMC-FZ28 **Aperture:** f8 **Shutter speed:** 1/400 **ISO:** 100

Erica Haines
Day's end at the Bay, Glenelg, SA

Camera: Lumix DMC-TZ7 **Aperture:** f4.5 **Shutter speed:** 1/400 **ISO:** 80

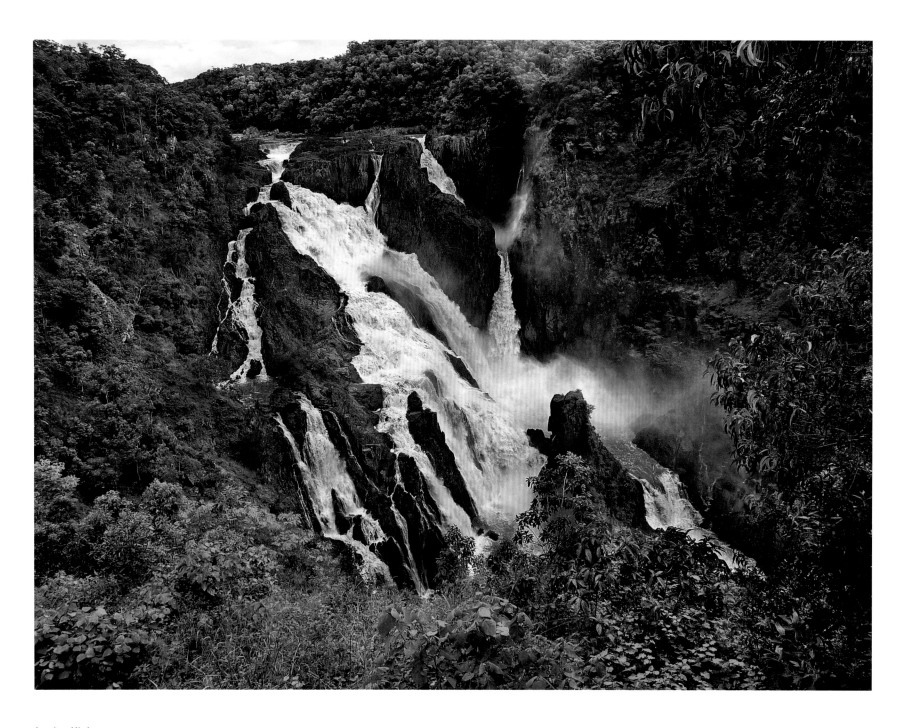

Louise Vickers
Barron Falls, Kuranda, Qld

I was able to see the falls soon after the rains; they were spectacular
at this time of the year.

Camera: Lumix DMC-TZ7 **Aperture:** f4.5 **Shutter speed:** 1/400 **ISO:** 80

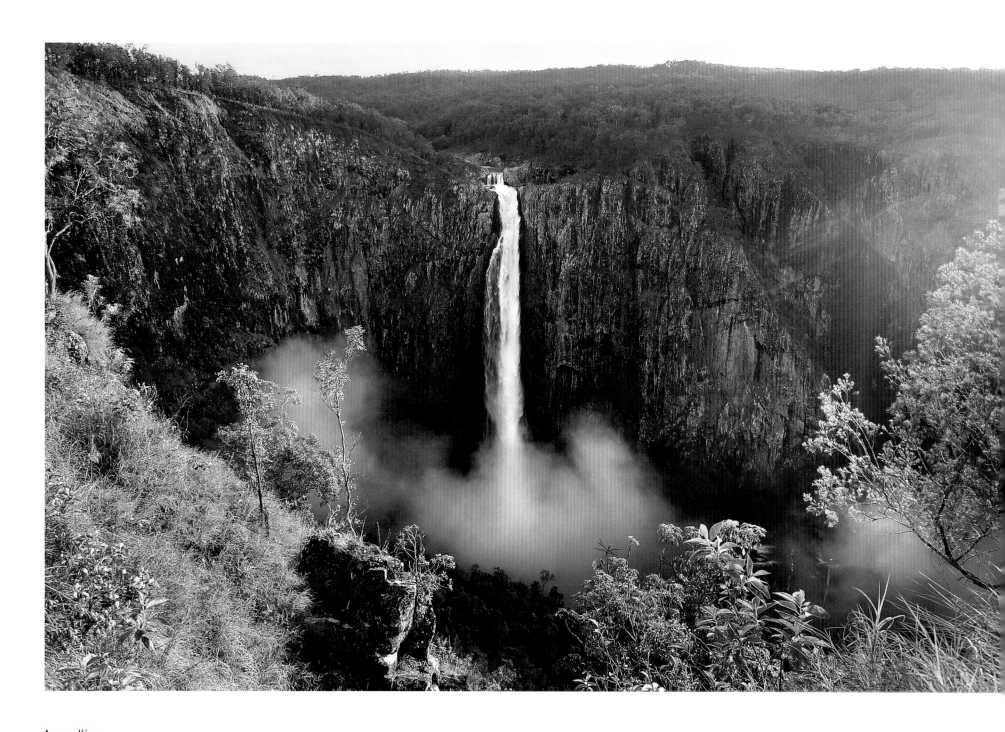

Agnes Kim

Wallaman Falls, Qld

This shot captured a lovely sunset and an amazing mist from the highest single drop waterfall in Australia.

Camera: Lumix DMC-LX3 **Aperture:** f2.2 **Shutter speed:** 1/100 **ISO:** 80

Ted Grambeau

Born in Melbourne in 1954, Ted Grambeau grew up in the towns of Wonthaggi and Foster in the South Gippsland region. He studied photography at RMIT in Melbourne and soon combined his passion for travel with adventure surf photography. These expeditions have seen Ted scouring some of the most remote reaches of the planet looking for surf – from Russia to Iceland, Mozambique to the Galapagos – almost thirty years of near continuous travel. A brief interlude assisting acclaimed Magnum photojournalist Burt Glinn in New York had a profound influence on Ted's photography. Ted's work blends a photojournalistic style with the more technical foundation of commercial illustrative photography.

www.tedgrambeau.com

Some tips from Ted

Seek "emotional" content in images

The greatest photos of our time evoke an emotion in one way or another. You have to steal the moment, be discreet, be a fly on the wall. Don't try to construct your images or control your subject; record moments of real life. Be amongst your subjects, and be aware of the natural light (remember that artificial light creates artificial moments). Try to anticipate situations and reactions, and have a camera always readily accessible. Record moments of the seemingly mundane: work, home, public places – the normal things that surround us – and look for the emotion.

Vary your perspective

Use whatever perspective best suits your shot: low, high, tight, far away. Be aware that varying the perspective can totally change the mood of a photo. Using a chopper is an extreme version of such a change. But it can be as subtle as lowering oneself to eye level when photographing a child so as to achieve their perspective. Constantly search for fresh angles. Take risks, though don't use gimmicks. Shoot into the light, don't be afraid of flare, look for reflections, shoot through glass – anything that may add to the story of the moment but retain its integrity.

Be aware of light

Light is your medium. Use it wisely! Learn to hunt for your images when conditions are prime. Low light – early and late – creates texture and warm hues, both for scenes and people. In first and last light, people look really healthy and vibrant. They glow! Midday means harsh light and shadows on the eyes (and always remember that with people, the eyes are the all important connection).

Ted Grambeau

Fish eye view, Bondi Beach, NSW

Lying on the bottom, letting the waves break over me, enabled me to capture a whole new perspective, though it required many shots of surfers passing overhead to get a few successful ones. However, it was more than worth while. It was quite literally how sea creatures see surfers! I shot my water images with my little Lumix FT1, which is both waterproof and shockproof. It's an ideal camera for those active shots that would otherwise not be possible without the alternative expensive water housings. This camera soon became a favourite of mine.

Camera: Lumix DMC-FT1 **Aperture:** f3.3
Shutter speed: 1/1000 **ISO:** 250

Ted Grambeau

Scooter boy, Bondi, NSW

Camera: Lumix DMC-G1 **Aperture:** f10 **Shutter speed:** 1/250 **ISO:** 100

Ted Grambeau

Surfer chicks waiting for a set, Bondi, NSW

This shot again showed what a little gem of a camera the waterproof FT1 is. Smaller than a packet of cigarettes, it opens up a whole range of photo opportunities. In this case it was a couple of young girls out the back waiting for a set. The low back-light created the obvious silhouetted look as well as providing strong lines of shadow in the foreground, all helping to strengthen the overall composition.

Camera: Lumix DMC-FT1 **Aperture:** f10
Shutter speed: 1/500 **ISO:** 250

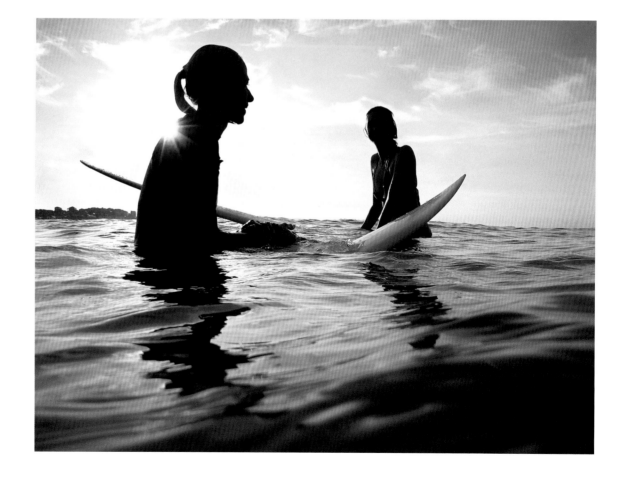

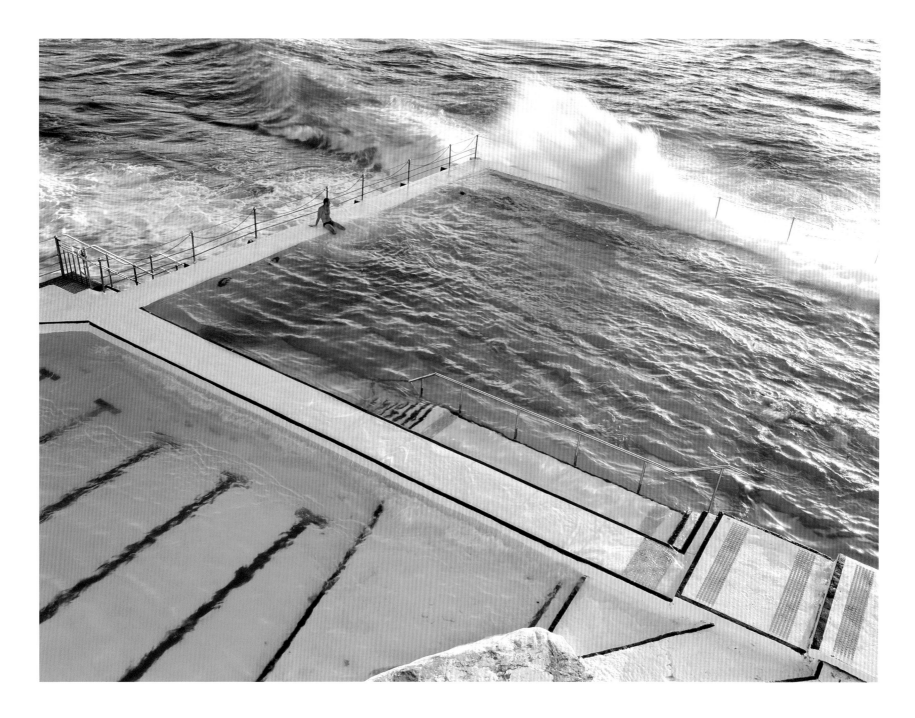

Ted Grambeau
Bondi Icebergs, first light, Bondi, NSW

All year, a crew of hardy souls ventures down at first light to do laps in one of the world's most scenic pools. Here, a sitting swimmer savours the moment. The elevated perspective reveals a graphic interplay of lines and shapes.

Camera: Lumix DMC-G1 **Aperture:** f22 **Shutter speed:** 1/10 **ISO:** 100

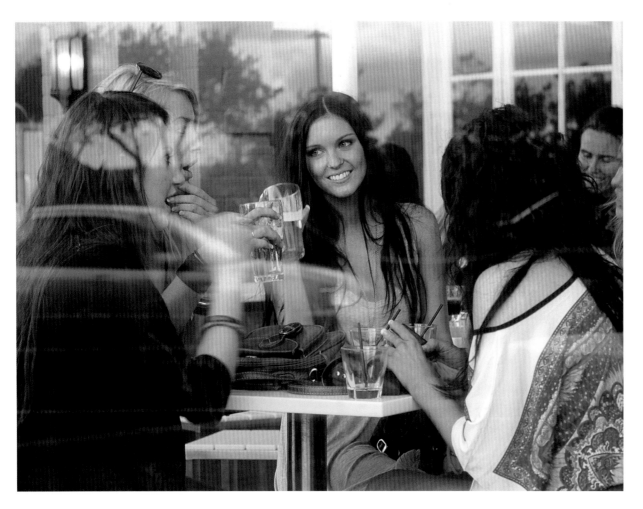

Ted Grambeau

Saturday arvo at the beer garden, Bondi Hotel, Bondi, NSW

This is a very typical scene in Australia on any sunny
Saturday "arvo" – some girls relaxing in a beer garden.
I asked their permission to observe from a distance and it
wasn't long before the girls returned to their conversation
fully engrossed. The shot was photographed through a glass
barrier, adding a further dimension, reflected from the out-
side. My aim was to achieve a "fly-on-the-wall" perspective
of a very natural social phenomenon.

Camera: Lumix DMC-G1 **Aperture:** f4.1
Shutter speed: 1/40 **ISO:** 200

opposite

Ted Grambeau

The devil inside, Bondi, NSW

This was just one of those photojournalistic "moments",
a random scene on the main beach front parade at Bondi.
Evidently employed as some sort of promotional stunt,
the devil strolls along here like any normal member of the
crowd. The shot is framed by some nice bright lights, but
more importantly there is the interplay with the beer bottle
in the bottom right of the frame – alcohol being the trigger
in many of those "The Devil made me do it!" situations.

Camera: Lumix DMC-G1 **Aperture:** f5.6
Shutter speed: 1/125 **ISO:** 400

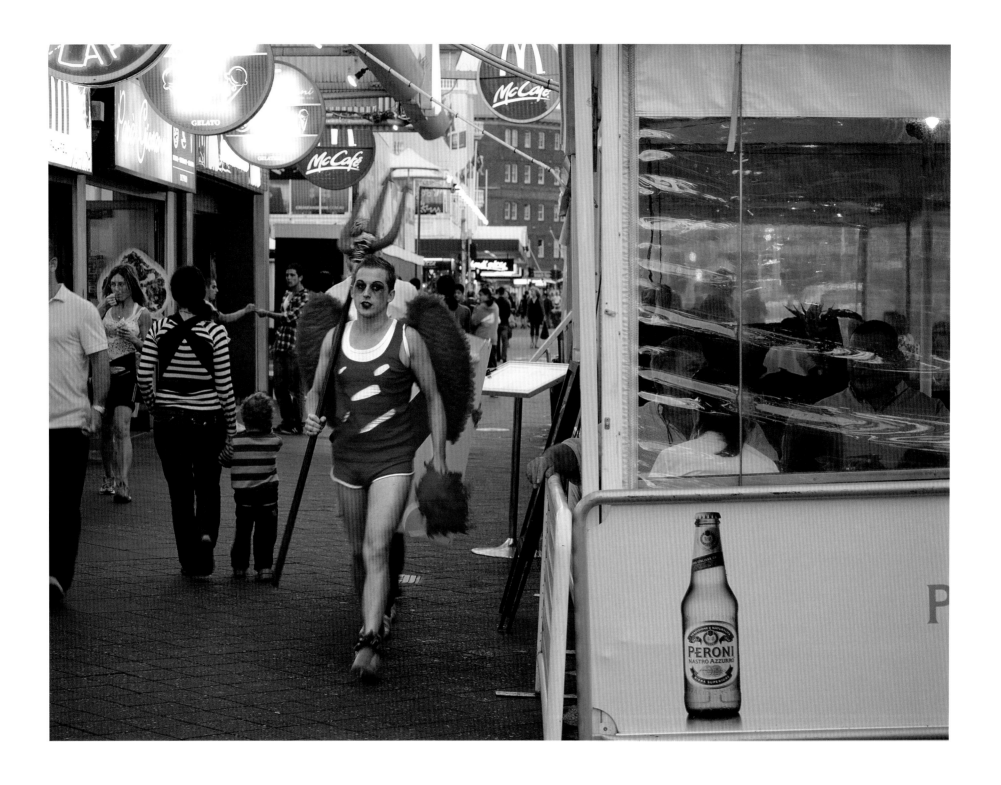

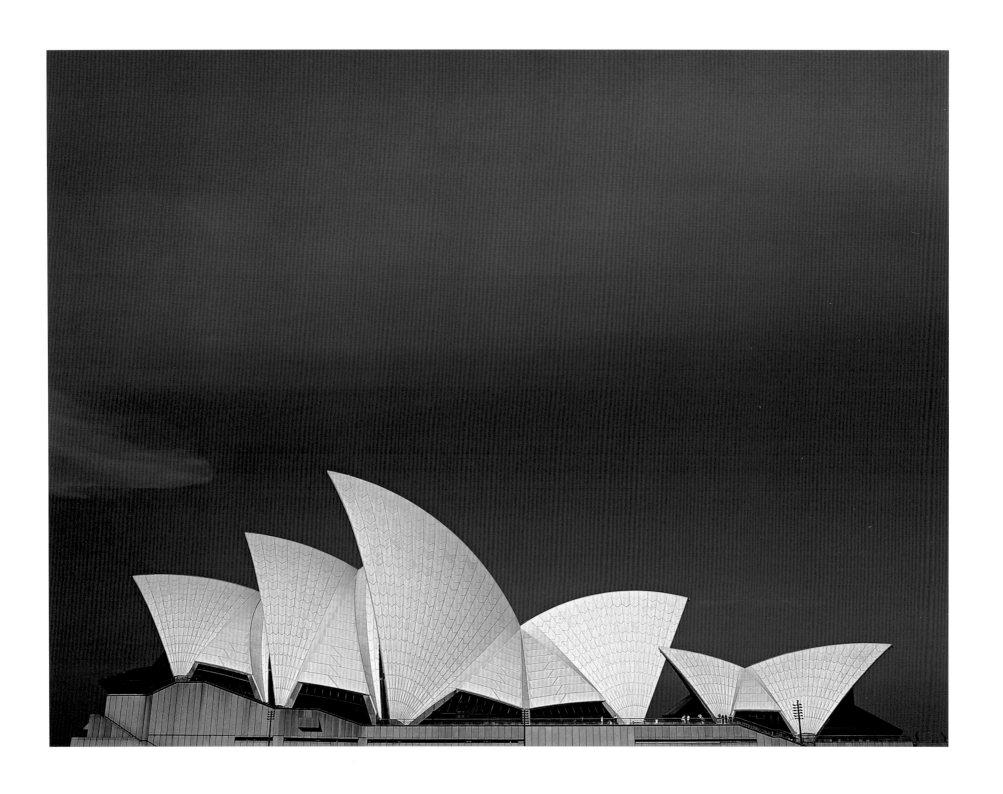

Ted Grambeau

Pure Opera House, Sydney, NSW

I shot this from a ferry just prior to docking, slightly underexposing the photo to enrich the deep blue sky and to give good highlight detail in the Opera House roof. I was basically looking for a way to utilise the graphic nature of the roof-line. It only seemed to work when the ferry gave just the right alignment for the scene. Then, by cropping out all the extraneous parts of the image, it became, for a brief moment, "pure Opera House".

Camera: Lumix DMC-G1 **Aperture:** f14
Shutter speed: 1/320 **ISO:** 160

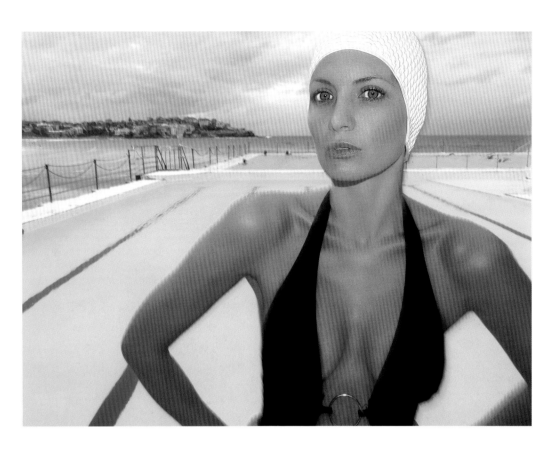

Ted Grambeau

Style and fashion at Icebergs, Bondi, NSW

Camera: Lumix DMC-G1 **Aperture:** f20
Shutter speed: 1/4 **ISO:** 100

Ted Grambeau

Pop art at the Blue Hotel, Woolloomooloo, NSW

Camera: Lumix DMC-G1 **Aperture:** f4
Shutter speed: 1/15 **ISO:** 800

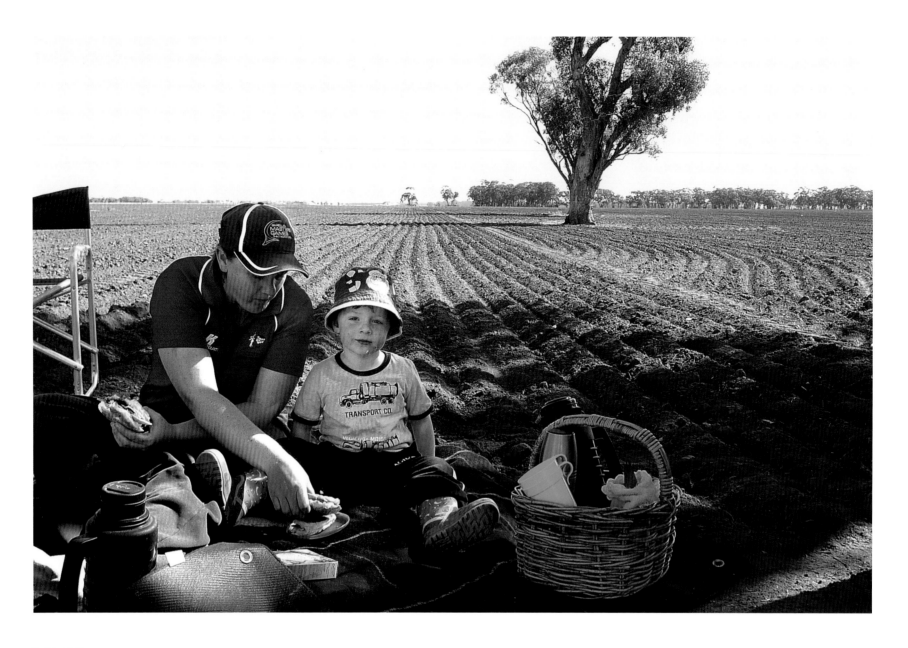

Robin Tiffen
Out in the field, Barellan, NSW

Picnic lunches with Dad are the order of the day when sowing of
the wheat is under way.

Camera: Lumix DMC-LX3 **Aperture:** f2.8 **Shutter speed:** 1/320 **ISO:** 80

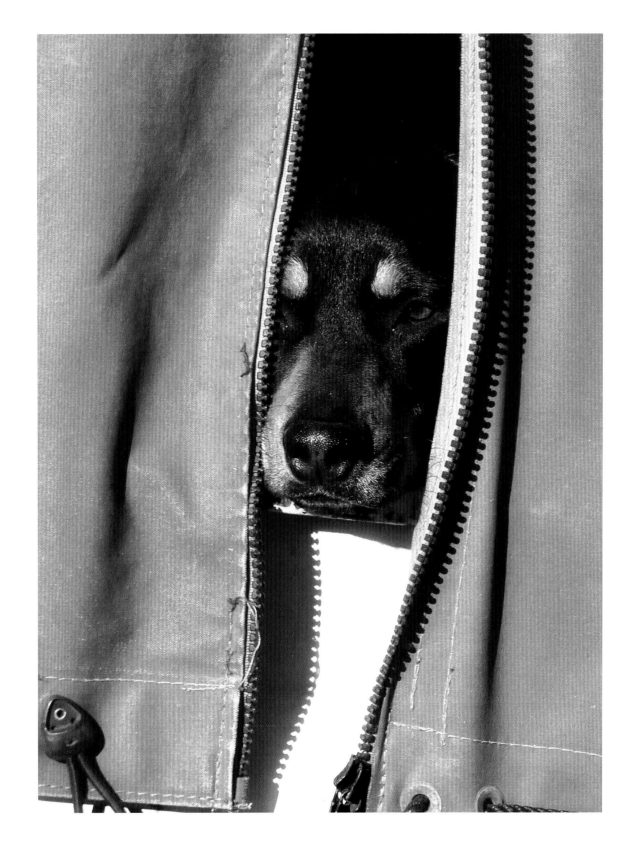

Sue Quinn

"Let's get going", Exmouth, WA

Spotted on the North West Coastal Highway, this dog was anxiously awaiting the return of his owner so they could continue on their travels!

Camera: Lumix DMC-TZ6 **Aperture:** f4.6
Shutter speed: 1/250 **ISO:** 80

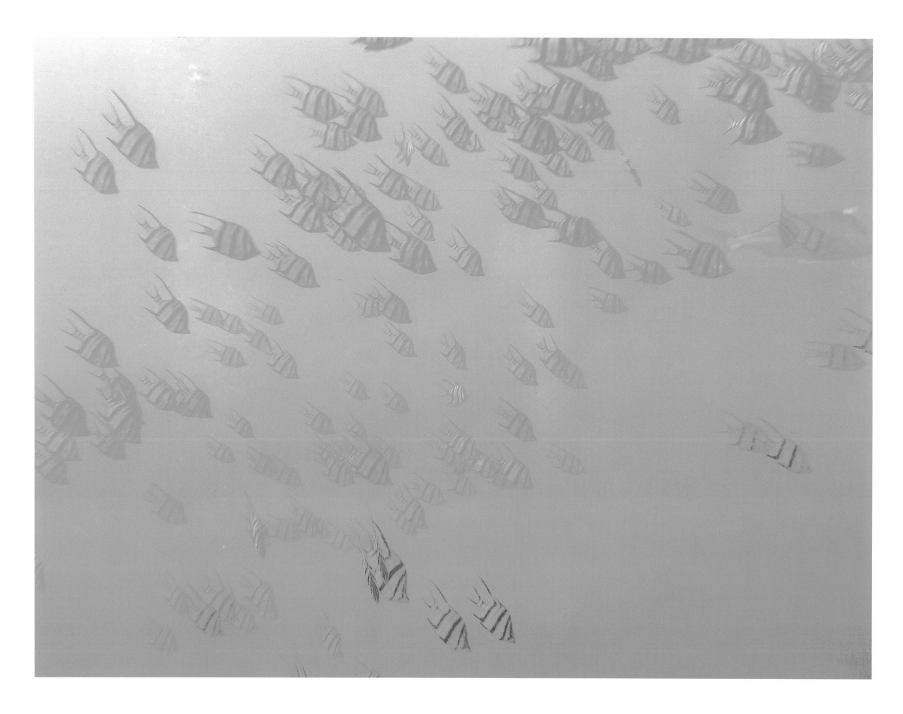

Katie Phelan
School of old wives, Nelson Bay, Port Stephens, NSW

Camera: Lumix DMC-TZ7 **Aperture:** f3.3 **Shutter speed:** 1/30 **ISO:** 1250

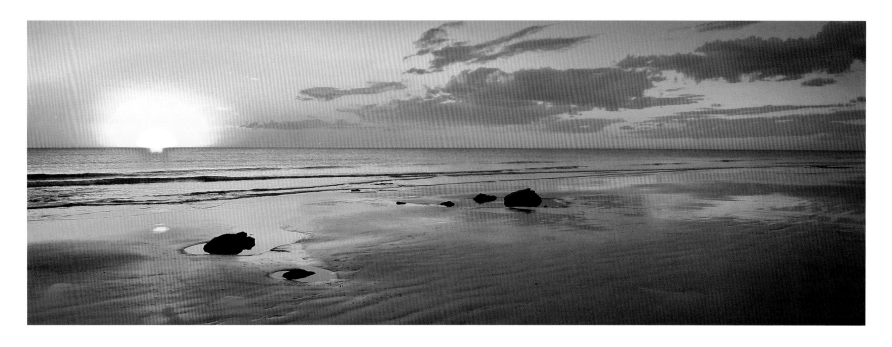

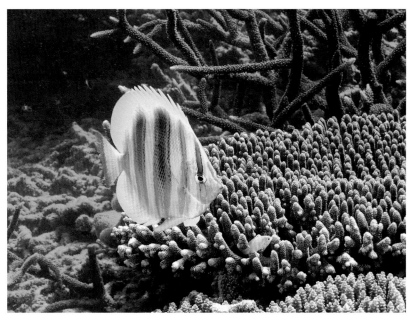

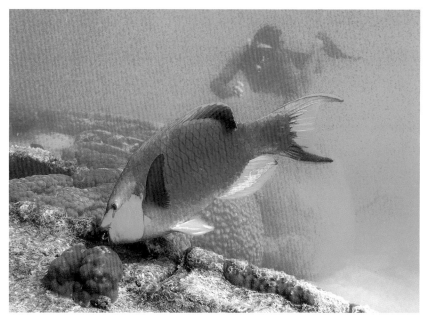

Susmita Thomson
Sunset, Cable Beach, Broome, WA

Camera: Lumix DMC-LX3 **Aperture:** f3.2 **Shutter speed:** 1/200 **ISO:** 80

Troy Mayne
Rainfords Butterflyfish, Moore Reef, Great Barrier Reef, Qld

Camera: Lumix DMC-ZR1 **Aperture:** f4.9 **Shutter speed:** 1/160 **ISO:** 100

Peter Burns
Blue Parrotfish, Turquoise Bay, WA

At Turquoise Bay (a part of Cape Range National Park) Denis Andrews keeps me company while I photograph a beautiful Blue Parrotfish during this fantastic snorkel drift. Many people come to swim in these protected waters, where the fish, turtles and even sharks are not shy and are often very friendly. These colourful creatures of the sea allowed me to get up close and personal for a truly magical experience.

Camera: Lumix DMC-FT2 **Aperture:** f3.3 **Shutter speed:** 1/125 **ISO:** 80

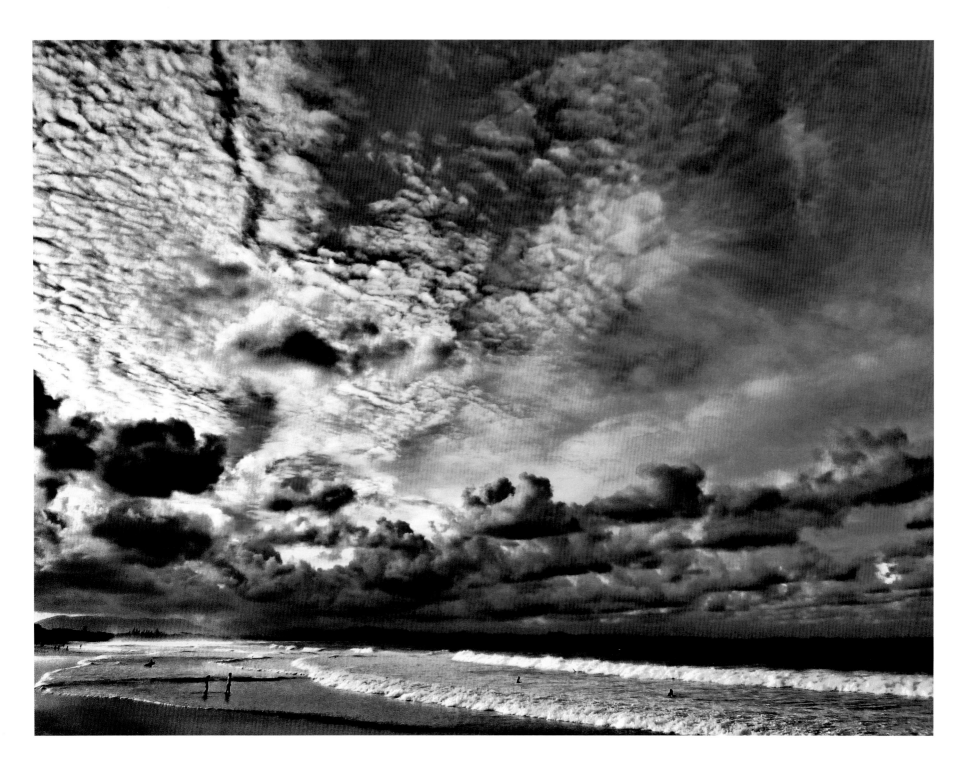

Lyndsey Hughes
Fluffy clouds, Byron Bay, NSW

Camera: Lumix DMC-FX38 **Aperture:** f6.3 **Shutter speed:** 1/640 **ISO:** 160

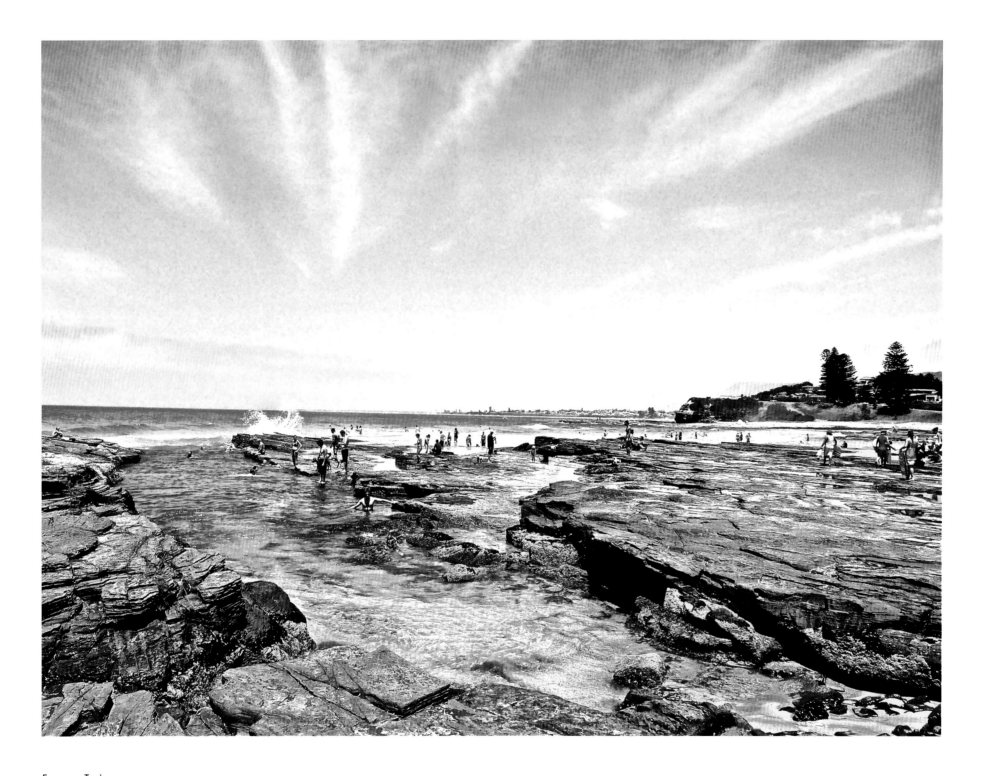

Frances Tyrie
Austinmer Beach, NSW

The beach is where we meet on equal ground. The light draws us,
and pretence falls away with a good wave.

Camera: Lumix DMC-TZ7 **Aperture:** f5.6 **Shutter speed:** 1/640 **ISO:** 80

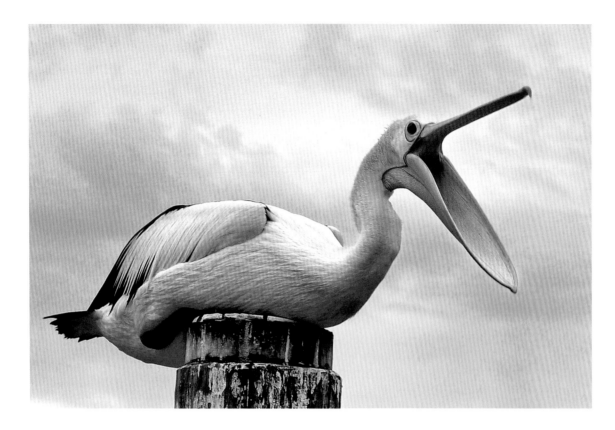

Nadya Zviaguina
Pelican, Myall Lake, NSW

Camera: Lumix DMC-LX3 **Aperture:** f4
Shutter speed: 1/1000 **ISO:** 125

Christine Wittig-Silva
Young fur seal, Portarlington, Vic

Relax and "easy does it" – this young seal at Portarlington Pier
was practising the true Aussie lifestyle!

Camera: Lumix DMC-G1 **Aperture:** f4.8
Shutter speed: 1/320 **ISO:** 100

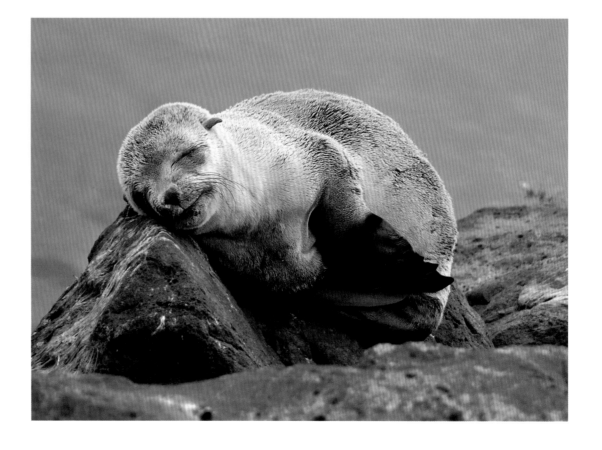

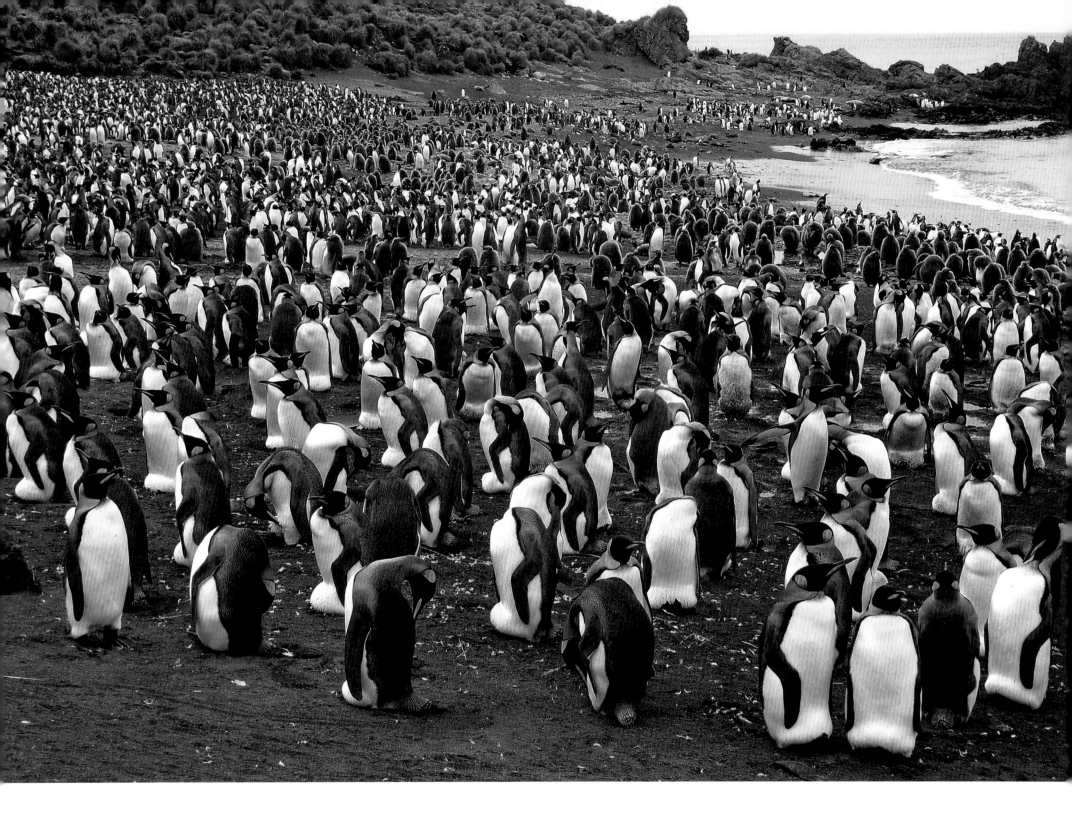

Michael Taylor

King Penguins, Macquarie Island, Tas

This shot of the King Penguin rookery at Sandy Bay shows the immature
"oakum-boys" interspersed with the adults. Some of the adults are still
carrying eggs on their feet, under the little fold on their bellies.

Camera: Lumix DMC-TZ7 **Aperture:** f4.5 **Shutter speed:** 1/320 **ISO:** 100

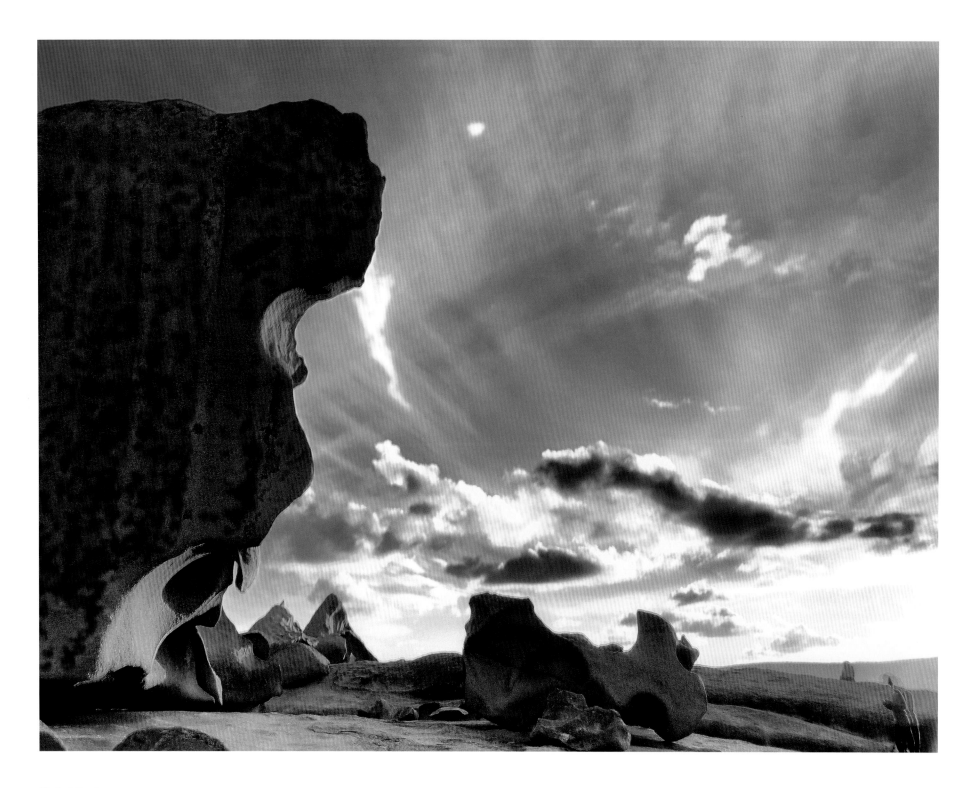

Michel Kettler

Remarkable Rocks, Weirs Cove, Kangaroo Island, SA

The combined forces of wind, rain and spray shaped these wonderful rock
formations over a period estimated at 500 million years.

Camera: Lumix DMC-FZ35 **Aperture:** f4.5 **Shutter speed:** 1/20 **ISO:** 80

Brooke Andrew
Meandering, Wyndham, WA

Camera: Lumix DMC-TZ10 **Aperture:** f4 **Shutter speed:** 1/500 **ISO:** 80

Paul Hyndes
Cracked mud, late dry season, Parry Lagoons, WA

Camera: Lumix DMC-FT1 **Aperture:** f3.3 **Shutter speed:** 1/320 **ISO:** 80

Michel Kettler
Morning dew, Centennial Park, Sydney, NSW

Camera: Lumix DMC-FZ8 **Aperture:** f4 **Shutter speed:** 1/200 **ISO:** 100

Colin Seton
Crowd mosaic, 2010 World Cup, Darling Harbour, NSW

Camera: Lumix DMC-LX3 **Aperture:** f2.8 **Shutter speed:** 2.5 seconds **ISO:** 80

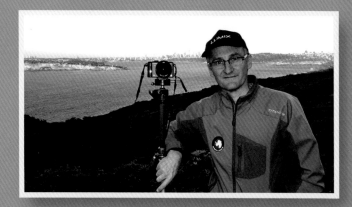

Peter Eastway

Peter Eastway has worked in most areas of professional photography, but his passion is for landscapes. His work is so respected that Lonely Planet chose him to write their international photography guide book on landscape photography. He has won many awards. In 1996 and 1998 he was the AIPP Australian Professional Photographer of the Year. He was Australian Landscape Photographer of the Year in 1995, 1996 and 1998, Australian Illustrative Photographer of the Year in 2004, and NSW Professional Photographer of the Year in 1995, 1996, 2004 and 2010. Peter is also a Grand Master of Photography, one of only a handful in the world.

www.petereastway.com

Some tips from Peter

Shooting panorama photographs

Shooting panoramas can be a lot of fun. It gives you another way to look at the world. Of course, the easiest way to make a panorama is to crop the top and bottom off any of your photographs. "Panorama" refers to the format of the photograph, meaning a long low rectangle – or a tall narrow one as verticals are also permissable!

Most people, however, think of stitching several frames together to create a panorama. There are lots of software programs that will stitch your photographs together for you, but you'll get better results if you do a few things to help the software too. First, if you can set your camera to manual focus, manual exposure and manual white balance, you can be sure of maintaining the same focus, exposure and colour balance for all of the frames. Second, if you have a tripod with a panoramic head, you can make the alignment process a lot more accurate. Finally, make sure you overlap your photos by at least thirty percent. With wide-angle lenses, I overlap by fifty percent. It might take a few extra frames, but the results can be well worth it.

When you get your images back home, open them in your favourite image processing software and look for something like "photo merge" or "panorama maker". You'll need to select the files you want to stitch together, but after that everything is automatic. At the end, your panorama might have irregular edges, so use the crop tool to tidy things up with straight edges. The resulting file will be larger than normal, but you'll also be able to make larger prints with excellent quality

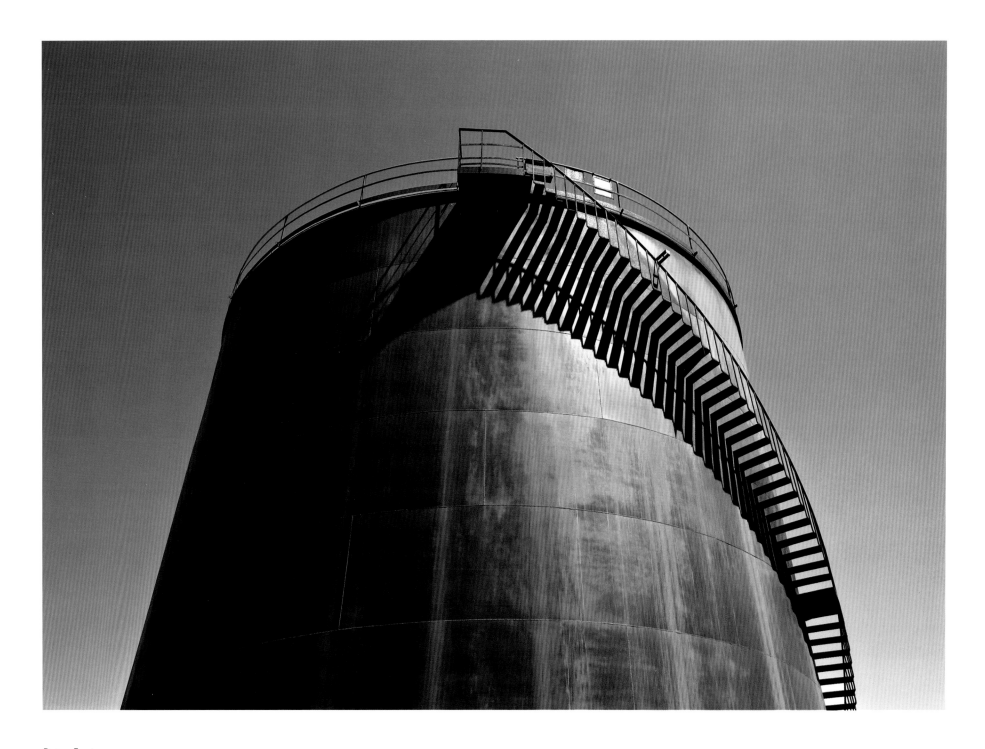

Peter Eastway

Storage tank, main road into Port Hedland, WA

The wonderful thing about photographing tanks is the play of light.
Simply by walking around a tank at any time of day, you can find light and
shade, and if you're lucky, you may find that the ladder running up the side
throws some amazing shadows to photograph.

Camera: Lumix DMC-GH1 **Aperture:** f7.1 **Shutter speed:** 1/200 **ISO:** 100

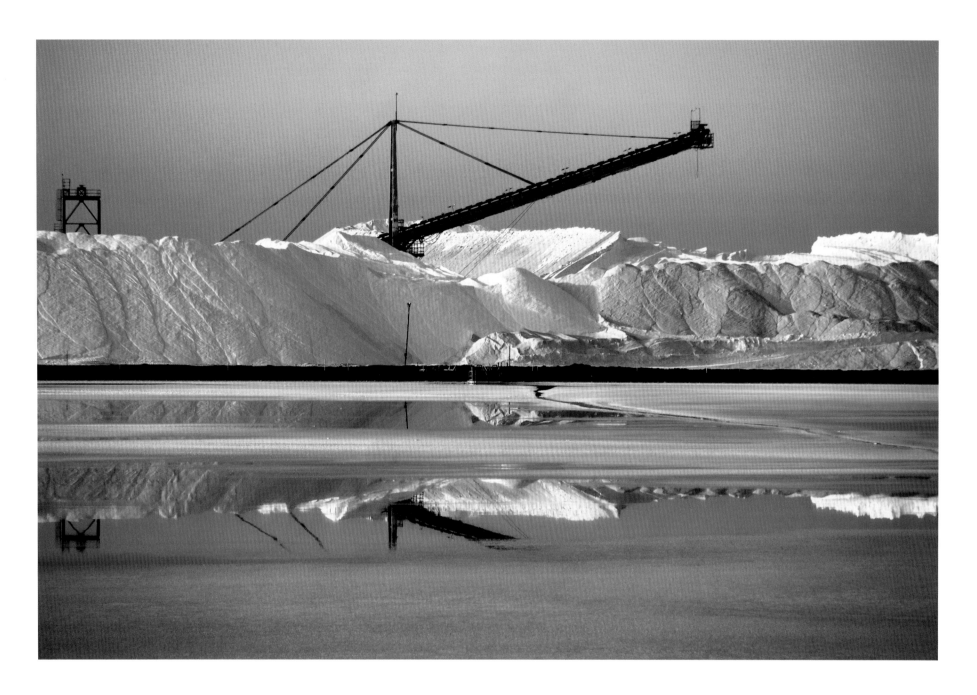

Peter Eastway

A large conveyor belt towers over mountains of salt, Port Hedland, WA

This salt "mine" at Port Hedland is operated by Rio Tinto Minerals through its company Damier Salt Limited. The operation comprises a series of large lakes draining into smaller ponds which eventually evaporate to leave salt. The salt is then scooped up and stockpiled within sight of the main Port Hedland road. This image was taken in the early morning and looks across a near-empty salt pond, producing a reflection of the conveyor arm.

Camera: Lumix DMC-GH1 **Aperture:** f9.0 **Shutter speed:** 1/250 **ISO:** 125

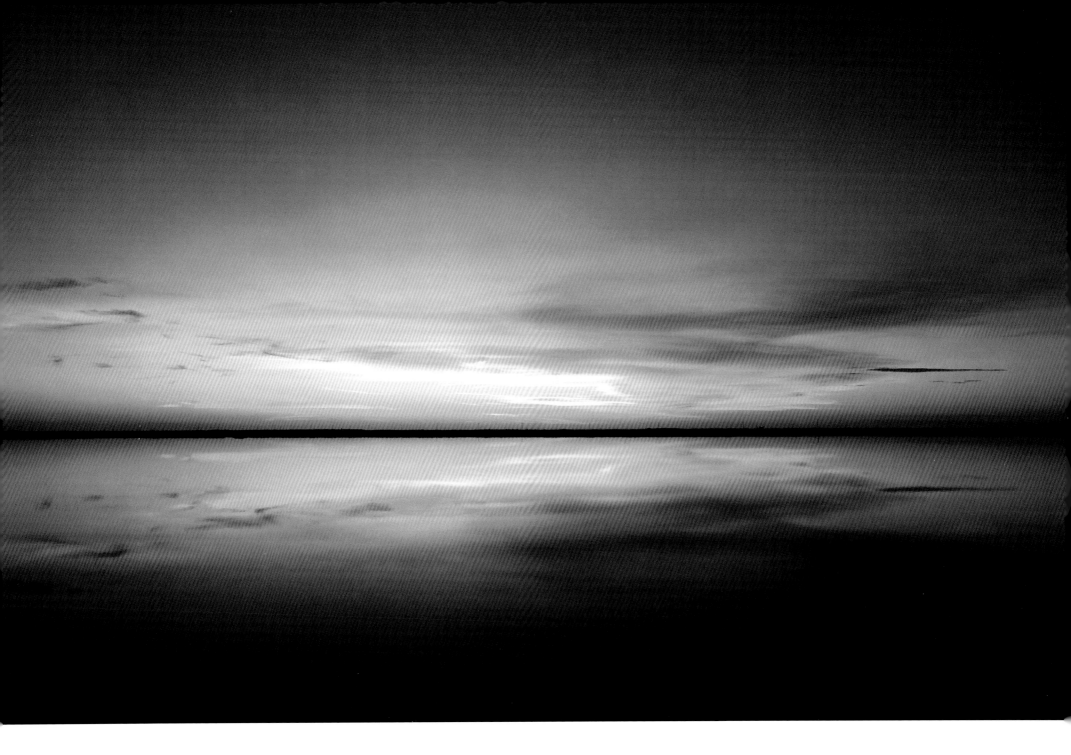

Peter Eastway

Pre-dawn light over a salt pond, Port Hedland, WA

My aim was to photograph the white salt stockpiles as the sun rose,
so I arrived at my destination well before dawn. As I dragged my cameras
and tripod from the car, I remembered that it always pays to look around.
Sure enough, behind the car I discovered the perfectly still waters of a
salt pond, reflecting a magnificent sunrise. Suffice to say my first shots
were made exploring this remarkable horizon.

Camera: Lumix DMC-GH1 **Aperture:** f11 **Shutter speed:** 1/30 **ISO:** 320

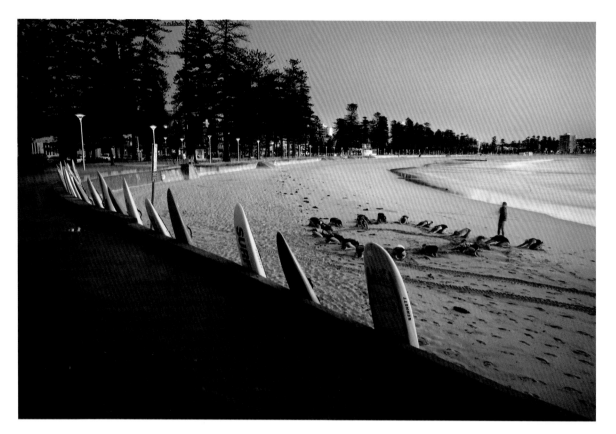

Peter Eastway

Warming up, Manly Beach, NSW

Some locations are deserted at dawn, but not Manly Beach. Manly, on the surf side at least, comes alive at dawn. Well before the sun rose, this group of paddlers was warming up on the sand, their surf rescue boards lined up against the sea wall. A few minutes later, as the first rays of sunshine kissed the small waves, the group was racing out to sea for a quick paddle around the headland and across to Fairy Bower. Although it doesn't look it, it was quite dark when this photo was taken and you can see the street lights are still shining!

Camera: Lumix DMC-GF1 **Aperture:** f8.0
Shutter speed: 2.5 seconds **ISO:** 100

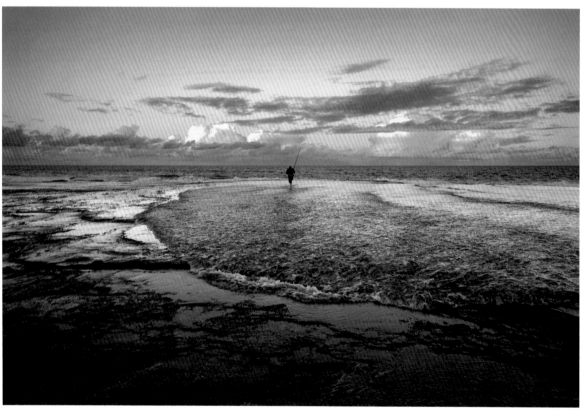

Peter Eastway

Fisherman, Mona Vale rock shelf, NSW

Camera: Lumix DMC-GF1 **Aperture:** f7.1
Shutter speed: 1/50 **ISO:** 100

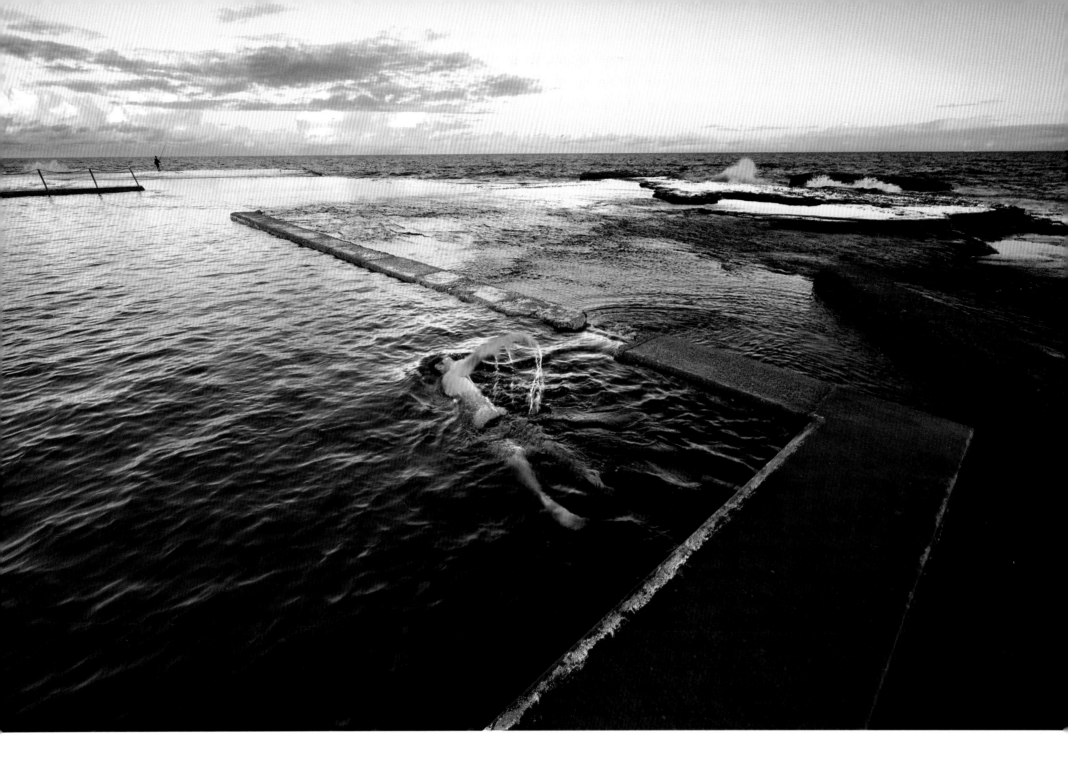

Peter Eastway

Swimmer, Mona Vale rock pool, NSW

There are some amazing rock pools around Australia's coastline, and none is more picturesque than the pool at Mona Vale, sitting at the end of a finger of sand and protected by a low, seaweed-covered rock shelf. It's late in the afternoon and this swimmer was finishing his laps as the tide washed over the pool's low walls.

Camera: Lumix DMC-GF1 **Aperture:** f8 **Shutter speed:** 1/40 **ISO:** 100

Peter Eastway
Tree outside Marble Bar, WA

The Pilbara in north-west Australia is a remarkable land. In the wet season, it is hot and sticky, while in the dry you can wait weeks just to see a cloud. Marble Bar is known as the hottest town in Australia and on our trip it certainly lived up to its name. It was so hot that some of the roadside orange witches hats had melted! This image was taken at dawn before the heat set in. A series of six images was taken and stitched together to create a panoramic format, with the golden light provided by nature.

Camera: Lumix DMC-GF1
Aperture: f8 **Shutter speed:** 1/40
ISO: 100

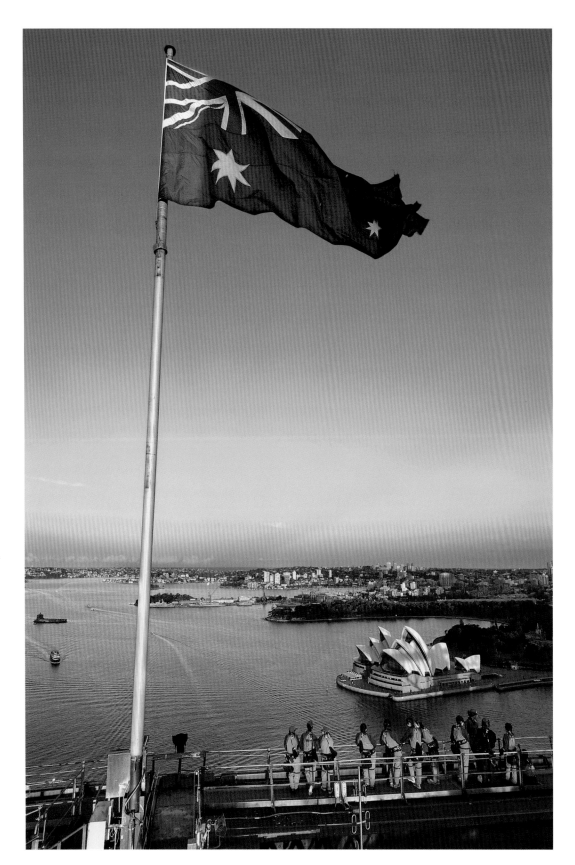

James Morgan

View from the top, Sydney Harbour Bridge, NSW

Opened on March 19th 1932, the Sydney Harbour Bridge offers amazing views of our city and harbour, especially when you're standing on the tip of it!

Camera: Lumix DMC-GH1 **Aperture:** f5
Shutter speed: 1/160 **ISO:** 125

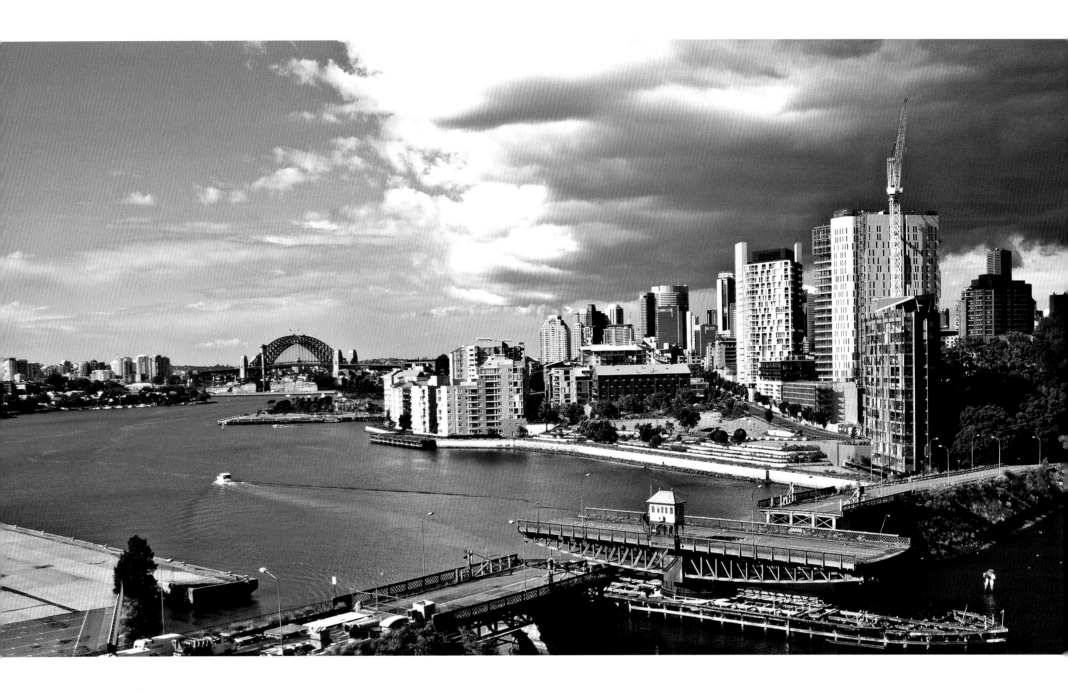

John Sharp
Harbour sky, Sydney, NSW

Having come from deep in the Southern Ocean, a cold front sweeps across
the suburb of Pyrmont in Sydney, before heading into the vast Pacific. Its rain will
wash the city and make the air crystal clear. Once, this area was a source of food and
shelter for the local Aboriginal tribes. Later it became a site where the first European
settlers quarried sandstone for many of the city's finest buildings. Then it became an
industrial site. Now it is an expensive dormitory suburb close to the city's centre.

Camera: Lumix DMC-LX2 **Aperture:** f8 **Shutter speed:** 1/200 **ISO:** 100

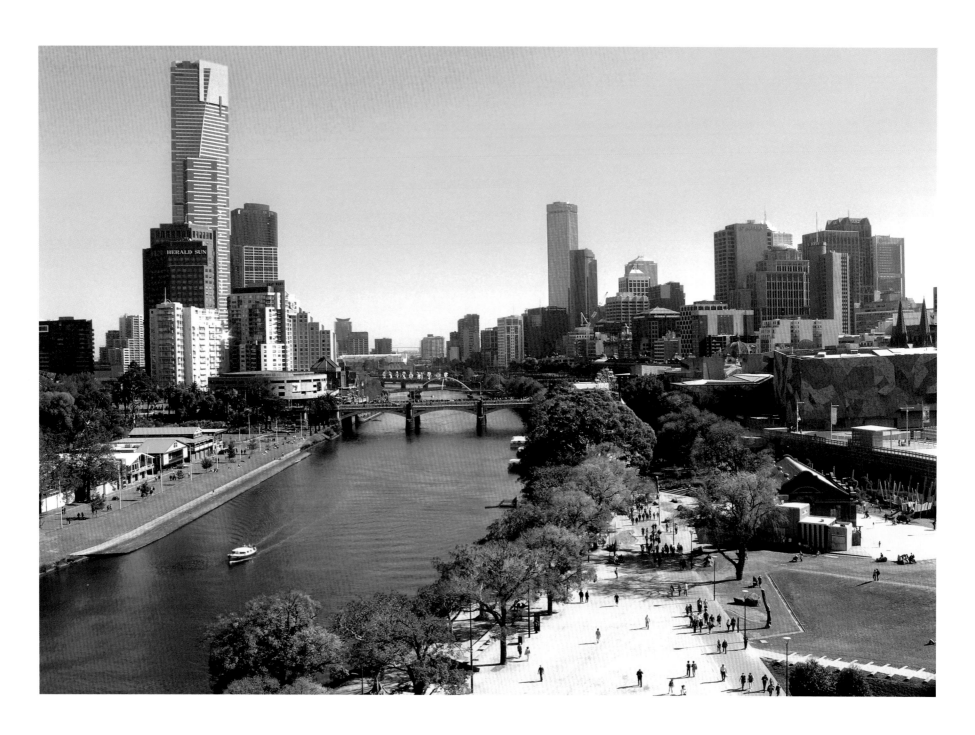

Graeme Edwards

Cityscape, Melbourne, Vic

Camera: Lumix DMC-FZ30 **Aperture:** f5.6 **Shutter speed:** 1/125 **ISO:** 100

Colin Seton
Morning exercise, Melbourne, Vic

An early morning rower relaxes into the stroke on the Yarra River, which runs through the heart of the CBD.

Camera: Lumix DMC-LX2 **Aperture:** f4
Shutter speed: 1/160 **ISO:** 100

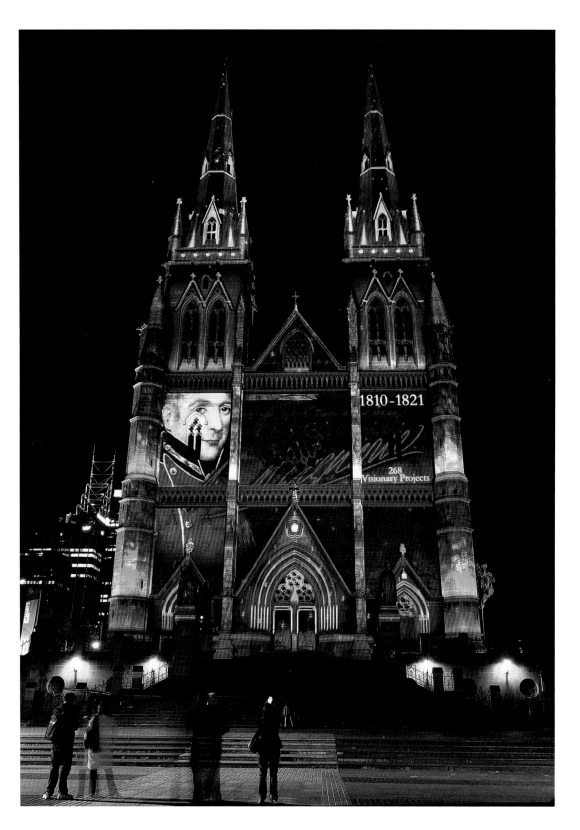

Janette Taylor
St Mary's Cathedral, Sydney, NSW

The strong colours reflected on this well-known beautiful church appealed to me. The head is that of Governor Lachlan Macquarie.

Camera: Lumix DMC-TZ3 **Aperture:** f3.4
Shutter speed: 5 seconds **ISO:** 100

opposite

Alexandra Badarau
Luna Park, Sydney, NSW

The smiling face of Luna Park beaming across the harbour – quintessential Sydney!

Camera: Lumix DMC-FT2 **Aperture:** f3.5
Shutter speed: 1/13 **ISO:** 400

Lan Nguyen
Artwork "Solar Equation", Federation Square, Melbourne, Vic

Camera: Lumix DMC-LX3 **Aperture:** f8
Shutter speed: 5 seconds **ISO:** 80

Lan Nguyen
Flinders Street Station, Melbourne, Vic

The iconic Flinders Street train station is photographed here during a cold and wet winter's night. The rain gave great reflections on the street.

Camera: Lumix DMC-LX3 **Aperture:** f4.5
Shutter speed: 3/5 **ISO:** 80

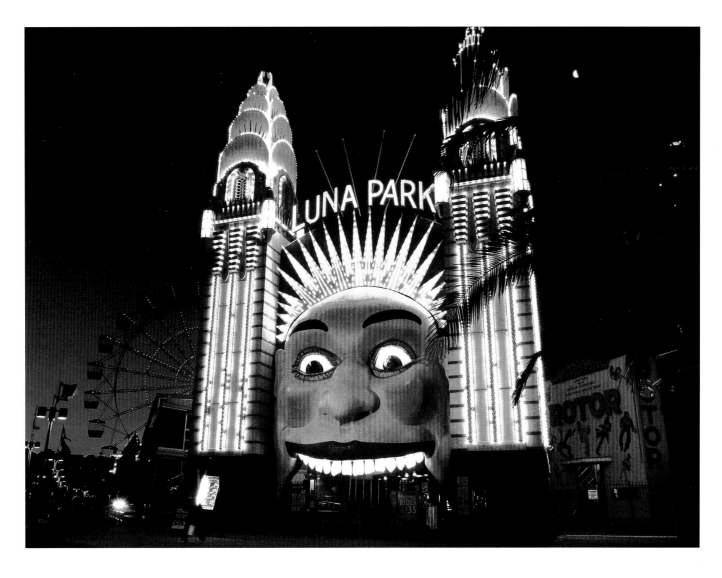

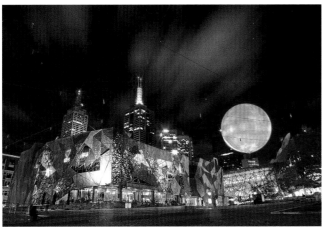

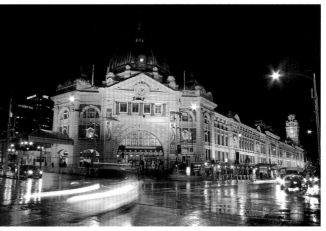

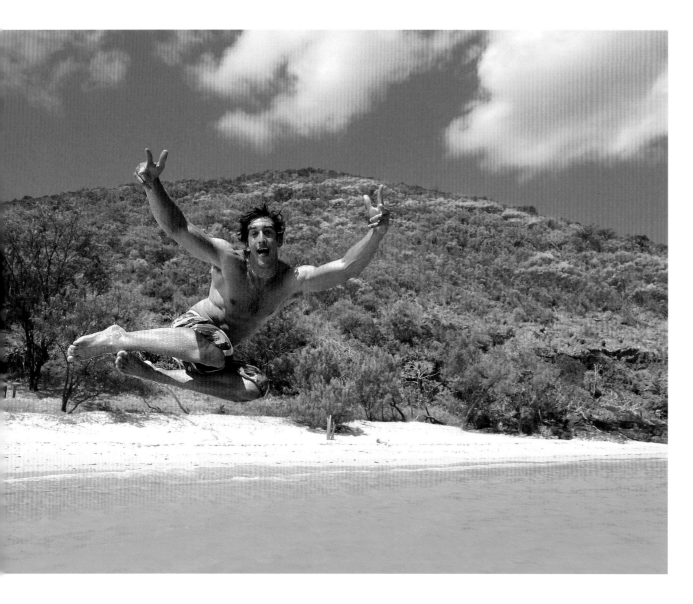

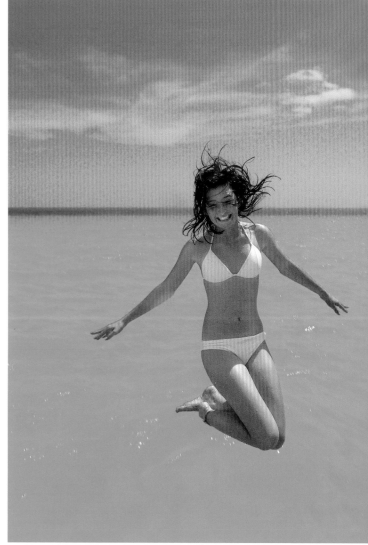

Patricia Gros-Dubois

The jump, Keswick Island, Qld

A fun jump off the boat in the Whitsundays!

Camera: Lumix DMC-TZ7 **Aperture:** f6.3
Shutter speed: 1/500 **ISO:** 80

Patricia Gros-Dubois

Flying, Keswick Island, Qld

Another leap. The beautiful clear waters made launching off the boat seem irresistible!

Camera: Lumix DMC-TZ7 **Aperture:** f5.6
Shutter speed: 1/800 **ISO:** 80

Marty Schoo

Katherine Gorge, Nitmiluk National Park, NT

A kayaker is dwarfed by the sheer cliffs of the beautiful Katherine Gorge.

Camera: Lumix DMC-FT1 **Aperture:** f3.3
Shutter speed: 1/640 **ISO:** 80

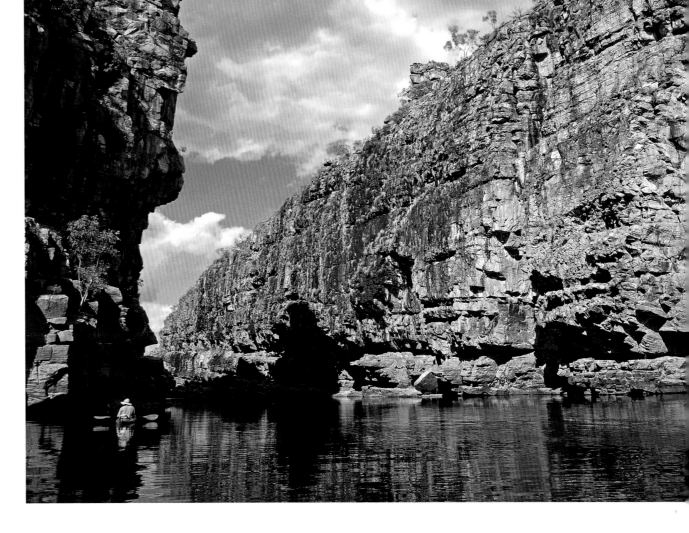

Karina Ardizzone

To the limit, Nissan Patrol, Lithgow, NSW

Here, on the Australia Day long weekend, a tough Nissan Patrol was pushed to its limits in the great Aussie bush.

Camera: Lumix DMC-TZ11 **Aperture:** f3.3
Shutter speed: 1/160 **ISO:** 100

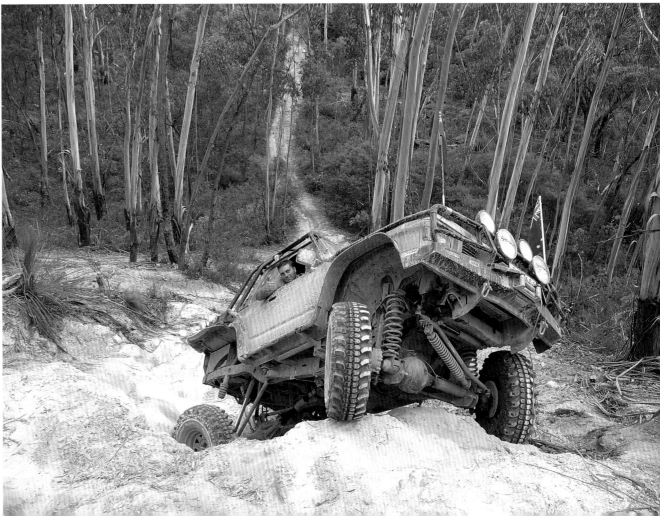

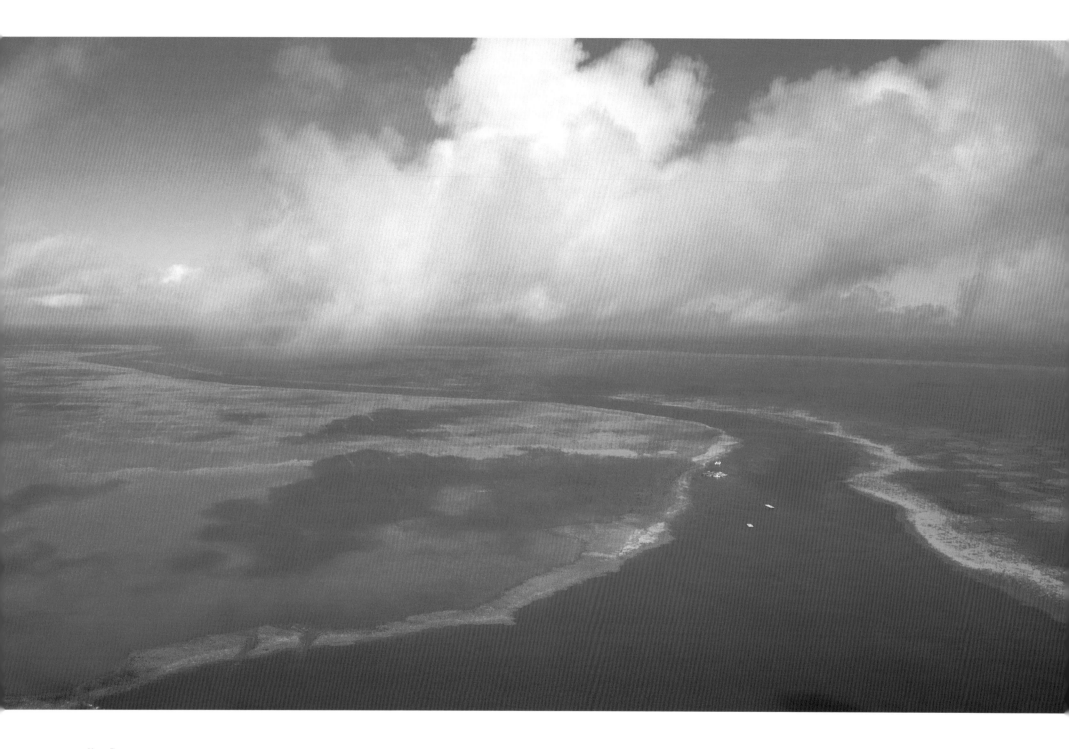

Ken Duncan

Hardy's Reef aerial, Qld

I clicked this scene while the helicopter was popping in and out of low-level clouds.
It shows an "ocean river" – a deep channel between two halves of the coral reef.

Camera: Lumix DMC-LX2 **Aperture:** f8 **Shutter speed:** 1/500 **ISO:** 100

Ken Duncan

Australia's *A Current Affair* has described Ken Duncan as "one of Australia's most iconic image makers". He has won numerous awards for his work, including the Photo Imaging Council of Australia's Gold Tripod award, an AIPP Honorary Fellowship, an Honorary member of the ACMP and a Medal of the Order of Australia (OAM). His photos have been published in leading magazines and in more than fifty books, and he is recognised as a pioneer and market leader for his spectacular framed Limited Edition Prints and other products. The very successful Ken Duncan Galleries in Erina, Sydney, Melbourne, Cairns and the Hunter Valley are the largest group of privately owned photographic galleries in Australia.

www.kenduncan.com

Some tips from Ken

Stop talking and start taking

One of the hardest parts of photography is getting out of bed. Yet those who do will be rewarded with some great shots. Be sure to get up for sunrises even if it's an overcast day, because the sun will often break through and give amazing light. Patience will be rewarded, but we need to get out there, and put in the hard yards.

Break the rules

Don't miss fleeting moments worrying about technical matters – click the shutter and grab the shot. The bottom line is: there are no rules. If an image works, it works; if it doesn't, it doesn't. At one of my exhibitions, a person with a doctorate in photography was looking at one of my shots and I could see she was puzzled. "I can't believe this!" she said to me (not knowing I was the photographer). "This guy has the horizon in the middle. It should be one-third sky, two-thirds foreground. But this really works!" So I replied, "Isn't it lucky he didn't know the rules, or this shot may never have happened!"

Create the third dimension

Photography is a two-dimensional medium, so we sometimes need to try and create a third dimension – especially in landscapes – to give depth to an image. Try using strong foreground interest, or utilise lines within a shot to draw the viewer in: a road, a fence or a curve of beach can work. Shooting from a higher vantage point is sometimes a good way to get better depth in a shot. I often take shots from the top of my car, or standing on my camera case.

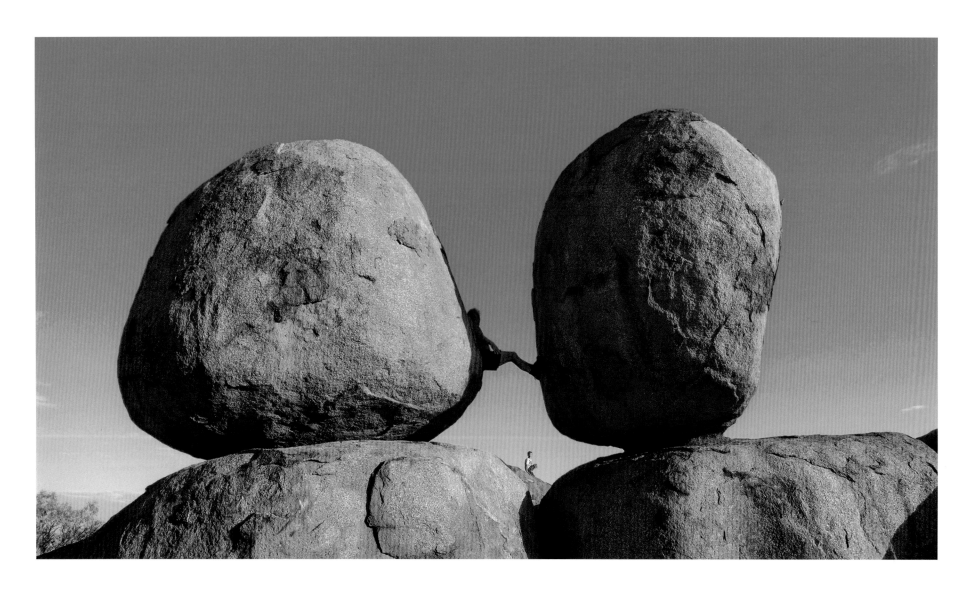

Ken Duncan

God's Marbles, near Wauchope, NT

I have been visiting the so-called Devil's Marbles over many years (and have been trying to get them renamed "God's Marbles" – in honour of their true creator – for almost as long!). On this recent visit, I arrived in the morning and I was alone. I was pondering how to convey a sense of scale for these wonderful desert boulders. All of a sudden some people arrived, adding the perfect subject matter to the scene. As the man wedged himself hard into the rock, I couldn't help but think: Now is not the time for the boulders to roll together and touch!

Camera: Lumix DMC-LX3 **Aperture:** f4 **Shutter speed:** 1/500 **ISO:** 80

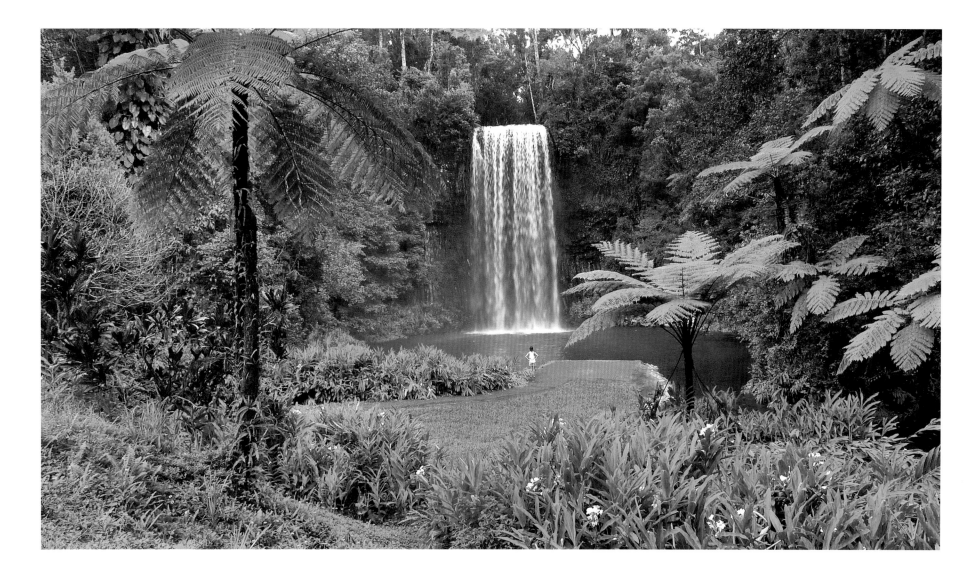

Ken Duncan

Millaa Millaa Falls, Atherton Tablelands, Qld

I had been sitting here for ages with my large-format camera, waiting for the leaves of the fern trees to stop dancing. It's a common problem at waterfalls, for cascades cause an almost continual air-flow. Suddenly a young lady ran into the falls, providing a wonderful sense of scale. There was no way I could snap the moment with my large film camera. So I quickly pulled out my compact Lumix LX3 and took this shot. It seemed ridiculous that I could achieve such quality in a mini-second after having waited for so long with my big professional set-up!

Camera: Lumix DMC-LX3 **Aperture:** f5 **Shutter speed:** 1/30 **ISO:** 200

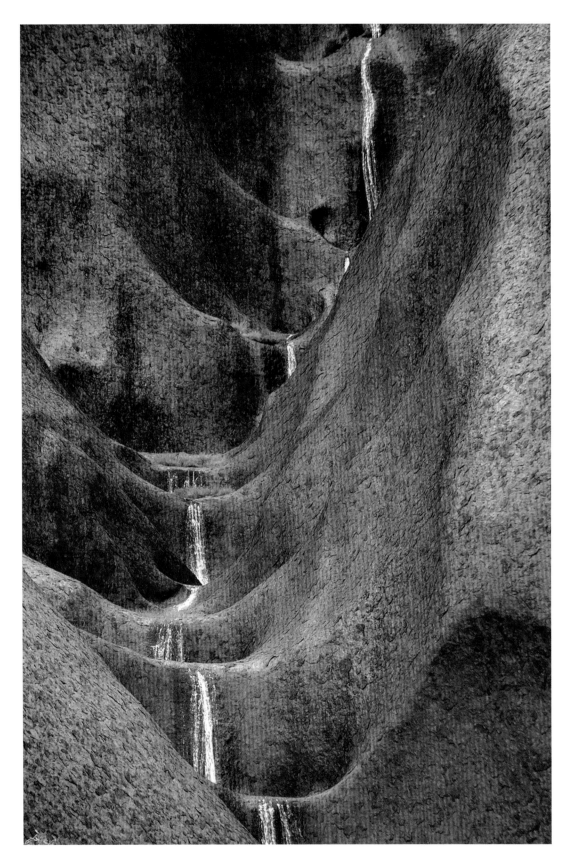

Ken Duncan
Waterfall, Uluru, NT

On the day I took this photo I was just a tourist, visiting Uluru with an international friend of mine. How blessed we were when it began to rain and we saw water cascading down the rock-slope. Fortunately I had my little Lumix GF1 on me, with a zoom lens. I took a shot and it worked out beautifully: a wonderfully shaped portrait of trickling water and curved stone. Often we try to shoot only "big" pictures, with large vistas and far-off skies. But this photo reminded me that some of the most satisfying shots simply isolate a single detail.

Camera: Lumix DMC-GF1 **Aperture:** f5.8 **Shutter speed:** 1/50 **ISO:** 100

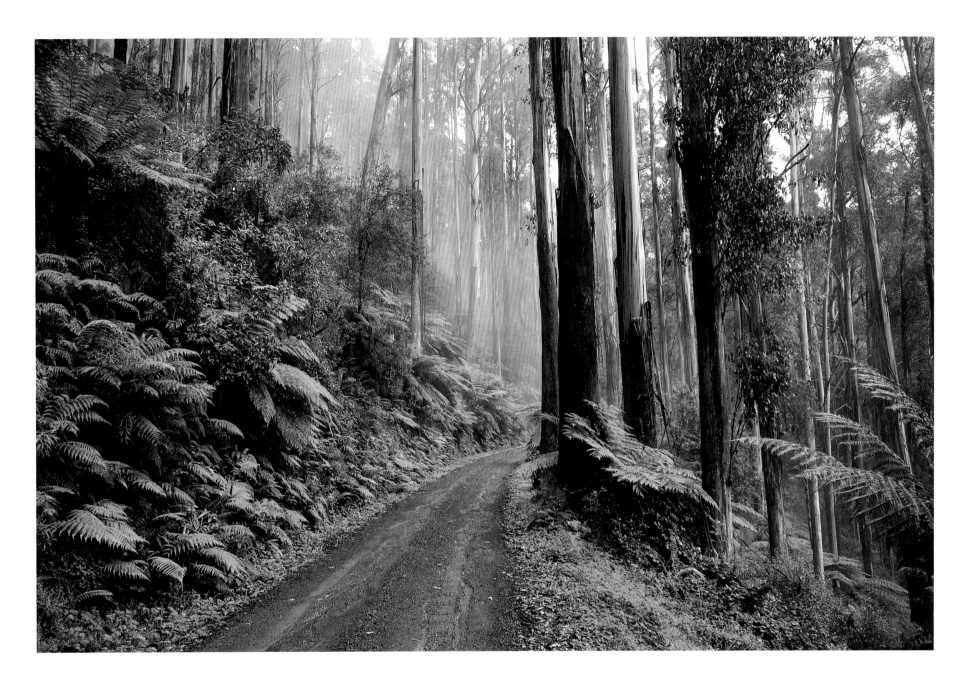

Ken Duncan

Yarra Ranges National Park, near Healesville, Vic

I had travelled through vast areas devastated by the Black Saturday bush-
fires before I came across this beautiful section of forest on a back road. It
had somehow escaped the ravages of the fire. I photographed it in light rain
with a lovely rising mist, a fitting tribute to the beauty that once extended
across the whole region.

Camera: Lumix DMC-GF1 **Aperture:** f4 **Shutter speed:** 1/60 **ISO:** 200

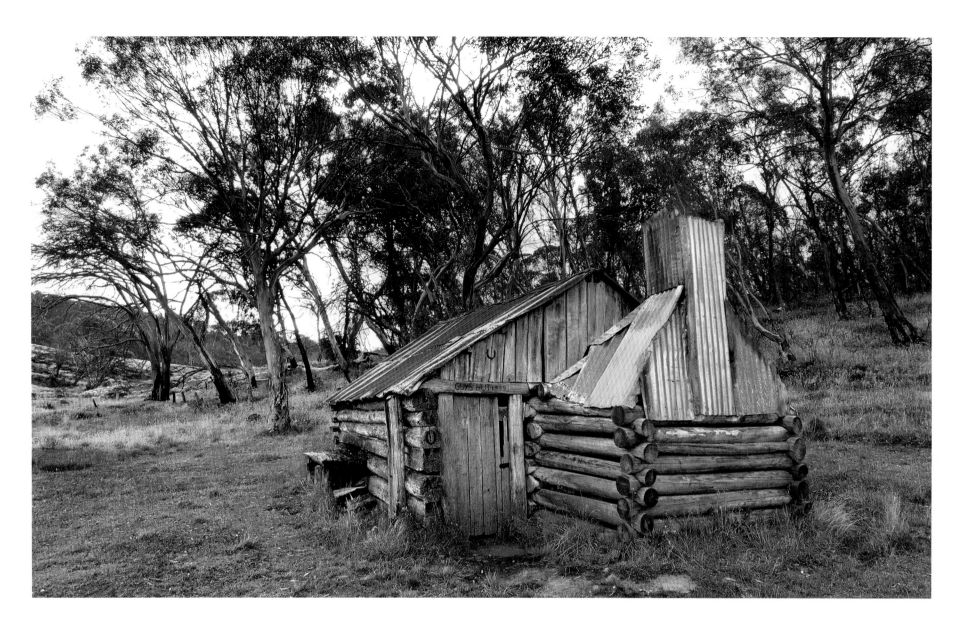

Ken Duncan

Guys Hut, Alpine National Park, near Licola, Vic

This late afternoon shot shows a classic high country cattleman's shelter constructed by Alex Guy in 1940. The tragedy of this hut – and so many other huts like it – lies in the fact that the modern-day cattlemen are now locked out of these areas by National Parks authorities. It seems a terrible irony that such tough, resilient characters have been finally defeated by mere bureaucrats. It is my hope that these great heroes will one day ride again in the mountains they have made so famous.

Camera: Lumix DMC-LX3 **Aperture:** f3.2 **Shutter speed:** 1/400 **ISO:** 125

Ken Duncan

Ken Connley and horse, Benambra Pub, Vic

Ken Connley is one of the legendary high country cattlemen. On the day of this photograph, I had been shooting him and some of his mates mustering brumbies. That evening, we decided to go to the local for a beer, and I jokingly suggested to Ken that he take his horse. Just for a lark, he did. He rode it straight in, and I got this classic shot. We probably broke a bunch of health and safety regulations doing it, but it was certainly fun! The horse did not have a drink.

Camera: Lumix DMC-LX3 **Aperture:** f2 **Shutter speed:** 1/30 **ISO:** 320

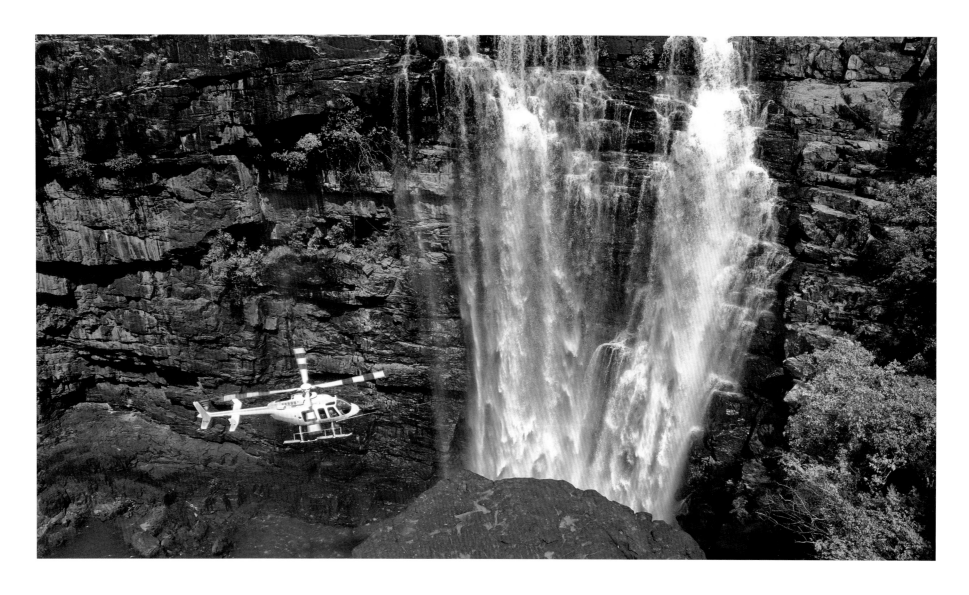

Ken Duncan

Murchison Falls, The Kimberley, WA

At the close of the wet season, it is impossible to access much of the
Kimberley except by helicopter (the roads are all blocked by the swollen
rivers). I was dropped into this location by a pilot who arranged to pick
me up later. There I was, clicking away. Some time afterwards I heard
the chopper, but couldn't tell where it was approaching from. Suddenly it
appeared from low in the gorge and ascended right in my face. With my
little Lumix, I was able to capture this moment: a wonderful waterfall,
and a helicopter dwarfed by nature's sheer magnificence.

Camera: Lumix DMC-LX2 **Aperture:** f5.6 **Shutter speed:** 1/400 **ISO:** 100

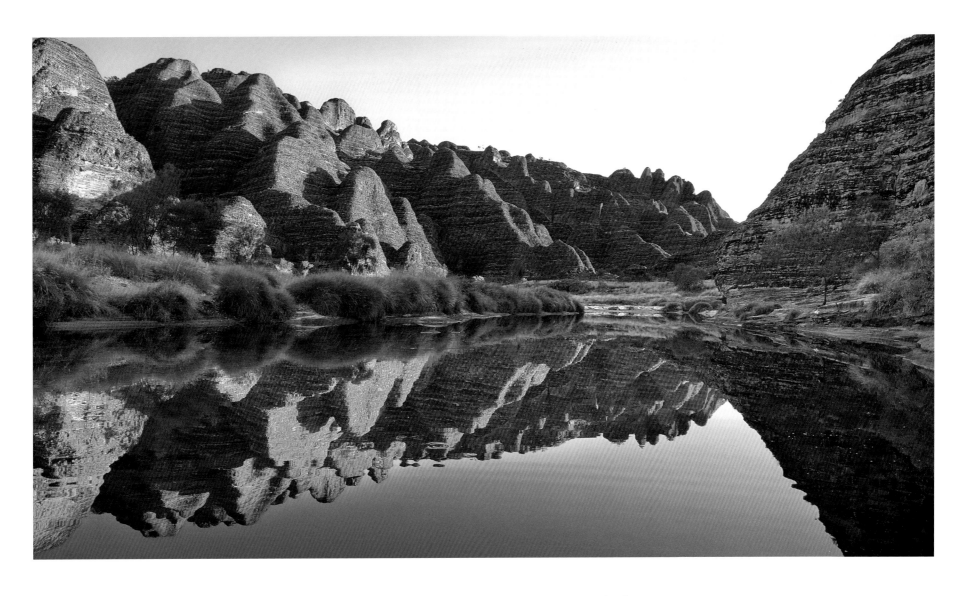

Ken Duncan

Piccaninny Creek, Purnululu National Park, WA

The best time to see this area is straight after the wet season, as soon as the roads are dry enough to let vehicles through. In a good year, there are wonderful pools to catch the reflections of the rock-forms. I was one of the first to arrive in this particular season, and in this shot I managed to capture the fantastic rich domes at sunrise, reflected in a large fore-ground pool. The extremely wide angle lens of my Lumix gave an incredible depth of field even at a wide aperture. Everything necessary was in focus, allowing me to make the most of the kaleidoscope-like symmetry.

Camera: Lumix DMC-LX3 **Aperture:** f3.2 **Shutter speed:** 1/100 **ISO:** 100

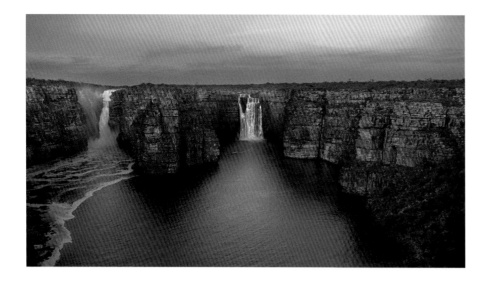

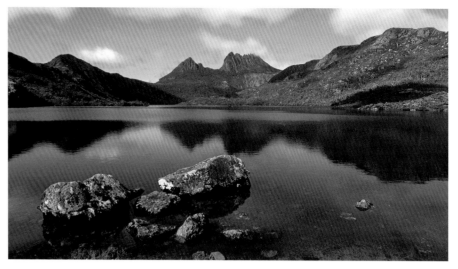

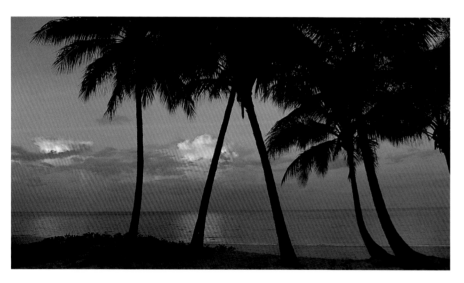

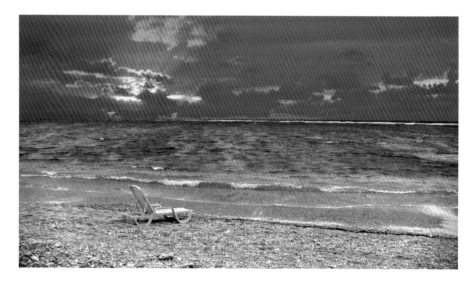

Ken Duncan

Sunrise, King George Falls, The Kimberley, WA

Camera: Lumix DMC-LX3 **Aperture:** f2.8 **Shutter speed:** 1/30 **ISO:** 125

Ken Duncan

Sunset, Ellis Beach, Qld

Camera: DMC-LX3 **Aperture:** f2 **Shutter speed:** 1/80 **ISO:** 80

Ken Duncan

Dove Lake, Cradle Mountain – Lake St Clair National Park, Tas

Camera: Lumix DMC-LX3 **Aperture:** f4 **Shutter speed:** 1/640 **ISO:** 80

Ken Duncan

Sunrise, Turtle Beach, Lady Elliot Island, Qld

Camera: Lumix DMC-LX3 **Aperture:** f2.8 **Shutter speed:** 1/60 **ISO:** 100

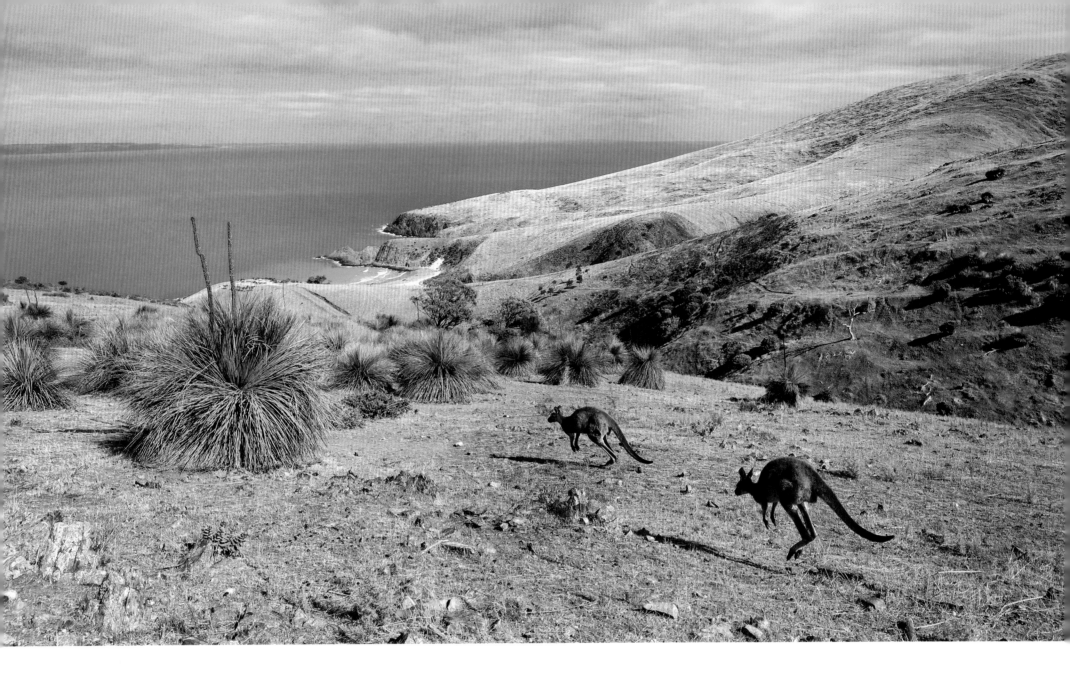

Ken Duncan

Blowhole Beach, Deep Creek Conservation Park, SA

One of the best ways to find good locations is to ask the locals. I had
been in Adelaide visiting some friends, and they gave us directions
to this delightful spot, which – after a lot of wrong turns! – we finally
found. We saw the kangaroos sitting in the field just as we approached.
There was no time to set up my big gear, so I whipped out my LX3 and
took this shot as the kangaroos took off. To me, it makes for a quintes-
sential Australian scene, with the roos not only providing great subject
matter but also adding to the lines of the overall composition.

Camera: Lumix DMC-LX3 **Aperture:** f4 **Shutter speed:** 1/1000 **ISO:** 80

Photographers' acknowledgements

Bill Bachman gratefully acknowledges:

Sandra Ennis, Shire of Campaspe, Vic

Kevin Hutchinson and Graham Trist, Echuca, Vic

Jo Jephcott, Sovereign Hill, Vic

Patrick Keane, AFL Media Relations Department

Ewan and Barbara Waugh, Clare Station, Balranald, NSW

Chris Stoney, Mansfield, Vic

Ken Duncan gratefully acknowledges:

Matt Mannall for the portrait shot.

Peter Eastway gratefully acknowledges:

Colin Harm for the portrait shot.

Ray Martin gratefully acknowledges:

Photographer Colin McDougall for the portrait shot;

Robert Heazlewood of the Brand Tasmania Council Inc.

Nick Rains gratefully acknowledges:

Ciaran Handy, General Manager Hamilton Island Resort,

 www.hamiltonisland.com.au

Fantasea Adventure Cruising Whitsundays,

 www.fantasea.com.au

Brisbane Story Bridge Adventure Climb,

 www.storybridgeadventureclimb.com.au

Surf Life Saving Queensland, www.lifesaving.com.au

Murgon Showgrounds / CMC Rodeo Contractors

Gold Coast Meter Maids,

 www.metermaids.com.au

Thanks also to:

Sydney Harbour Bridge Climb, www.bridgeclimb.com

Mike Roberts

Gecko, Eudunda, SA

How's this for a "screen-saver"? Who needs fly spray when you've got these little geckos around on most summer nights?

Camera: Lumix DMC-FT1 **Aperture:** f3.3 **Shutter speed:** 1/30 **ISO:** 100

Focus on Australia
Winning Photos from the Nation's Best
Professionals and Amateurs using Lumix cameras
First published 2010
by Panasonic Australia Pty Ltd
www.panasonic.com.au

©2010 Panasonic Australia Pty Ltd
ABN 83 001 592 187
1 Garigal Road, Belrose, NSW 2085
Telephone +61 (0)2 9986 7400
Facsimile +61 (0)2 9986 7693

Photography and text by Bill Bachman, Hugh Brown, Ken Duncan, Peter Eastway,
Ted Grambeau, Ray Martin, Leo Meier, Frances Mocnik, Nick Rains and entrants
of Panasonic Australia's Lumix Life competition.
All photography and text reproduced with permission of the respective copyright owners.

Produced for Panasonic Australia by Panographs Publishing Pty Ltd,
a division of The Ken Duncan Group, **www.kenduncan.com**
Edited by Peter Friend
Designed by John Bull, The Book Design Co.
Reprographics by CFL Print Studio, **www.createdforlife.com**
Printed and bound in China by Everbest Printing Co. Ltd

The National Library of Australia
Cataloguing-in-Publication entry:
Title: Focus on Australia : winning photos from the nation's best.
Professionals and amateurs using Lumix cameras / photography &
text by Bill Bachman ... [et al.].
ISBN: 9780980527889 (hbk.)
Notes: Includes index.
Subjects: Australia—Pictorial works.
Other Authors/Contributors: Bachman, Bill.
Dewey Number: 919.4

lumixlife.com.au

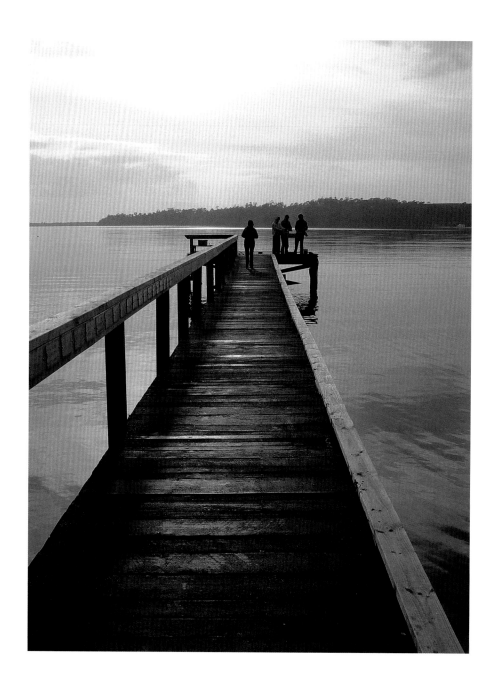

Julie Rodman
Jetty, St Helens, Tas

My friend walking down the jetty at St Helens to chat with the fishermen.

Camera: Lumix DMC-FZ7 **Aperture:** f3.3 **Shutter speed:** 1/320 **ISO:** 80